"No one helps us 'see' a painting, sculpture, mosaic, or tapestry quite like Elizabeth Lev, whose unique aesthetic insight brings the elusive St. Joseph vibrantly alive in this wonderful book."

—George Weigel
**Distinguished Senior Fellow and
William E. Simon Chair in Catholic Studies
Ethics and Public Policy Center**

"Elizabeth Lev has written another great book! In her accessible, conversational style, she has brought together centuries of theological, devotional, and artistic reflection on St. Joseph, the foster father of Christ and chaste spouse of the Virgin Mary, in a handsomely illustrated volume that students of Catholic culture will read with joy. With the sure hand of an accomplished writer and with the verve that distinguishes her work, Elizabeth Lev introduces us to this 'hidden man,' or, as she calls him, 'Silent Knight' of the Church, rekindling the love Christians have felt for Joseph for two thousand years."

—**Mons. Timothy Verdon**
**Director, Florence Cathedral Museum
(Museo dell'Opera del Duomo di Firenze)**

"The Christian world has been silent about the 'silent knight' for too long. St. Joseph is now being studied and venerated as never before, and rightly so. Following the history of artwork on St. Joseph, Elizabeth Lev fills a huge gap in this study while producing another masterpiece. Not only rich with resplendent artwork, *The Silent Knight* is also replete with historical documentation and commentary. This will be a treasured volume for art lovers, theologians, scholars, novices, and all who love a good read."

—**Steve Ray**
CatholicConvert.com

"This book by Elizabeth Lev is a fabulous insight into the story of St. Joseph, an inspiring 'portrait in words' of an iconic saint, a journey into the chronology of depictions of him in art throughout the centuries, and a passionate reminder of him as a timeless subject of divine inspiration to the artists of today."

—**Igor V. Babailov**
Vatican Papal Artist

THE SILENT KNIGHT

Also by Elizabeth Lev
from Sophia Institute Press:

How Catholic Art Saved the Faith
The Triumph of Beauty and Truth
in Counter-Reformation Art

ELIZABETH LEV

THE
SILENT
KNIGHT

A History of
St. Joseph
as Depicted in Art

SOPHIA INSTITUTE PRESS
MANCHESTER, NEW HAMPSHIRE

Scripture quotations are taken from the *Revised Standard Version of the Bible: Catholic Edition*, copyright © 1965, 1966 the Division of Christian Education of the National Council of the Churches of Christ in the United States of America. Used by permission. All rights reserved.

Sophia Institute Press
Box 5284, Manchester, NH 03108
1-800-888-9344

www.SophiaInstitute.com

Sophia Institute Press® is a registered trademark of Sophia Institute.

paperback ISBN 978-1-64413-574-7
ebook ISBN 978-1-64413-575-4
Library of Congress Control Number: 9781644135747

First printing

To the Bear,
who made me believe that
there are still St. Josephs out there

CONTENTS

ACKNOWLEDGMENTS

This book owes its existence to Pope Francis, whose pontificate has highlighted the importance of St. Joseph from the first day. Thank you to Duncan Stroik of the *Sacred Architecture Journal* and Pablo Kay of *Angelus News*, who urged me to explore the rich tradition of St. Joseph in art. Much gratitude goes to Zelda Caldwell of Aleteia, who gave me the opportunity to explore this subject in greater depth, and then to Charlie McKinney, Anna Maria Dube, and the tireless Nora Malone of Sophia Institute Press, who helped transform my thoughts into these pages.

I am immensely indebted to the scholarly work of Carolyn C. Wilson and Fr. Joseph Chorpenning, O.S.F.S., on whose shoulders this book rests, and to the people and institutions that were so quick in assisting me with research and images, including Biblioteca Nazionale Centrale di Firenze, Fr. Laurence Lew O.P., Janet McKenzie, and Donal MacManus as well as Dr. Rosanna DiPinto and Filippo Petrignani at the Photographic Archive of the Vatican Museums.

There is no way to repay the debt to my friend Fr. Roger Landry for his painstaking reading of my work and to my mother,

Mary Ann; husband, Thomas; and children, Claire, Giulia, and Joshua for offering up their summer vacation to get this book done on time. I can only ask St. Joseph to bless them for their quiet forbearance with me.

INTRODUCTION

→ · ✦ · ←

Nineteenth-century female novelists swooned over the strong, silent type, a man of few words and decisive action. For pages upon pages, they penned portraits of the perfect fictitious partner, apparently oblivious to the fact that their masculine ideal, the original quiet-yet-resolute man, had existed for almost two millennia—in the person of Joseph of Nazareth. As spouse of the Blessed Virgin Mary, foster father of Christ, and regular interlocutor with angels, Joseph (the reader may be surprised to discover) never uttered a single word recorded in the Bible. In all four Gospels, a mere fifteen lines are dedicated to his deliberations, his communications, and his actions, and he disappears from the salvation narrative after the second chapter of Luke. So elusive a figure was he that he did not appear in Christian art until the fifth century.

Yet, over time, St. Joseph's importance has grown so dramatically that the scope of his intercession ranges from husbands, fathers, and popes to workers, refugees, and the universal Church herself. As Pope Francis has noted, "After Mary, the Mother of God, no saint is mentioned more frequently in the

papal magisterium than Joseph, her spouse."[1] In his silence, St. Joseph became one of the most effective teachers of the Faith.

As the Church meditated on the example of this chaste, hard-working, faithful man, different aspects of his humble holiness shone forth like the many facets of a diamond. Artists, inspired by the iconographic possibilities of this increasingly nuanced saint, coursed alongside theologians to create ever-more-striking images of Joseph. By the twentieth century, Joseph had been portrayed by Giotto, Raphael, Murillo, Reni, William Blake, and actor Tobias Moretti in the 1999 Italian film *Joseph of Nazareth*.

After a year of devastation wrought by the 2020 coronavirus pandemic, Pope Francis invited the Church to "go to Joseph" by dedicating 2021 to this unsung champion of the Gospels. In his apostolic letter *Patris Corde*, Francis compared to St. Joseph the many quiet heroes of this age who, with their "unnoticed, daily, discreet and hidden presence," have saved lives and played essential roles in meeting the challenges of a disease that has taken so many lives and turned so many others upside down. St. Joseph, Pope Francis wrote, "reminds us that those who appear hidden or in the shadows can play an incomparable role in the history of salvation."[2]

St. Joseph is very much a saint for today, just as he has been the right man to intercede in many centuries before ours. He teaches, by silent example, that although we may feel overwhelmed by what Francis calls "all the arrogance and violence of worldly powers," God always finds a way to carry out his saving plan.[3]

[1] Pope Francis, Apostolic Letter *Patris Corde* (December 8, 2020), introduction.
[2] *Patris Corde*, introduction.
[3] *Patris Corde* 5.

While Augustus, the new Roman emperor, was reordering the world to launch his divine lineage and the client king Herod was defending his dwindling power by killing any man, woman, or infant who might threaten his precarious throne, Joseph—the just man—quietly cooperated with the Lord to bring about salvation.

Joseph's quiet leadership through example speaks in a special way to the visual arts. Exhorted by the post-Tridentine Church to become "mute theologians" and to encourage people to contemplate Scripture and the sacraments through their pictures, artists could identify with Joseph, who saw but did not speak, who transformed visions into actions, and who grasped the complex reality surrounding him without a flood of words.[4] Baroque artist Annibale Carracci once rebuked a chatty colleague, noting that "painters speak with their works."[5] Joseph, too, worked to protect the Virgin in marriage, to carry his Son to safety, and to craft objects for their livelihood. Over the centuries, painters found in Joseph a creative outlet, reinventing the saint to suit the circumstances of their ages.

The dramatic, and sometimes contradictory, changes over the centuries in Josephine iconography, however, beg for interpretation.[6] The reader will be struck by the remarkable variety of Josephs in these pages: at times elderly to the point of doddering,

[4] Gabriele Paleotti, *Discourse on Sacred and Profane Images*, ed. Paolo Prodi, trans. William McCuaig (Los Angeles: Getty Research Institute, 2012), 309.

[5] Giovan Pietro Bellori, *Lives of the Modern Painters, Sculptors and Architects*, trans. Alice and Hellmut Wohl (New York: Cambridge University Press, 2005), 77.

[6] The word *Josephine* is used among scholars to refer to things pertaining to St. Joseph, much as *Marian* is used as a descriptor for feasts, studies, or devotions regarding the Blessed Virgin.

at other times young and vigorous; on some occasions industrious, yet often depicted fast asleep; one era seems to poke fun at him, while another transforms him into an iconic superstar.

In researching St. Joseph's place in art, I uncovered a treasure trove of beautiful paintings and sculptures with an equally enriching theological backdrop. These works of art have varied historical contexts, theological resonances, and aesthetic distinctions. Yet there is a dearth of literature summing up the comprehensive history of the pictorial progress of this omnipresent saint. Sifting through the myriad images—tied to seminal moments in ecclesiastical history and illustrative of numerous theological debates over the centuries—has been a daunting task. St. Joseph, however, has proven himself to be more than just a field of inquiry for this art historian. If there was ever a saint to assist in an undertaking of this nature, trying to apply some order to mystery, imagery, and history, the best advice would still be "Go to Joseph."

This book aims to accompany the reader through the artistic wonderland that is Josephine iconography. It is a guidebook of sorts through the numerous historical, apocryphal, and theological vicissitudes of devotion to St. Joseph, revealing how each new facet of veneration produced a different trend in imagery. It attempts to make sense of the visual jumble of the old, young, weak, strong, silly, dignified, forceful, and meek representations that fill museums, chapels, galleries, card shops, and websites and to offer the reader a chance to let the beauty of the art draw him or her into greater contemplation of the many virtues of this saint. Joseph has the potential to be a mirror for everyone, no matter what the individual's needs and situations may be.

Most people are acquainted with altarpieces featuring an older Joseph wrapped in his cloak by the side of the manger in Nativity scenes, and some will know the young man with the flowing

locks favored by Murillo. Many will have only been exposed to the bland mass-produced statues in Christmas crèches. Happily, there are many more marvelous Josephs yet to meet: the gentle suitor of Raphael, the skilled craftsman of Georges de La Tour, the domestic caretaker of Hieronymous Bosch, the hopeful moribund of William Blake, and the New World protector of Miguel Cabrera, to name just a few. In the following fourteen chapters, the reader will be able to explore these different iconographies, understand their context and meaning, and hopefully find images that excite both prayer and emulation, the true purpose of religious art, according to Council of Trent.

In laying out this banquet of images, I also hope to stimulate an appetite for more Josephine art. The Holy Father's conviction that this silent saint has much more to say to our modern world provides an opportunity for artists to stand side by side with their celebrated predecessors to help the present age rediscover St. Joseph.

Joseph is a beacon in an era that undervalues fatherhood, denigrates masculinity, and ridicules chastity. He is a champion of the unborn in the face of the modern Herods who wantonly murder children in the womb. To the millions unemployed in the wake of the pandemic, he is a reminder of the dignity of the worker; to those who die alone and without the sacraments, he is the harbinger of a good death. In a globalized world, he watches over the universal Church but also protects husbands and wives in the intimacy of the home. To these many iconographic indications, Pope Francis added another in *Patris Corde*: that of "creative courage," alluding to Joseph's ability to find inventive solutions to difficult situations.[7] With a fiancée mysteriously pregnant before

[7] Pope Francis, *Patris Corde* 5.

their marriage, Joseph seeks a solution to safeguard her honor; for a wife in labor with no available shelter, he finds a stable. Facing an imminent threat to the life of his Child, he figures out how to get the family to Egypt. Just as artists produce brilliant works within the confines of a canvas, a panel, or a marble block, so Joseph, within his own limitations, participated in the greatest artistry of all: salvation.

Welcome to these pages of images past and present, of distant stories and modern struggles, centered on this extraordinary man who embodies the power of silence and yet still speaks to the hearts of all who turn to him.

THE ELUSIVE SAINT

➤ · ✦ · ⬅

We know St. Joseph as a fixture in Catholic art and spirituality, a constant at the crèche, a reflexive invocation, a sentinel by the altar, the third party in "JMJ" annotations. Not only is he patron of the universal Church, but with intentions from real estate to soul mates, young and old invoke Joseph in a steady stream of prayers and litanies. This was not always the case, however. Joseph spent many centuries waiting in the wings for his moment to shine.

As the original "strong, silent type" (not a single spoken word is attributed to him in the Gospel narratives), St. Joseph was so reticent that it took almost half a millennium for him to make an appearance in Christian art. Based on evidence derived from catacomb painting and carved sarcophagi, Christians began producing art in the late second century. They used a limited repertoire of biblical images, favoring the Old over the New Testament, but in their Christological iconography, they preferred infancy images: the Nativity and, above all, the Adoration of the Magi. These two Gospel accounts, recounted in the first two chapters of Luke and Matthew, constitute the only biblical references to the foster father of Christ. Yet, despite Joseph's scripturally documented

presence at both events, he remained strangely absent in these scenes until well after Christianity was legalized in the Roman Empire in AD 313.

Though early Christian carvers adopted a more austere style to focus on the essentials of the story, they often indulged in a meticulously rendered ox and ass, or the additions of stable, straw, manger, and swaddling clothes to the scene. Painters, too, found a place for shepherds in short tunics or Magi in pointed hats, but invariably Mary presented Christ to worshippers without her consort.

One of the many early Christian sarcophagi to represent the Nativity, the Adelphia relief from the lid of a fourth-century marble coffin found in the Catacombs of St. John in Sicily, appears to compress Luke's and Matthew's accounts into one. The three Magi approach from the left bearing recognizable gifts, with the lead figure pointing toward a star. A single shepherd, clad in a typical *exomis*, or one-shouldered tunic, holds his curved staff. The Christ Child lies inside a shelter, where the artists portrayed the details of clay tiles of the roof, the wicker weaving of the manger, the folded strips of swaddling, and even the whorl pattern of fur on the forehead of the ox. The relief was decorated with colors, rendering the scene still more vivid, yet for all the extras, Mary sits by herself on a throne-shaped rock, seemingly abandoned by the man whom the shepherds saw and who hastily packed up the family after the departure of the Magi. What sort of man would leave his wife alone to receive strangers with their newborn child far from home?

Joseph's absence in early Christian art, however, was not the fruit of callous indifference or careless oversight but of humble prioritizing and theological care. He remained in the shadows to allow the fledgling Church to spotlight the divinity of Christ and the Virgin Birth in their proclamation to the Gentiles.

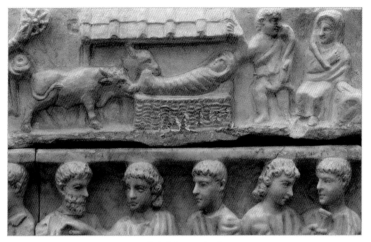

Adelphia relief

The Greco-Roman world teemed with mythological gods who sired children, sometimes through comically absurd zoomorphic unions and more often through rape, and thus "Son of God" sounded to the pagan ear like the result of yet another lust-struck deity's seduction of a hapless Mediterranean maiden. Mary's virginity distinguished the Savior from Hercules, Romulus, Castor and Pollux, and the host of flawed demigods whose temples peppered the empire. Joseph gallantly stood aside to let Mary's purity shine forth. In a world where promiscuity was the norm, where Emperor Elagabalus married a vestal virgin to show his disdain for ritual chastity, the miracle of the Virgin Birth not only defied the laws of nature but challenged the prevailing Zeitgeist.

Christianity also proclaimed that Jesus, though born of a mortal woman, was also truly God. Pagan religions had scores of divinized men, but God-made-man, fully human and fully divine, was a shockingly new concept for the empire and for the world. Shepherds and sages worshipped the Christ Child, held by His

mother, represented stiffly upright, like a stylized throne. The message of divinity could afford no doubts, so Joseph allowed himself to be upstaged by oxen and extras to forestall any confusion about the paternity of Jesus, a discreet assist to help the Church proclaim the fullness of truth in all its splendor.

Things changed in AD 380, when Emperor Theodosius proclaimed Christianity the sole religion of the empire, opening a floodgate of new artistic possibilities. Fifty years after that momentous event, St. Joseph made his artistic debut in Rome's Basilica of St. Mary Major, the first Western church to be dedicated to the Mother of God. Joseph dominated the iconographic stage in mosaic scenes of the Incarnation on the triumphal arch, where he was depicted a remarkable *five times*, more than either Jesus or Mary in the same space.

Joseph enters the history of art relatively unobtrusively in the upper left register of the mosaics. A glamorous *Annunciation* is unfolding with a regally robed Virgin seated before a closed temple (symbolic of her virginity), surrounded by a host

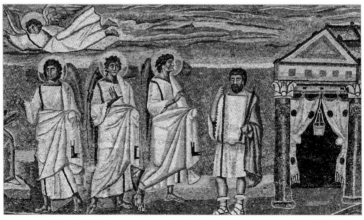

Annunciation to Joseph, St. Mary Major

of celestial attendants, but the scene continues toward another house, where Joseph emerges in subdued conversation with an angel. In this, the first depiction of Joseph, he is portrayed as a young man with dark hair and beard wearing a short tunic and an orange mantle, the costume of an imperial attendant. Virile and attentive, Joseph stands in an open doorway. His placement suggests a consciousness that he is arriving for the first time on the art historical stage as the two curtains part to reveal the guardian of the Holy Family. In this image, the Gospels of Luke and Matthew converge, and, as the two are absorbed in their respective divine conversations, Mary and Joseph are assigned their personal missions in tandem.

In the *Presentation of Christ*, Joseph, clearly the head of the household, leads his little family into the Temple. It is he who indicates the way for Christ toward Simeon and Anna. Joseph appears to have aged in this scene; he is still strong and energetic but with graying hair, perhaps a sign of another artist at work. This scene reiterates Joseph's privileged communication with

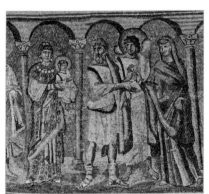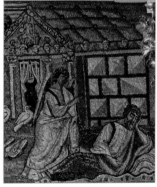

Presentation of Christ with dream of Joseph, St. Mary Major

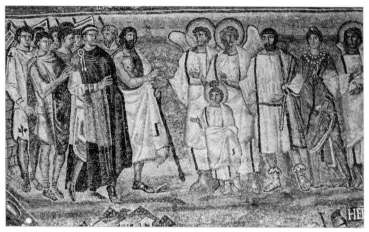

Holy Family in Sotinen-Hermopolis, St. Mary Major

the Lord, as the far corner shows a seemingly rejuvenated Joseph receiving the warning dream to flee with his family.

What follows is a surprising episode from the apocryphal *Gospel of Pseudo-Matthew*, a text that appeared in the seventh century. On the flight to Egypt, the Holy Family stopped in the city of Sotinen-Hermopolis, where Governor Aphrodisius recognized Christ as God. In this image, Joseph again takes the lead, standing before Mary, his raised hand protectively indicating his Son. Alongside Mary and Jesus, Joseph maintains his regal poise in the presence of politicians, philosophers, and soldiers.

For his final appearance on the arch, Joseph joins the three kings. Almost hidden by the ornate costumes of the Magi, he stands at the outer edge of the group, looking out at the viewer. He appears ready to step off the stage while ushering one of the Magi toward Christ.

The magnificent mosaic scenes of St. Mary Major, however, set the stage for much of the Josephine iconography to come. The

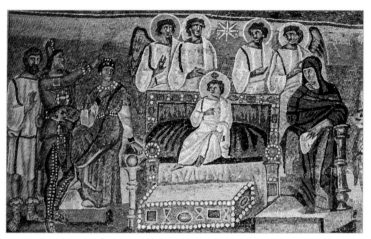

Adoration of the Magi, St. Mary Major

diverse images—speaking, dreaming, presenting, protecting—resemble the overture of a symphony, hinting at the melodies that will later unfold. The richness of this composition has led several scholars to believe that it was created by an archdeacon named Leo, the theological right-hand man of Pope Sixtus III, who built the church. In 440, Leo would himself ascend to Peter's throne and become known to history as Pope Leo the Great. If Pope Sixtus, who had called the council of Ephesus in 431 on the eve of embarking on the construction of the basilica, intended the Church to champion the Marian title of Theotokos ("Mother of God" or "God Bearer"), Leo, during his reign, would lead the Church into a deeper understanding of the two natures of Christ, fully divine and fully human.

Pope Leo, who gave more than twenty sermons on the Nativity and the Epiphany, felt a particular devotion to the Incarnation, when the Divine Word became flesh. His sermons consistently emphasized Jesus' genealogy, noted in the Gospels

of Luke and Matthew, culminating in Joseph in both. Although two lines meet in the person of Christ, Leo wrote, "one remains from eternity and the other began in time, both have nevertheless come together into a unity. They can neither be separated nor come to an end."[8] Joseph's lineage, passed on to Jesus, affixes his birth in human history, while the angels who surround Christ in every scene underscore His divine origin.

St. Mary Major, surmounting the wealthy Esquiline Hill, was surrounded by the palaces of Roman aristocrats, obsessed by lineage and ancestry. Joseph's royal descent would also elevate the status of the Holy Family for the Gentile audience. Addressed as "Joseph, of the house of David" (Luke 1:27), he established Jesus' link with the royal line of kings of Israel. In the mosaics, his cloak is rendered in the costly shade of saffron, far from the cheap garb of a laborer, a visual suggestion of his high rank. The time for humble representations of Mary and Joseph would come, but not in the triumphal arch of the church intended to influence the influencers.

Most of the depicted events surrounding the Incarnation, Nativity, and Infancy of Christ were drawn from Sacred Scripture, but despite the theological debates of the age, artists and patrons did not entirely spurn embellishments from unofficial sources, and the increasing use of apocrypha allowed for the development of Josephine imagery in the successive centuries.

Apocrypha, or noncanonical writings, served to fill in gaps left by the Gospel. While not part of the body of canonical Scripture relaying the inspired word of God, and not intended to be taken

[8] St. Leo the Great, Sermon 30, in *Sermons*, trans. Jane Patricia Freeland and Agnes Josephine Conway (Washington, DC: Catholic University of America Press, 1996), 130.

literally as factual accounts, apocrypha responded to the thirst to know more about the story of salvation and its protagonists. They tied up loose ends, from the death of John the Baptist's father to what Jesus did during the "missing years" of his youth. These accounts—creative, thaumaturgic, and filled with charming details—provided background information not only for promoting devotion to the Holy Family but also inspiration for the arts.

One of the earliest apocryphal sources for Josephine imagery was the *Protoevangelium of James*.[9] Probably written in the late second century, it evidently enjoyed great popularity, given the discovery of more than 150 extant manuscripts and its numerous translations. The Latin Church, however, condemned the text, as it tried to reconcile the scriptural problem of Jesus' "brothers" (*adelphoi*) by depicting Joseph as a widower with grown children at the time of his betrothal to Mary. Nevertheless, the work formed the basis of many Marian devotions and went to great lengths to demonstrate the virginity of Mary to the particularly incredulous and licentious world of the Roman Empire.

The contemporary *Infancy Gospel of Thomas*, or more properly known as the *Childhood Deeds of Jesus*, invited readers into the home of the Holy Family during Christ's youth, while the *History of Joseph the Carpenter*, written in the fourth or fifth century, recounted the life of Joseph through a first-person account by Jesus Himself. The latter text, which shares the circumstances of Joseph's death, would resurface as a crucial resource during the Baroque era.

The *Gospel of Pseudo-Matthew* was probably compiled a few centuries later. This text, written in Latin, was based on the

[9] The apocryphal infancy narratives and their histories are helpfully set out in James Keith Elliott, *A Synopsis of the Apocryphal Nativity and Infancy Narratives* (Leiden: Brill, 2016).

Protoevangelium and the *Childhood Deeds*, but it also recounted events of the flight to Egypt. Given a veneer of respectability by a fabricated "endorsement" by St. Jerome, this would become the principal source for much of the imagery regarding the infancy of Christ in Western art.

In St. Mary Major, the choice of the apocryphal scene at Sotinen-Hermopolis emphasized the message of salvation to the Gentiles. Here, Joseph also plays a symbolic role in revealing the messianic prophecy. In the preceding register, Joseph is instructed to "rise, take the child and his mother, and flee to Egypt" (Matt. 2:13). Obeying immediately, Christ's foster father takes his ward to a foreign land and fulfills the words of the prophet Hosea: "Out of Egypt have I called my son" (Matt. 2:15; see Hos. 11:1). The human father works in concert with the divine Father to proclaim Jesus, the Son of God.

This encounter with the Egyptians, the same people who, centuries earlier, had enslaved Joseph the patriarch, serves as a redemptive story arc. Aphrodisius welcomes Jesus, even as Herod, king of the Jews (portrayed in the panel below this), seeks to murder Him. The redemption of the Egyptians through their recognition of the divinity of Christ is visually facilitated by Joseph, who indicates the Savior. The Old Testament Joseph distributed bread in times of famine, and the New Testament Joseph brings to Egypt Jesus, who is, in the words of Pope Leo, "the Bread of Life and the Food of reason that came down from heaven," saving these people from "that worse than all famines under which the Egyptians' minds were laboring, the lack of truth."[10]

[10] Pope Leo I, Sermon 33, on the feast of Epiphany, no. 4, in *Sermons of St. Leo the Great*, trans. Charles Lett Feltoe, in vol. 12 of Nicene and Post-Nicene Fathers, Second Series, ed. Philip

Joseph also facilitates this encounter in his final mosaic appearance with the Magi, where he indicates the Christ Child to the king. Whereas King David had prophesized in the psalms, "All the nations thou hast made shall come and bow down before thee, O Lord, and shall glorify thy name" (Ps. 86:9), his descendent Joseph, courtly consort and protector of the Savior, looks out at the viewer as if to confirm that the prophecy has come true.

In his sermon celebrating the Epiphany, Pope Leo declared: "In the three Magi let all people worship the Author of the universe: and let God be known not in Judaea alone, but in all the world, so that everywhere His name may be great in Israel."[11] In this glorious church overlooking the capital of the Roman Empire, Joseph leads the triumphal parade of the Savior, who has conquered the pagan gods and brought all nations to the glory of truth.

The Josephine momentum begun by the mosaics of Mary Major continued in the stunning episcopal throne carved in 545 for Maximian, bishop of Ravenna. The city on the Adriatic had served as capital of the Western Roman Empire and remained the locus of Byzantine authority even after the last Roman emperor, Romulus Augustus, surrendered the insignia of Rome in 476. Ruling from afar, Justinian lavished exquisite churches, dazzling mosaics, and exceptional bishops on the port city. The spectacular workmanship on this ivory *cathedra* suggests that it was commissioned in Constantinople for Justinian's new episcopal appointee Maximian, sent to continue the process of restoring

Schaff and Henry Wace (Buffalo, NY: Christian Literature Publishing, 1895), revised and edited for New Advent by Kevin Knight, https://www.newadvent.org/fathers/360333.htm.

[11] Ibid., no. 3.

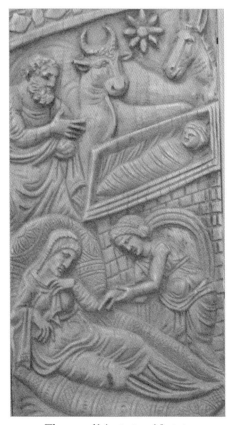

Throne of Maximian, Nativity

theological orthodoxy.[12] Ravenna was shaping into a theological battleground, after fifty years of rule by Arian Ostrogoths who promoted the heresy of Arius, which claimed that Christ was not the Creator but a creature.

[12] Derived from the Greek words for "raised" and "chair," *cathedra* is the Latin word used to describe a seat of authority, such as that of a bishop, and is where the word *cathedral* comes from.

Throne of Maximian, trial of poisoned water
and the Annunciation

The throne has amazingly maintained sixteen of the original twenty-four historiated panels intact. The scene selection, drawn from the Old Testament, the New Testament, and the Apocrypha, suggests a percolating awareness of the devotional possibilities of Joseph. Both the Nativity and the Adoration scenes feature Joseph, although he is represented distanced from the Virgin, again evincing the preoccupation with Mary's purity. In the Nativity scene, Joseph stands amid the animals, while in the Adoration carving (the panel containing the Magi is missing), he peeks out from behind Mary's throne. The Nativity scene also includes the miracle of the withered hand, first recounted in the *Protoevangelium of James*. One of the midwives brought by Joseph to tend to Mary doubted the latter's postpartum virginity and demanded proof. Her hand withers after touching Mary, only to have it heal when she adores the newborn Christ Child. Joseph is honored by association in this story, since he believes whereas the midwife doubts.

The Nativity is placed above a rarely represented scene of Mary and Joseph defending their chastity, also taken from the

Protoevangelium of James. When Mary is discovered pregnant at the Temple, both she and Joseph stand accused of having violated their consecration to chastity. To assuage the suspicions of the high priest, they must both drink poisoned water. When they both remain unharmed, they are vindicated. These recurring emphases on Mary's virginity as well as Christ's divinity served as a visual reinforcement to the bishop's preaching against the Arian heresy: absent its occupant, the throne continued to proclaim the truths of the Faith.

Joseph's future role as patron of husbands was hinted at in another panel, in which the angel tells Joseph: "Do not fear to take Mary your wife" (Matt. 1:20). He appears twice, first asleep and then solicitously assisting a pregnant Mary riding a donkey. This second charming scene, far more intimate than the regality of the St. Mary Major mosaics, is drawn from the account of Pseudo-Matthew, who notes that they were accompanied by "a beautiful boy, clothed in white raiment," who would be described a few lines later as an "angel" and is visible in the panel.[13]

The exterior of the throne, however, contains no fewer than ten images dedicated to Joseph the patriarch, from his imprisonment in the well to his reunion with his brothers. Although the stories of Joseph — betrayal, wrongful accusation, forgiveness — were traditionally associated with Christ, similarities with Jesus' foster father grew more pronounced. The carvings allude to both Josephs' gaining knowledge through dreams, while the

[13] *Gospel of Pseudo-Matthew*, chap. 3, in vol. 8 of Ante-Nicene Fathers, ed. Alexander Roberts, Sir James Donaldson, and Arthur Cleveland Coxe (New York: Christian Literature Publishing, 1886), Gnostic Society Library, http://gnosis.org/library/psudomat.htm.

episode of Potiphar's wife accusing Joseph unjustly of unchastity mirrors that of Mary, Joseph, and the poisoned water.

As a protagonist in the spectacular decorative program of St. Mary Major and with a recurring role in the Throne of Maximian, Joseph seemed poised to rule the iconographic roost. Yet the elusive Joseph would disappear again, only to return later in a far more subdued guise. Joseph's dynamic debut in art might suggest that the Church had overcome its concerns about virgin births and divine paternity, but after this blockbuster introduction, he was soon relegated once again to the sidelines of iconography.

THE ENIGMATIC ELDER

St. Joseph's next appearances in the scattered artifacts from early Christianity markedly differed from his glamorous debut. Not only had he aged considerably, but he often found himself relegated to the peripheries of the story. From chief negotiator at the Temple during the Presentation to the encounter with the Egyptians, in later representations Joseph seemed abandoned among the animals, almost an afterthought to the events.

The Eastern Church saw the cult of Joseph flourish: the Coptic Church celebrated July 20 as his feast day, and he featured in their compilation of hagiographies.[14] In the Western Church, however, Joseph's devotional journey was fraught with travail. As the liturgy was being codified in the seventh century, Joseph was omitted from the Roman Canon, the oldest Eucharistic Prayer of the Western Church, a lacuna that would not be rectified until Pope John XXIII did so in 1962. In those years, Joseph was even excluded from one of the most important works of literary art from the era following the fall of the Roman Empire: a Nativity poem

14 See "Who Is Saint Joseph?," St. Joseph's Church, San Antonio, Texas, https://stjsa.org/who-is-saint-joseph.

written in Constantinople and sent as a gift to Pope Gregory the Great. The twenty-four lines had an enormous impact on Marian iconography, yet the literary imagery concentrated on the Virgin and Child, evoking the numerous Madonna and Child enthroned icons starting to circulate in churches; it spares nary a syllable for Joseph.

The meager visual testimony to Joseph remaining from the seventh century to the turn of the first millennium is quite diverse: a mosaic, an encaustic panel, an ivory book cover, and a reliquary lid constitute the highlights of a tiny body of iconographic evidence. This is due in no small part to the iconoclast movement that raged through Eastern Christian lands from 727 to 843, causing the destruction of many works of art, as well as high-handed renovations in Western Christendom that obliterated "old-fashioned" works in favor of newer styles.

These surviving works reveal Joseph's return to reticence. A few common threads unite these varied pieces. Joseph is always cast as an older man with a full head of white curls matching his bushy beard. Joseph's posture also transforms from the upright, virile courtier of the Mary Major mosaics or Mary's supportive partner in the Throne of Maximian into a bowed figure wrapped tightly in his cloak.

These changes might be traced to the increased demand for popular art, smaller objects destined for travel. Except for the mosaic, all the other objects under examination are lightweight, small, and transportable. The displacement of the artifacts from one site to another made for a very efficient means of sharing types of imagery, which, for orthodoxy's sake, meant a reduction of apocrypha and a further simplification of scenes. Marian devotion, developing rapidly at this point, required constant reinforcement of her purity as well as her chaste marriage with

Joseph, and, taken with the numerous ingenious ways in which the divinity of the Christ Child was underscored, the unfortunate result was the ostracization of St. Joseph.

A charming icon probably dating from the seventh century and today kept in St. Catherine's monastery on Mount Sinai in Egypt serves as an example of what defenders of images in later centuries would describe as a work *delectare et docere*, "to delight and to teach." The busy panel jumbles the natural and supernatural events of Christ's birth into one cheery hive of adoration and jubilation. The round faces and highly stylized figures suggest that it is a work of folk art, although it was created using the prestigious medium of encaustic, fusing hot wax with vegetable color before applying it with special instruments to wood or canvas. This technique had been perfected in the area of making portraits in the tombs of the mummified elite.

The newborn Christ Child occupies the center of the work, propped up in His swaddling clothes before the remarkably primitive and abruptly truncated ox and ass. Angels frolic in the upper register against a golden background, one pointing out the star of Bethlehem that emanates directly from the heavenly firmament above. Mary, drawn with graceful curves reminiscent of ancient Hindu art, tends to the child. The Magi appear on the right, and shepherds are scattered amid black and white sheep peppered through the lower area of the panel. The work offers a few nods to the narrative embellishments of the *Protoevangelium*—Mary gives birth in a cave, and the midwives bathe the newborn—and these elements help to anchor the scene in a relatively familiar locus, but Joseph seems almost like an addendum in the lower left side of the work. He faces away from the activity of the midwives, confined in his own cave like a groom tasked with watching the horses for the Magi. From the triumphal arch of St. Mary Major, Joseph has fallen from the

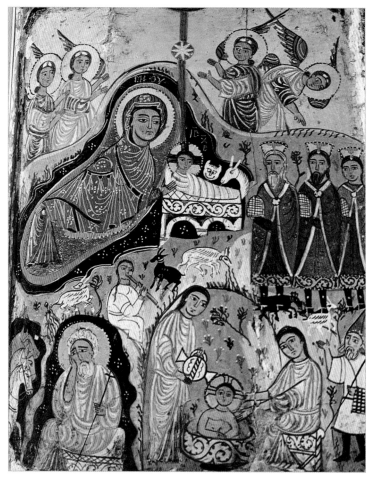

Nativity icon, Monastery of St. Catherine, Sinai

stars to the stables (to invert an old Italian adage), and, judging by his expression, he seems to have suffered during the crash.

Another intriguing portrayal can be found in a reliquary box from the seventh century, currently housed in the Vatican Museums.

Before the rise of Islam, pilgrims traveled around the Mediterranean basin visiting the holy sites connected with the lives of Christ and the saints. Anticipating the age of ubiquitous souvenir shops, these pilgrims took dirt from the places where they had prayed, collecting it in decorated boxes.

Painted in encaustic like the Sinai panel, the Vatican relic box shows several stories spanning the life of Christ, probably tracing the sites visited by the pilgrim who commissioned it. The Crucifixion occupies the heart of the panel, while the scenes above depict the empty tomb and the Ascension and the lower quadrants recount the Nativity and the Baptism of Christ.

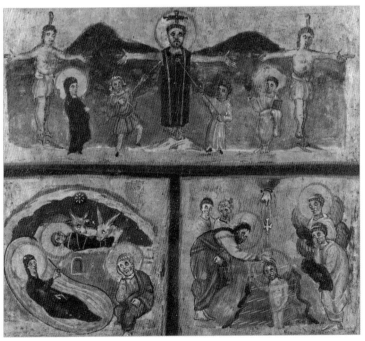

Reliquary box, Vatican Museums

The Nativity leaves out midwives, shepherds, and Magi to focus on Christ. In this austere composition, the artist makes several interesting choices. Mary and Christ both recline inside delineated spaces, whereas Joseph is posed in what is becoming his typical position: seated with his hand on his cheek, lost in thought. The Virgin and Child are both enrobed in a midnight blue, the most eye-catching color in the work, contrasting with the earth tones of Joseph's mantle. Despite these distinctions, Joseph appears more engaged in the action, balancing a compositional triangle formed by the mother, the Son, and himself. He also wears a halo, reinforcing the existence of an Eastern cult to Joseph, well before its development in the Western Church. It is worthy of note that Joseph finds himself back-to-back with St. John the Baptist, who also wears the same shades of brown, in the adjacent panel. It appears that the artist had found a way of maintaining St. Joseph as part of the family by pairing him with Jesus' cousin, who, like Joseph, would die before Jesus' salvific sacrifice. The pairing of the two, seen for the first time in this reliquary, would return in later centuries as theologians worked to define with greater precision Joseph's role in the history of salvation.

Many seeds were germinating for the future of Josephine iconography, yet images of Joseph remained stagnant over the following centuries. Present only in Nativity and Magi scenes, Joseph was depicted as a diminutive figure behind Mary's throne or a pensive elder crouched in a corner. Even in extravagant papal commissions, where one might expect to find daring iconographic choices, the figure of Joseph remained fairly staid. In 706, the newly elected pope, John VII (705–707), planned to add to the Basilica of St. Peter's a new chapel dedicated to the Mother of God. Constructed by the entrance to the basilica, the Oratory,

as it was called, covered an area of forty by twenty-eight feet. It was destroyed in 1609 under Pope Paul V in order to build the new facade for the church, but drawings made by Giacomo Grimaldi shortly before its demolition reveal the original decoration for the chapel. Pope John VII was the son of a Byzantine imperial official, a fact that permitted him extensive resources for his building.

The walls were completely sheathed in costly marble, with the altar wall covered in mosaics displaying thirteen scenes of the life of Christ arrayed around an eight-foot figure of the Blessed Virgin with arms raised in prayer.[15] Today, only a few scattered fragments are preserved, the majority kept in the grottos under St. Peter's Basilica. Joseph appeared in three of the scenes: the *Nativity*, the *Adoration of the Magi*, and the *Presentation at the Temple*. With the exception of the *Nativity*, Joseph was not only placed outside the main cluster of figures but was given a name tag, as if a beholder might wonder who this extraneous figure could be. In the *Adoration of the Magi* panel, today in Rome's Santa Maria in Cosmedin Church, Joseph's physical stature is reduced next to the towering figure of Mary and is the only figure among Mary, Jesus, and the angel to be shown without a halo.

Another precious surviving fragment depicts Joseph at the Nativity. This smaller panel (two and a half feet in height) still exists in the Pushkin Museum in Moscow. Although the mosaic has been heavily reworked, there are noteworthy changes in the

15 Paola Pogliani, "Il Perduto Oratorio di Giovanni VII nella Basilica di San Pietro in Vaticano. I Mosaici," in *Santa Maria Antique tra Roma and BizanzioI*, ed. Giuseppe Morganti, Giulia Bordi, and Maria Andaloro Electa (Milan: Electa, 2016), 243.

Drawings by Giacomo Grimaldi revealing the original decoration for the
Oratory at St. Peter's Basilica before the Oratory's destruction in 1609

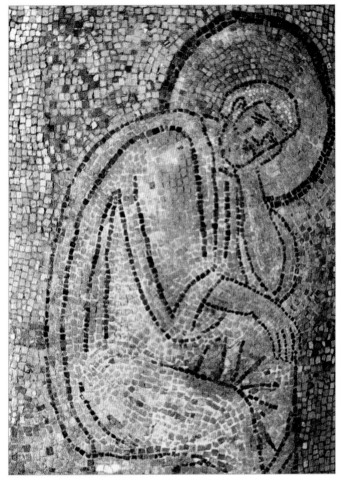

Detail of a mosaic depicting Joseph at the Nativity, Pushkin Museum

iconography of Joseph. In both the *Adoration* and the *Nativity*, Joseph wears a white tunic, a new development highlighting his personal purity. In the Pushkin fragment, Joseph does have a halo, but it is blue, unlike the golden halos of the Madonna and the Child, and is similar to that of the angel in the *Annunciation* panel.

Joseph's pose in the *Nativity*, seemingly codified at this point in Byzantine-influenced art, remains the same bowed contemplative form as in the preceding century, in this case, contrasting with the activity of the midwives on the other side of Mary. The meditative Joseph, juxtaposed with the business of the women at work, would eventually encourage Josephine devotion by contemplatives such as St. Teresa of Ávila.

The millennium drew to a close with few changes to the iconography of Joseph. If anything, Joseph's lowly status in the iconographic hierarchy seems emphasized. In a carved ivory Gospel cover dating from the eleventh century, today in the Vatican Museums, three angels hover around the crib at the top of the panel, a Trinitarian allusion. Mary stretches across the middle of the panel, enclosed in a kind of protective bubble, the precursor of the *mandorla*, the almond-shaped frame placed around Mary and Jesus in late medieval art. Along the left side, an angel proclaims the good news to a shepherd as a cascade of sheep and goats tumble down the side toward the figure of Joseph in the lower left, where he is turned away from the Christ Child in the bath, looking more morose than usual. Joseph's age, placement, and positioning in the work all serve to highlight to the reader that he is *not* the biological father of the Child.

These glum depictions of Joseph, apparently the only person not jubilant at the birth of Christ, were most likely inspired by what apocryphal authors described as Joseph's "troubles." In both the *Protoevangelium of James* and in the *Gospel of Pseudo-Matthew*, Joseph is often troubled. The writers portray Joseph as afraid of becoming the laughingstock of the village for his marriage to such a young girl at his advanced age. He hesitates to refuse her, for fear of punishment. He is then terrified to find Mary pregnant

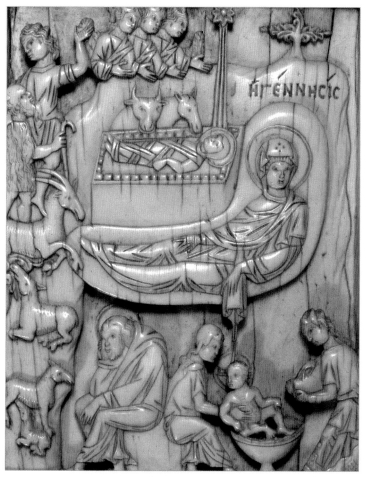

Carved ivory Gospel cover

and worries about putting her aside, torn between two tough
options: "If I hide her sin, I shall be found fighting against the
law of the Lord; and if I manifest her to the children of Israel,
I fear lest that which is in her be the seed of an angel, and I
shall be found delivering up innocent blood to the judgment

of death."[16] He is distraught at taking Mary on a long journey and uncertain about where she would be able to give birth. The *Protoevangelium* recounts that on the road to Bethlehem for the census, Joseph is confused when Mary alternates between laughter and tears and asks her what is happening. Mary answers: "Because I see two peoples with my eyes; the one weeping and lamenting, and the other rejoicing and exulting."[17] This duality is reflected in the moroseness of Joseph contrasted with the jubilant shepherds in the upper corner.

In some works, Joseph even fears the holiness of Mary. Sixth-century Byzantine composer Romanos the Melodist put these verses on the lips of Joseph: "O luminous One, I see a flame, a fire which surrounds you and I am terrified of it. Mary, protect me and do not consume me. Your guiltless womb is suddenly become a furnace filled with fire; let it not melt me, spare me, I beg you."[18]

Joseph's uneasiness is also a theme of *The Infancy Gospel of Thomas*, in which he is often befuddled by the power of his Son, and the *History of Joseph the Carpenter* dedicates paragraphs to an old man's terror of death. Joseph, while always obedient, suffers in the apocryphal stories from self-doubt and a feeling of inadequacy in fulfilling the enormous task set before him. Thus, while depicting the midwives made the birth event more relatable

[16] *Protoevangelium of James*, chap. 14, trans. Alexander Walker, in vol. 8 of Ante-Nicene Fathers, ed. Alexander Roberts, James Donaldson, and A. Cleveland Coxe (Buffalo, NY: Christian Literature Publishing, 1886), revised and edited for New Advent by Kevin Knight, https://www.newadvent.org/fathers/0847.htm.

[17] *Protoevangelium of James*, chap. 17.

[18] Father Frederick L. Miller, *St. Joseph: Our Father in Faith* (New Haven, CT: Knights of Columbus Supreme Council 2021), 18, https://www.kofc.org/un/en/resources/cis/cis328.pdf.

for viewers, so Joseph in medieval art became a conduit for the beholder to meditate on the extraordinary events taking place around an ordinary man who has been called from a quiet existence to play his role amid political upheavals, deadly rivalries, and the greatest mystery in human history.

Pier Paolo Pasolini returned to this iconography in his 1964 film *The Gospel According to Matthew*, in which the opening scene confronts the viewer with the troubled face of a balding, bewildered Joseph before he turns and walks away from the mysteriously pregnant Virgin Mary.

The troubles of Joseph the Carpenter emphasized his similarities to his Old Testament namesake, whose betrayal by his siblings, sale into slavery, and harrowing exile to Egypt were heralded by distressing dreams. On the surface, the iconography of Joseph seemed to be stagnant during these long centuries, but, in reality, it was in fermentation, about to emerge in a variety of visual vintages in the coming years.

THE SILENT KNIGHT

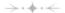

With its stylized, repetitive motifs and its tendency toward stability in sacred images, the Byzantine influence on Christendom meant that little changed in Josephine iconography until the turn of the new millennium. But as the Western Church began to flourish in its own right, acquiring lands and governing subjects, the prestige of the clergy swelled into what would become the First Estate, posing new challenges for the Church. Wealth and power were followed by corruption, plunging ninth-century ecclesiastics into a world of crime, scandal, and interference by temporal powers. Who would safeguard the purity of the Church? Who would protect her from being subsumed by greedy sovereigns? St. Joseph. St. Joseph returned in the Age of Chivalry, riding in like a shining, albeit silent, knight, ready to serve and to defend the Church, his damsel in distress.

Counter-Reformation historian Bishop Caesar Baronius (1538–1607) coined the term *saeculum obscurum*, or "dark ages," to describe the period between 888 and 1043, an era that opened with the trial of a pope's cadaver, then piled insult upon injury with a twenty-year-old pope, a murdered pope, a layman pope,

a couple of deposed popes, and antipopes galore.[19] The mistress of one pontiff imprisoned another, while emperors, kings, and petty nobles took turns planting their puppets in the chair of Peter. From de facto marriages among priests to rampant clerical homosexuality to the scourge of sex abuse, the corruption was fueled by the vast amounts of money circulating around benefices and landowning dioceses. It is a small wonder that the fictitious invention of Pope Joan was inserted into this period: for those looking to undermine the papacy, the story fit well among the other tales of sex and scandal.

Just as the crusades began in 1099 with the intention of liberating the Holy Land from Muslim rule, serious reform was underway to free the Church from her captivity to corruption. Pope St. Gregory VII spearheaded this period of purification, with a vanguard of Benedictines. Urging a reluctant world to find the strength to turn away from sin, St. Bernard of Clairvaux pulled St. Joseph off the bench and thrust him into battle as an example of chivalric discipline and fortitude.

A tireless preacher, Bernard launched St. Joseph as the face of the reform movement in his sermon "St. Joseph, Husband of Mary." In it, he dismissed the image of a doddering old man put forth by the *Protoevangelium of James*, extolling the virtues of Joseph and holding him up as a noble, humble paragon of self-mastery.

In this era when battleground bravery was highly prized, St. Bernard reexamined "Joseph's troubles." Earlier ages had trapped Joseph in a prison of fear, but the Mellifluous Doctor claimed that Joseph's hesitations came from his own humility, his sense that

[19] Caesar Baronius, *Annales Ecclesiastici*, vol. 10, *Coloniae Agrippinae: Sumptibus Ioannis Gymnici & Antonii Hierati* (Rome, 1602), 647.

"he would not be able to live with a woman who was so great, whose wonderful and superior dignity he feared."[20] In this, St. Bernard argued, Joseph resembles St. Elizabeth, who wondered, "Why is this granted to me, that the mother of my Lord should come to me?," or St. Peter, who exclaimed to Jesus, "Depart from me, for I am a sinful man" (Luke 1:43; 5:8). But despite his conviction of his own unworthiness, Joseph mastered his fear and shouldered this awesome responsibility.

The feudal world of the Middle Ages hung on birthrights and lineage, noble patents, crests, and coats-of-arms displayed on every occasion. Bernard reminded the contemporary audience that no one bore a greater lineage than Joseph, claiming: "He was truly a descendant of the house of David, of a royal race; noble of rank, more noble still of mind."[21] It is this chivalrous Joseph who appears in the art of Gislebertus (d. 1135), the celebrated master sculptor who worked on the legendary abbey at Cluny and the glorious shrine of Vézelay. From 1120 to 1132, Gislebertus carved seventy stone capitals as well as the tympanum decoration for the stunning cathedral of St. Lazare in Autun, reviving the almost extinguished art of decorative sculpture. Gislebertus mastered the ability to carve stories on the small space atop a column, and one of his most successful works was the *Flight to Egypt*. In the tight trapezoidal space Mary sits sideways on a donkey, holding a very vertical Christ Child, who resembles a mini Pantocrator, solemnly resting His hand on a globe, all elements reminiscent of Byzantine art. But the representation of Joseph

20 St. Bernard of Clairvaux, *Laudes Mariae* 2, Prayers4Reparation, https://prayers4reparation.wordpress.com/2013/08/04/writings-of-the-church-fathers-st-bernard-of-clairvaux-on-st-joseph-the-spouse-of-mary/.

21 *Laudes Mariae* 2.

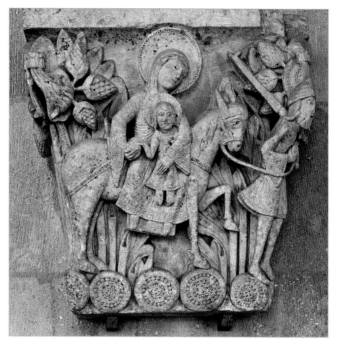

Flight to Egypt by Gislebertus

presents a striking innovation. Dressed in armor down to helmet and boots, Joseph is depicted as a knight, holding the reins of the animal carrying his lady and his overlord, and leading the way with a sword, instead of a staff, resting on his shoulder. This agile, alert man evokes the finest virtues the age of chivalry had to offer. St. Joseph, who courageously led his family to safety during the tumult of Herod's rage, revealed himself as an ideal guide to accompany the Church out of the chaos and corruption of the end of the first millennium.

Adding to the qualities evinced by this brave protector, St. Bernard praised the continence of Mary's husband, building upon the comparison with Joseph the Old Testament patriarch first

proposed in the Throne of Maximian. "The first was faithful to his master and treated his wife with honor," he wrote, "the second, too, was the most chaste guardian of his bride."[22] This comparison with the young, handsome man pursued by Potiphar's wife out of lust, upholds Joseph's chastity as the fruit of self-restraint, not infirmity of age. As the Church was forcefully calling for clergy to respect their clerical vows, she simultaneously offered a model in Joseph.

In art, a Joseph who was chaste by choice provided justification to begin trimming some years from his depictions, a de-aging process that would see Joseph grow younger as the centuries wore on.

What captured the mystical imagination of St. Bernard, however, was the similarity between the two biblical figures as "dreamers." Joseph of Egypt "was given the understanding and interpretation of dreams" while Jesus' foster father enjoyed "the knowledge of, and participation in, the heavenly mysteries."[23] Joseph's privileged communications, taking place in the silence of his four dreams, would have a direct effect on the art of the age.

The impetus of St. Bernard bore a great deal of fruit in Josephine devotion. In 1189, the city of Bologna, a hub of pious and intellectual activity after the first university in the West had been founded there a century earlier, built the first church to be dedicated to St. Joseph.[24] The first steps toward universal devotion were underway.

[22] *Laudes Mariae 2.*

[23] *Laudes Mariae 2.*

[24] Pope Benedict XIV, a Bolognese, affirmed the existence of a church dedicated to St. Joseph in Via Gallerie. Don Marcello Stanzione, "La prima chiesa in Italia dedicata al culto di san Giuseppe," Aleteia, January 5, 2018, https://it.aleteia.org/2018/05/01/bologna -prima-chiesa-italia-dedicata-san-giuseppe/.

Renewal in the Church also meant renewal in art and architecture as cathedrals embellished with the new decor of stained glass and relief carvings sprang up throughout Europe. Pilgrims flocked alongside the local faithful to the latest holy sites and shrines, marveling at the images that covered every surface. Chartres Cathedral, one of the most ambitious and successful building projects of the twelfth century, was one of the first sites to reveal the "new" Joseph. The world-famous array of stained-glass windows illustrated salvation history from Genesis to the contemporary age, represented by farmers and hunters. The scene of the Nativity, featured in the Incarnation window, executed around 1150, was placed in the lowest section of the window and thus was one of the most visible panels.

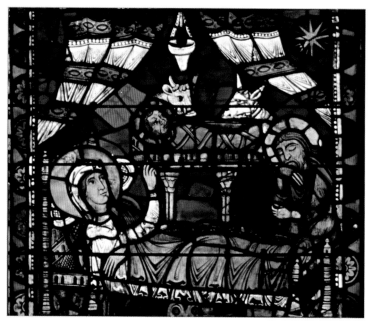

Nativity stained-glass panel, Chartres Cathedral

Instead of the omnipresent cave or stable, Jesus is framed by a pair of cheery striped curtains opening to focus attention on His crib. The tightly swaddled Christ Child lies on a raised altar held up by two columns, with the ox and the ass peering at him. Below, Mary rests on a bed, gesturing up toward her child, as in many other images before. Joseph, however, represented as younger than he has been seen in five centuries, sleeps with his cheek resting on his hand. Vibrant colors, the great triumph of stained-glass production in Chartres, play an essential role in interpreting this work. The robes and halos of Christ and Mary are rendered in the famous Chartres blue — a deep, mesmerizing cobalt. As one of the most expensive colors to produce, this blue was the vitreous equivalent to lapis-lazuli paint employed when painting Jesus or the Blessed Virgin to denote their special status. Joseph, on the other hand, sports a lighter turquoise halo, although a swatch of Chartres blue brightens his brown tunic. A closer look at Jesus' halo reveals that both colors appear, a cobalt disc and a turquoise cross. The colors underscore His humanity and His divinity: Mary bore Him through the power of the Holy Spirit, but Joseph gave Him a family name, a genealogy, and an identity in the society. Mary and Joseph are depicted across from each other in this work, both seated below Christ, at the foot of the altar, as it were. It is worth noting the fine details of intricately inlaid wood on Mary's bed, a flash of virtuosity for the glassmakers, but also a homage to Joseph's craftsmanship.

The image of sleeping Joseph was also transmitted through illustrated manuscripts. These were generally prayer books to aid the faithful in contemplation through drawings. Mostly produced for the noble classes, these books were often artistic treasures and were meant to be transported so the owner could practice daily devotions. They usually portrayed the Holy Family in a clearing,

with Mary cradling the infant while Joseph slept next to them. As in the Chartres window, Joseph is usually depicted on the same pictorial level as Mary, balancing her visual absorption with the Lord with his sleep-induced visions.

The sleeping Joseph serves as a particularly powerful visual device to illustrate contemplative prayer, in which the worshipper is rapt on another plane in the divine presence. St. Bernard, who was so famed for his mystical experiences that he would succeed Virgil and Beatrice as guide to Dante Alighieri in the final stages of gazing at the beatific vision in the *Divine Comedy*, described contemplative prayer as discerning God's will for us, instead of putting forth our needs and woes. "Contemplating ourselves brings fear and humility," he preached; "contemplating God brings us hope and love."[25] This contemplation requires silence, for, in the words of Robert Cardinal Sarah, "Silence is where God dwells."[26] The silence of St. Joseph, who, in the quiet of his sleep, conversed with angels, made him an effective model for contemplative prayer. Joseph, like the pilgrims or personages of the Middle Ages, was surrounded by noise — the lowing of animals, the pageant of the Magi, midwives, customers, and tools — yet he was able to retreat into his silent sleep to discover God's will for him. This interior prayerfulness appears as the source of his strength. Cardinal Sarah writes: "Silence of the heart consists of quieting little by little our miserable human sentiments so as to become capable of having the same sentiments as Jesus."[27] In this light, Joseph's chastity in his marriage

[25] St. Bernard, Sermo 5, "On the Words of Habakkuk 2:1."

[26] Robert Cardinal Sarah, *The Power of Silence: Against the Dictatorship of Noise* (San Francisco: Ignatius Press, 2017), 30.

[27] Sarah, *The Power of Silence*, 45.

is the result not of impotence but of self-mastery, embodying the cardinal's observation that "silence of the heart is the silence of the passions."[28]

Many other contemplatives, both male and female, took St. Joseph as a role model. St. Gertrude of Helfta, also known as Gertrude the Great, was a thirteenth-century Benedictine mystic as well as the only female saint to date who bears the title of "Great." On the feast of the Annunciation, St. Gertrude experienced a vision in which Mary revealed to her the heavenly glory of St. Joseph. She wrote, "I saw Heaven opened and St. Joseph sitting upon a magnificent throne. I felt myself wonderfully affected when, each time his name was mentioned, all the saints made a profound inclination toward him, showing by the serenity and sweetness of their looks that they rejoiced with him on account of his exalted dignity."[29] Even though Joseph did not yet have his own feast day in the thirteenth century, the Benedictines were zealously promoting him as a powerful intercessor for the faithful.

Although contemplatives extolled the prayerful silence of Joseph, Scripture also shows him as a man of action. Joseph awakens from his dreams ready to go. His first vision propels him to take Mary as his wife, and subsequently, every time an angel speaks, Joseph moves. He escapes to Egypt, returns to Judea, and settles in Galilee. Sleep begets action with St. Joseph. Indeed, one Roman priest quipped in a homily, "There must have come a moment when Mary was plying Joseph with coffee to keep him awake so they wouldn't have to move again."

[28] Sarah, *The Power of Silence*, 45.

[29] *The Life and Revelations of Saint Gertrude: Virgin and Abbess of the Order of St. Benedict* (London: Burns, Oates and Washbourne [1870?]), 370–371.

Medieval writers did not diminish the importance of Joseph's active life even as they praised his meditative nature. St. Bernard highlighted the humility of this descendant of kings who did not scorn manual work to support his family, and, even more poignantly, he invited his listeners to visualize Joseph permitted by God "to carry Him in His arms, rear Him, embrace Him, kiss Him, nourish and watch over Him."[30] St. Benedict had founded his order in the sixth century on the premise of *ora et labora*, "pray and work," so it seems appropriate that the Benedictine reformer would be the first to explore the life of prayer that fueled Joseph's love and labor.

A singular work by Sienese artist Duccio di Buoninsegna (1255–1319) illustrates this duality of Joseph's ministry. In 1308, the city of Siena commissioned an extraordinary altarpiece, called the *Maestà*, in honor of the Blessed Virgin, the protectress of the town. Sixteen feet high, it was covered with seventy-five painted panels illustrating the lives of Christ and saints. The breathtaking painting has since been dismantled and several panels lost, but the surviving image of the *Flight to Egypt* demonstrates Duccio's innovative iconography. Joseph is depicted twice in the seventeen-inch-square space: first, on the far left, cocooned inside his cloak and fast asleep as an angel comes to warn him to "take the child and his mother, and flee to Egypt" (Matt. 2:13). Immediately to the right, Joseph appears again, fully alert, duly packed, with their meager possessions over his shoulder, shepherding his family away from danger. Most remarkably, the ever-silent Joseph seems to be speaking. With his open hand gesticulating to indicate speech and his intent gaze toward the face of the Virgin, he seems to be explaining the reasons for their hurried departure. Images of

[30] *Laudes Mariae* 2.

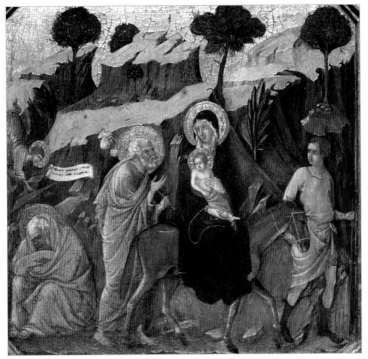

Flight to Egypt by Duccio di Buoninsegna

Joseph urgently ushering the Holy Family had started appearing in Tuscany during the thirteenth century: the mosaics of the Florentine Baptistery and a panel by Guido da Siena from about 1260 both suggest a speaking Joseph, but Duccio's juxtaposition of the contemplative Joseph and the active Joseph was completely new.

In Duccio's work, the apparent tension between the active and the contemplative life finds in Joseph an ideal harmony that is possible only for those who possess the perfection of charity. St. John Paul II, writing *Redemptoris Custos* in 1989, noted that St. Augustine distinguished between the love of the truth (*caritas veritatis*) and the practical demands of love (*necessitas caritatis*),

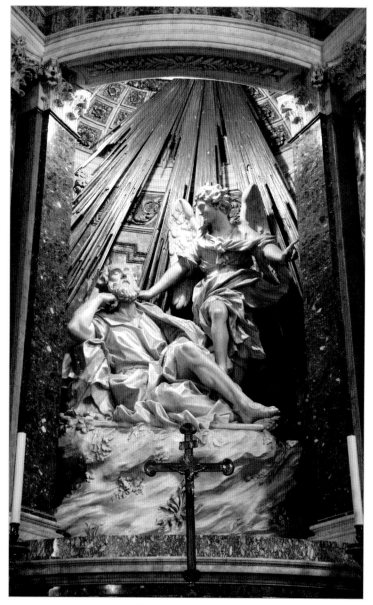

Dream of Joseph by Domenico Guidi

proposing that Joseph "experienced both love of the truth—that pure contemplative love of the divine Truth which radiated from the humanity of Christ—and the demands of love—that equally pure and selfless love required for his vocation to safeguard and develop the humanity of Jesus, which was inseparably linked to his divinity."[31]

This image of Joseph would enjoy a revival in the sixteenth century thanks to contemplative Discalced Carmelites, whose art patronage would often focus on Joseph and his dreams. In the Carmelite Church of Santa Maria della Vittoria in Rome, built in 1620, Sleeping Joseph finally became the subject of an elaborately carved altarpiece, occupying the prestigious transept chapel across from Gian Lorenzo Bernini's *St. Teresa in Ecstasy*. Bernini's artistic competitor, Domenico Guidi (1625–1701), sculpted the work, which sadly, and not for lack of ambition, often goes overlooked in comparison with its more exuberant neighbor. Guidi attempted to convey the same sense of mystical weightlessness that Bernini had so perfectly executed in St. Teresa, shaping the marble foundation into a softly swelling mass, reminiscent of a pillow. But whereas Bernini's Teresa is self-contained, her ecstatic moment enclosed in a defined architectural space, in Guidi's work, the angel tugs and points, urging Joseph to wake and act. If the vision of St. Teresa signifies the preview of the sleep of death and the promise of Heaven, Joseph's dream foretells the awakening to his mission.

In the immediately succeeding centuries, however, Joseph would find himself increasingly called away from his meditations to take a greater role in caring for the human needs of Christ.

[31] Pope St. John Paul II, apostolic exhortation *Redemptoris Custos* (August 15, 1989), no. 27.

JOSEPH AND THE MENDICANTS

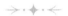

The advent of the Franciscan and Dominican Orders heralded a revolution in the history of preaching, spirituality, and art. If Western Christendom, under the sway of Constantinople, tended toward art emphasizing the divinity of Christ, the influence of St. Francis and St. Dominic shifted devotional focus toward His humanity. From the moments of their respective foundations, both of which occurred in the first decades of the thirteenth century, the mendicant orders shook Europe with their countercultural vision. Whereas renewed commercial activity brought luxury, the mendicants espoused poverty; whereas recently opened universities prized erudition, the mendicants preached in accessible language; and whereas conquest and expansion fostered hubris, the mendicants became models of humility. Their personal witness, like living, breathing works of art, launched their unique charisms throughout Europe at lightning speed. These friars, along with their championship of special devotions to the Blessed Virgin and their emphasis on Christ's human experience from crèche to Cross, inspired artists with new and surprising images of St. Joseph.

St. Francis of Assisi brought to the forefront of the medieval mind the human experience of Christ. Born in penury, raised in

obscurity, Jesus was ridiculed and rejected by the scribes, then subjected to the humiliation of the Cross. Francis's very public devotion to both Jesus' Nativity and His Crucifixion resulted in two miraculous events that were quickly known throughout Europe, despite the lack of telecommunication: the apparition at Greccio, where his preaching during a Christmas Mass culminated in a collective vision of the Christ Child, and Francis's reception of the stigmata, the wounds of Christ, on the mountain of La Verna. One of the results of the Christmas wonder attributed to St. Francis was an impetus to create the charming Nativity scenes that are the ancestors of the crèches that have become so popular in Christian households and churches. Another result was the stimulus for artists to explore new ways of portraying St. Joseph.

Both the Dominicans and the Franciscans were art patrons extraordinaire, sponsoring altarpieces, frescoes, chapels, reliefs, manuscripts, and more, each with elements intended to highlight their respective spiritualities. Since the Nativity was central to the Franciscan charism, the transformation of Joseph was more evident in scenes of Christ's birth, although Joseph was still frequently seen in the numerous images of the Adoration of the Magi, the Flight to Egypt, and the Presentation at the Temple commissioned by the orders. The first changes were gradual, only hinting at the dramatic metamorphoses that Josephine imagery was about to undergo.

In 1257, the prosperous port city of Pisa was exonerated from a papal interdict incurred sixteen years earlier when the Pisans had abetted the anti-papal forces of Holy Roman Emperor Frederick II. The arbiter of their return to grace was the new archbishop of the city, Federigo Visconti, whose close connections with the Franciscans went from having seen the saint in person—of which

he said "truly blessed are those who saw Saint Francis himself, as we ourselves, by the grace of God, did; and we touched him with our hand"—to a personal friendship with Pope Alexander IV, former protector of the Franciscan Order and the authority who affirmed the veracity of St. Francis's stigmata.[32] As Archbishop, Visconti strenuously supported the mendicant orders, urging the Pisans to help them in "all necessities."[33]

The archbishop launched an ambitious building program, focusing on Pisa's baptistery, the civic and ecclesiastical crossroads in Italian city-states, where infants received their identities as citizens as well as Christians. Visconti, influenced by the mendicant orders' insistence on the importance of preaching the Gospel, was himself an indefatigable preacher, whose numerous sermons were recorded in volumes still available today.[34] The archbishop was also a formidable art patron, befriending painter Giunta Pisano, a favorite of both Franciscans and Dominicans. For the construction of his baptistery pulpit, Visconti selected Nicola Pisano, the most influential sculptor of the age. A pulpit in a baptistery was something of a novelty, suggesting that the archbishop hoped to tame the unruly Pisan flock through evangelizing rhetoric during the joyful event of welcoming newborns into the Faith.[35] This emphasis on the power of preaching was made even more evident by the imposing size of the pulpit and the five marble reliefs carved by Nicola, illustrating scenes from the

[32] Eloise M. Angiola, "Nicola Pisano, Federigo Visconti, and the Classical Style in Pisa," *Art Bulletin* 59, no. 1 (March 1977): 1.

[33] Giuseppe Dell'Amico, *Federico Visconti Di Ricoveranza, Arcivescovo Di Pisa* (doctoral thesis, University of Pisa, 2011), 223, https://core.ac.uk/download/pdf/14701665.pdf.

[34] Dell'Amico, *Federico Visconti Di Ricoveranza*, 223.

[35] Dell'Amico, *Federico Visconti Di Ricoveranza*, 225.

life of Christ: three from His infancy, followed by the Crucifixion and the Last Judgment. Nicola's style has some resemblance to the bustling jumble of figures seen on Gothic cathedrals, but the distinctive character of his carvings reflects his study of narrative reliefs on the ancient Roman sarcophagi that decorated the exterior of the Pisa cathedral at the time.

Joseph appears in the Nativity scene, jammed into a cramped composition also showing the Annunciation and the angels appearing to the shepherds. Pisano's *horror vacui*, or aversion to empty space, derives from the influence of ancient art, which filled every crevice of reliefs with activity. Mary is clearly the dominant figure in the panel. In the Annunciation scene, she draws away, startled by the angel, but then reappears immediately below, reclining on one arm in the dignified pose of a Roman matron. Behind her left shoulder, the Child Jesus is wrapped tightly in swaddling clothes

Baptistery pulpit by Nicola Pisano

in a cradle decorated with the wavy lines of an ancient strigil sarcophagus, another artifact commonly seen in Pisa. The space of the baptistery lent itself well to this allusion to Christ's death at the moment of His birth: the tomb-manger conflation would become a common motif in many future depictions of the Nativity. As Mary appears twice in the work, so does Jesus, carved in the lower section, where He is bathed by midwives. Pisano placed in this group Joseph, not turned away, as in earlier depictions, but facing the activity, directing the viewer's attention toward the infant Jesus, to gaze upon the "Word became flesh" who "dwelt among us" (John 1:14). The nude Christ Child (sadly now acephalus) stands inside a chalice-shaped basin amid a wealth of naturalistic details, including the badly damaged pail of water, the flock of sheep—one goat scratching its ear—and the decoration of the midwife's sleeve. The viewer looked upon Jesus placed inside a Eucharistic chalice, one day to be poured out in remission of sin. The human flesh in the bare body of Christ underscores the historical, physical event of His birth and His death on the Cross. Nicola chose St. Joseph to preside over this part of the panel, although his eyes turn upward toward Mary and the swaddled Jesus, this time awake and awed by the event of God-made-man.

Nicola Pisano anticipated the exhortations of fifteenth-century preacher Bernardino da Feltre, who would lament, "Oh painter, do not depict him … sleeping. Do you believe that, in this moment when the whole world was rejoicing, Angels singing 'Gloria,' he would be sleeping? Show him as good-looking and agreeable."[36] St. Francis brought the love of the natural world into art, celebrating

[36] Bernardino da Feltre "De Sancto Joseph," in *Sermoni del Beato Bernardino Tomitano da Feltre* Renon Editore Milan: Renon Editore, 1964), 398.

all of creation in his "Canticle of the Creatures," finding wonder in the sun, the moon, animals, and people. It was composed in the vernacular, the language of the people, to help them joyfully express their awe of the Creator, who, having taken on human form, elevated the dignity of all of humanity.[37] Joseph, an everyday man with a profession and plans, was called to bear witness to the Incarnation, and, through him, a more vernacular form of praise and worship, perhaps less exalted, but no less sincere, became possible.

This Josephine motif was so successful that Nicola would repeat it in the pulpit for Santa Maria Assunta in Siena, and later his son Giovanni would continue it in both the cathedrals of Pisa and Pistoia, while their collaborator Lorenzo Maitani would reproduce it in the facade of the Cathedral of Orvieto in 1310.

St. Bonaventure (1221–1274), the seventh minister-general of the Order of Friars Minor, turned St. Joseph into a household word—preaching, writing, and promoting the saint's role in salvation history as second only to Mary. Bonaventure praised Joseph's evangelical humility, holding him up as an example for manual laborers, those who, while not particularly instructed, could "see with the eyes of faith."[38] Even as the erudite were exalted in the universities, St. Joseph was poised to lead the flock of those unable to enjoy the luxury of education, and his appeal would grow to an ever-greater audience.

Between 1310 and 1320, Giotto (1267–1337), Franciscan painter par excellence, translated the Pisano's motif of the dual

[37] Henry Thode, *Francesco d'Assisi e le origini dell'arte del Rinascimento in Italia* (Rome: Donzelli Editore, 2003), 59.

[38] St. Bonaventure, Sermo III, Vig. Epiph. Dmni, quoted in Noel Muscat, O.F.M., "Saint Joseph in Franciscan Theology," Franciscan Studies, October 3, 2018, https://franciscanstudies.files. wordpress.com/2018/10/ns31-st-joseph-fran-theology.pdf.

Jesus into fresco in his Nativity mural for the lower Basilica of St. Francis of Assisi. Giotto's career had been launched three decades earlier in that same city, where, following his master, Cimabue, he had worked on the groundbreaking cycle of frescoes in the Upper Basilica. Giotto was not only one of the first artists to use optical perspective to make scenes appear three-dimensional, but he also employed everyday observations—such as reactions of surprise or shame—and still-life details from nature, all with an eye to rendering the sacred histories in a more familiar context for the medieval European viewer.

This impetus toward more-accessible visual exegesis was another Franciscan feat. The medieval philosopher and Franciscan friar Roger Bacon, working in Oxford in 1260, wrote the *Opus Majus*, in which he discussed the four methods of scriptural exegesis—literal, allegorical, moral, and mystical—lamenting that preachers, while "quite skillful concerning the last three levels of interpretation … had not been quite as convincing … in getting the literal message across."[39] To remedy this, he hoped to find artists who would be able to illustrate biblical histories, claiming that "we can understand nothing fully unless its form is presented before our eyes."[40] Giotto is also credited with inventing the figure turned away from the viewer, pointing the beholder toward the scene, making him or her an eyewitness to the story of salvation, even though chronologically distant from the events.

Giotto was a superstar in the Franciscan artistic firmament when he executed his inventive Nativity above the tomb of St. Francis, in a much darker and more contemplative part of the

[39] Samuel Y. Edgerton Jr., *The Renaissance Rediscovery of Linear Perspective* (New York: Basic Books, 1975), 17.
[40] Edgerton, *Renaissance Rediscovery*, 18.

complex than the Upper Basilica. Giotto harnessed the mesmerizing power of lapis lazuli to recreate the night sky, contrasting it with pale, luminous colors. As an added flourish, gilt halos fashioned from modeled stucco glitter against the dark background, evoking the impression of a mystical vision.

Giotto divided the scene into two parts. The upper level shows a stable or cave (invented by him as a solution to rendering the story in a setting familiar to a Western audience) where Mary holds her newborn Son. Unlike Nicola Pisano's crowded space, Giotto placed the Madonna and Child against a simple expanse of taupe stone. Angels swoop in from all sides, forming a heavenly choir around the mother and Child, semi-embodied with faces and hands clasped in prayer, but robes that curve with a swish of color, resembling musical notes.[41] More celestial beings converge on the star of Bethlehem as golden rays descend upon the Christ Child. Even the animals appear awed by the arrival of the Creator in the world.

The divine jubilation is balanced by the representation of practical human activity. Mary gazes at Jesus with an expression recognizable as that of every mother being handed her baby for the first time. This poignant moment leads the eye into the lower part of the painting, guided by an angel on the right who breaks rank with the others to convey the glad tidings to the shepherds. The jewel-like colors attenuate upon entering the natural realm. Joseph, once again in the lower left corner, provides the key for entry into this part of the scene. The elderly figure contemplates, an

[41] Elizabeth Lev, "In Giotto's 'Nativity,' a Novel Pope Has Chosen a Novel Image," Aleteia, December 18, 2016, https://aleteia.org/2016/12/18/in-giottos-nativity-a-novel-pope-has-chosen-a-novel-image/.

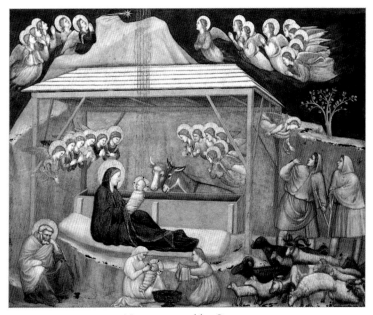

Nativity mural by Giotto

example of what St. Bonaventure would describe as "divine piety" or reverence.[42] Joseph serves not only as the protective sentinel to the sacred event but also as a witness to the earthly part of the story. Joseph supervises the feeding and the clothing of the Child, just as it will fall to him to provide for the infant Savior and protect him from the perils of this world. Giotto, after years of association with the spirituality of St. Francis, masterfully emphasized the dual nature of Christ, painting Mary absorbed by His glorious divinity and Joseph as testifying to His vulnerable humanity.

Joseph's popularity among the Franciscans was not limited to the men of the order. St. Margaret of Cortona (1247–1297),

[42] St. Bonaventure Sermo III, quoted in Muscat, *Saint Joseph in Franciscan Theology.*

whose raucous life resulted in her becoming an abandoned unwed mother, nurtured a special devotion to Joseph, declaring that Christ had told her to do so. The prayers of the Friars Minor to Joseph soon led to miracles demonstrating his celestial authority. One story tells of two Franciscans shipwrecked off the coast of Flanders. Cast overboard and clinging to a board from their ruined boat, they begged for assistance from St. Joseph. He appeared to them, "handsome and noble," and brought them safely to dry land.[43]

The zealous efforts of the Franciscans eventually led to the order's adoption of March 19 as a feast day in his honor in 1399, a decision that would be confirmed and added to the Roman breviary by a Franciscan pope, Sixtus IV (born Francesco della Rovere) in 1479.[44]

The Dominicans adopted the Josephine holiday shortly after the Franciscans. Dominican Jacopo da Varagine (1230–1298), archbishop of Genova, penned the most popular book of the Middle Ages, *The Golden Legend*, a hagiography following the liturgical calendar and filled with colorful anecdotes that provided a source of artistic inspiration for centuries. Even though St. Joseph did not have a feast day at the time of its publishing, Varagine, using both scriptural and apocryphal material, kept Joseph present in the minds of readers throughout the year. St. Albert the Great proposed a vow of virginity on the part of St. Joseph to complement that of Mary, which would have important repercussions on later representations of the saint, while St. Thomas Aquinas

[43] *Annals of St. Joseph*, vol. 10, no. 1 (De Père, WI: Archconfraternity of St. Joseph, 1898), 15.

[44] Meyer Schapiro, "Muscipula Diaboli, The Symbolism of the Mérode Altarpiece," *Art Bulletin* 27, no. 3 (September 1945): 182–187.

affirmed the validity of their marriage, which would also have a significant effect on the history of art.[45] A wonderful quotation is attributed to Thomas Aquinas regarding Joseph: "Some saints are privileged to extend to us their patronage with particular efficacy in certain needs, but not in others; but our holy patron St. Joseph has the power to assist us in all cases, in every necessity, in every undertaking," a perfect articulation of what Joseph would become for countless Christians and the Church.[46]

The Order of Preachers vied with the Franciscans for the title of most dynamic art patrons of the age, sharing an interest with their mendicant brothers in new types of iconographies. Fra Giovanni of Fiesole, later known as Beato Angelico, made a personal contribution to the work of artistic evangelization through his extraordinary paintings, produced in the first half of the fifteenth century. He produced several smaller Nativity scenes meant for private devotion, either as a portable diptych (two-sided panel) or as frescoes to accompany prayer in the convent of San Marco. These works are austere yet serene, with a minimal number of figures, depicted as lost in prayerful contemplation.

[45] Albert the Great's proposal of Joseph's and Mary's vow of virginity can be found in St. Thomas Aquinas, *Summa Theologica*, III, q. 28, art. 4: "Mater Dei non creditor, antequam desponsaretur Joseph, absolute virginitatem vovisse.... Postmodum vero, accepto sponso secundum quod mores illius temporis exigebant, simul cum eo votum virginitatis emisit."

[46] The Aquinas quotation, while ubiquitous, seems to have no source. After consulting with several Aquinas scholars, the consensus, expressed by Rev. Dominic Legge, O.P., is that although there is a citation using the "Gilby Summa" as the source, a search of the Latin database of the Opera Omnia yields no result, and it does not resemble the other writings of the saint; thus, the quote is probably, and unfortunately, spurious.

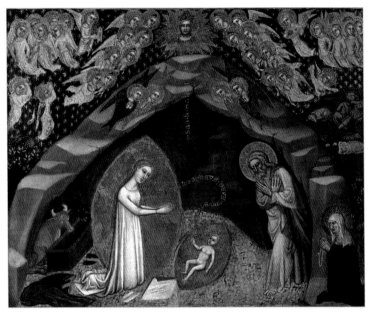

St. Bridget and the Vision of the Nativity by Niccolò di Tommaso

Without midwives, shepherds, or Magi, the images forge a greater sense of intimacy between the viewer and the scene.

The composition follows the description of an ecstatic vision experienced by St. Bridget of Sweden while visiting the cave of the Nativity in Bethlehem in 1372. Bridget saw the Virgin Mary, whom she described as a "golden-haired" woman, and an aged Joseph in a cave. As she watched, Joseph left, Mary knelt in prayer, and "the glorious infant was lying on the earth," amid "indescribable light and splendor that went out from him."[47] Bridget's influential writings brought about the popular image of

[47] St. Bridget of Sweden, *The Revelations of St. Brigitta of Sweden*, vol. 3, trans. Denis Searby (Oxford: Oxford University Press, 2006–2015), 250–251.

the baby Jesus on the ground, resting on rays of light, with Mary kneeling in adoration before her Son.

Fifteenth-century art embraced this image of the Nativity but added Joseph to the scene as a complement to the Virgin. Fra Angelico's variations on this theme placed Joseph so as to balance the figure of Mary, equidistant from the child. In a lovely panel from 1428, now in the Pinacoteca Civica of Forli, Joseph dominates the image as never before, his voluminous form swathed in red (in this case an allusion to mortality) with little swatches of cerulean blue inside his sleeve and collar, hinting at his hidden grace. He makes an elegant visual contrast with Mary, who is generally shown wearing a red or white dress covered with a blue cloak. Joseph kneels while tilting slightly forward, bent over the tiny radiant Infant with his hands crossed over his chest. Fra Angelico used this gesture frequently in pictures

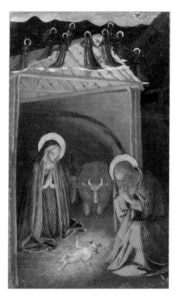

Nativity diptych by Fra Angelico

of the Annunciation to indicate Mary's fiat: "I am the handmaid of the Lord" (Luke 1:38).

Even more striking, the opposite wing of the diptych shows the apostles sleeping during the Agony in the Garden. Whereas Jesus' friends are unable to keep watch with Him, Joseph remains vigilant. It was a daring choice to extend the same positioning to Joseph, and perhaps it served to divide up the tasks of the two new parents. As Mary contemplates in quiet adoration and Joseph stands ready to serve the divine will, the two become the picture of the active and the contemplative life, the vocational equilibrium that the mendicants sought to achieve. The Forli panel, intended for private prayer, probably belonged to a man, since St. Joseph's position closest to the viewer and his more dynamic physical language suggest the saint as a model of male vigilance and devotion.

Joseph's adoption by the new religious orders during the Middle Ages resulted in an interesting iconographic anomaly. In 1493, Anton Koberger published the *Nuremberg Chronicle*, an extraordinarily ambitious encyclopedic effort to recount the history of the world through biblical ages, incorporating geography, zoology, and countless forms of human learning. In the section dedicated to the "Life of the Virgin," Michael Wohlgemut, printmaker and principal illustrator of the chronicle (as well as the teacher of Albrecht Dürer), designed a Nativity with a partisan twist.

Wohlgemut, who collaborated closely with Franciscan preacher Stephan Fridolin, employed the Bridgetine iconographic scheme, with the kneeling Virgin and the Christ child on the ground, and included Fra Angelico's addition of St. Joseph bent on one knee. In this case, however, Joseph appears animated, as if speaking, the long fingers of his right hand pointed toward his left hand, to highlight the gesture of the raised thumb and index finger while folding the other three under.

Nativity by Michael Wohlgemut

This gesture, recognizable from the era of the catacombs, was a symbolic assertion of Christian tenets. The raised digits signify the two natures of Christ and the other three symbolize the triune God. In Wohlgemut's woodcut, the long-silent Joseph appears to

be evangelizing, preaching even, an impression underscored by his costume, which bears more than a passing resemblance to a religious habit. Joseph as witness to the Word-made-flesh found new champions as he was coopted into the new mendicant orders. But like the Franciscans and the Dominicans, Joseph would have to contend with those for whom simplicity bred contempt.

FOOL FOR CHRIST

Thanks to the mendicant orders, Josephine imagery spread throughout Europe, finding surprisingly fertile ground even in less rarefied circles than colleges and convents. An accelerant to this growing devotion came in the form of a newly discovered relic, Joseph's *hosen*, or "pants," which appeared in the Aachen Cathedral in 1238. A tradition held that when Jesus was born, the poverty of the Holy Family was such that Joseph donated his own tattered clothes to swaddle the Newborn. As the capital of Charlemagne's empire, Aachen boasted a constant stream of pilgrims who came to pay their respects at the *Marienschrein*, a golden reliquary containing Mary's dress, the cloth that held the head of John the Baptist, Jesus' loincloth, and Joseph's trousers turned swaddling clothes. The sight of the first physical relic connected to Joseph fired the imaginations of the faithful and brought about a new and unexpected turn in the imagery of Joseph.

The discovery of the *hosen* coincided with a revival of the apocryphal infancy narratives of Pseudo-Matthew and Thomas, which were fused into a popular work titled the *Liber de Infantia Salvatoris*. In Northern countries, however, the renewed interest

Hosen relic, Shrine of Mary, reliquary chest, unknown artist

in Christ's childhood resulted in a trend to depict Joseph as a kind of scriptural comic relief.[48] One historian goes so far to describe him as a "clown in rags." Impresarios who saw the potential of a sacred sidekick to lighten the mood and appeal to wider audiences began composing musical ballads and theatrical pieces featuring what often appeared to be a "clueless" Joseph. An artistic current also followed this trend, but as shall be seen, these surprising works were less a denigration of the saint, as often supposed, and more of a democratization of the sacred.

A charming Netherlandish Nativity painted during the four-teenth century for Philip the Bold shows Jesus being cared for by His nursemaid while Mary rests. But the dignified domesticity is interrupted by an aged, barelegged Joseph awkwardly seated in the lower left corner, rending his leggings to make a covering for the naked Infant. While the scene brings a smile, with Joseph

[48] Johan Huizinga, *The Waning of the Middle Ages* (Harmondsworth: Peregrine, 1919), 164.

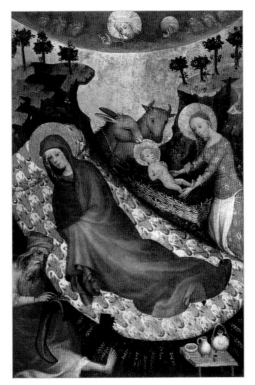

Nativity, unknown artist

as an ersatz tailor intent on his task, his extended discalced foot would have called to mind the penitential pilgrims who traveled humbly barefoot to holy sites such as Aachen.

Nativity plays, performed during Advent in anticipation of the birth of Christ, also influenced Joseph's new look. Particularly popular in Germany and England, these performances often engaged audiences through humor. England's *Second Shepherds' Play* revolved around a slapstick tale of sheep thieves hiding a lamb in Christ's manger, and the *Hessian Christmas Game* in Friedberg paraded a trouserless Joseph scouring the streets for a

midwife.[49] This comical spirit was reflected in art, with depictions of Joseph that treated the saint as a figure of fun: stumbling about in old clothes, aimlessly stoking a fire, fruitlessly seeking assistance, drying diapers, or fussing over the Christ Child's food, bedding, or bath.

Conrad von Soest's *Nativity* panel, produced in 1403, startlingly places St. Joseph on all fours, blowing on a fire as he cooks a simple repast. His prostrate position recalls the tiny figures of bowing donors kissing the feet of Christ in devotional panels (e.g., Pope Honorius III in the apse mosaic of St. Paul Outside the Walls from 1220), yet Joseph crouched before a pot of porridge makes for a comically banal contrast. Despite Joseph's undignified pose, Soest employs the same lapis blue for his hood and hose as he does for Mary's dress and decorates his belt with precious gilding.

More than derision, the painting evokes tenderness through its gentle humor. Mary and the little nude Jesus cuddle while Joseph, descendant of kings, busies himself with menial tasks, all while the ox and the ass exchange glances as if pondering the strangeness of the scene. The panel displays an early form of still-life art, with the wooden bowl, spoon, and stool prominently arrayed along the lower part of the work, all components of a typical peasant kitchen. The proximity of Joseph and these objects of daily life create for the viewer a sense of relatability to the sacred mystery.

[49] John Jeep, *Routledge Revivals: Medieval Germany* (New York: Garland Publishing, 2001), 175; Anne L. Williams, "Satirizing the Sacred: Humor in Saint Joseph's Veneration and Early Modern Art," *Journal of Historians of Netherlandish Art* 10, no. 1 (Winter 2018), https://jhna.org/articles/satirizing-sacred-humor-saint -josephs-veneration-early-modern-art/.

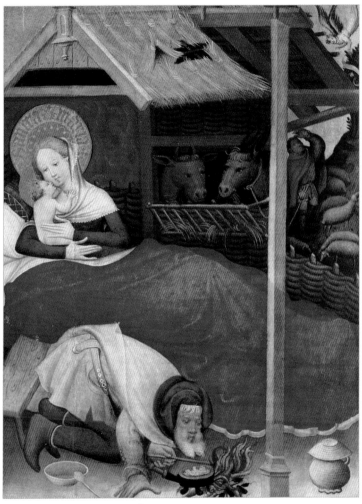

Nativity by Conrad von Soest

A fourteenth-century altarpiece in Prague also shows Joseph caught up in what would appear to be demeaning domestic occupations. Mary nestles with her Son on a rose-covered dais, cheek to cheek with their hands clasped, a paragon of postnatal bonding.

Below, Joseph attempts to assist the midwives who are preparing water for Jesus' bath; yet, instead of testing the water, the midwife seems to rebuke Joseph's contribution. Huddled around the wooden trough, the foster father of Christ could easily be mistaken for a servant, but the artist took steps to avoid this error by matching Joseph's mantle to Mary's clothes and adding a few flashes of royal blue to tie him visually to the painting's donor, who is kneeling on the right, offering a model of the chapel. Both Joseph and the patron are on their knees, and both are making an offering: the

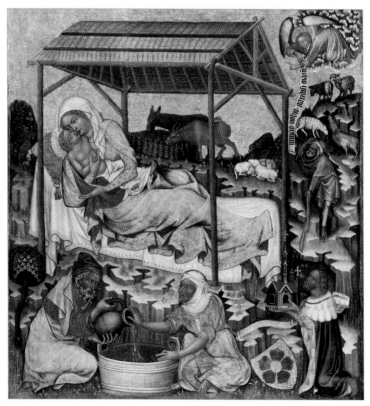

Prague altarpiece

donor, a splendid work of art, and Joseph, a pitcher of water. Joseph, despite this apparent demotion, is placed on a straight vertical axis with the Virgin and Child. He serves as the ballast for the group, indicating that, though he cannot offer exalted gifts, his humble service is the foundation of the Holy Family. This image provided a boost to all those men who were not part of the ancient nobility or the emerging class of wealthy merchants, celebrating the virtue of a constant, if at times bumbling, paternal presence.

Hieronymus Bosch (1450–1516), with his unparalleled eye for the absurd, produced perhaps the oddest St. Joseph of all. In his elaborate, symbol-laden 1485 *Adoration of the Magi*, painted for Peeter Scheyfve, a prosperous merchant in Antwerp, Joseph is completely absent from the main panel. Shepherds crawl on the roof, kings display their ornate garments and gifts decorated with scriptural references, and even the antichrist and his followers are given space, watching the scene aghast from a dilapidated doorway, but Joseph is nowhere to be found. A diligent search will reveal him in the adjacent wing to the left of the panel, behind the donor and St. Peter, crouching in a corner as if in punishment. Joseph's participation in the spectacular advent of the Magi is … drying diapers. His undignified position, his degrading task, and his contortion of the neck to try to see the events taking place in the larger panel would seem to solidify Joseph's status as comic relief for portentous Gospel events.

Theatrical productions and popular ballads seized upon the potential of Josephine humor. Some works went so far as to present Joseph as "God's cuckold," where Joseph would be tinkering with his tools next to a panel of the Annunciation.[50]

[50] Francesca Alberti, "'Divine Cuckolds': Joseph and Vulcan in Renaissance Art and Literature," in *Cuckoldry, Impotence and*

Adoration of the Magi by Hieronymus Bosch

Images of barelegged Joseph, puttering at tasks usually reserved for women, poked fun at gender roles by suggesting that Joseph didn't "wear the pants" in the family.[51] In an age of social upheavals, from plagues (1348) to heresies (Albigensian Cathars) to violence (the Hundred Years' War, 1337–1453), not to mention the scandalous exodus of the Pope from Rome to Avignon (1308–1378), most people felt swept up by turbulent external forces over which they had no control. Joseph's situation could be understood by the populations of Europe in the fourteenth and fifteenth centuries, caught up in dramatic historical currents. For many, satire can be a useful outlet for existential helplessness, and St. Joseph generously lent himself to the humor of the age, the willing butt of medieval jokes. In one charming altarpiece from the Pfarrkirche in Austria, the unknown fifteenth-century painter placed Joseph peeking out from inside the sturdy house apparently frightened by the exotic pageant of Magi that has arrived at his door. His consternation is mirrored by a man in contemporary dress, looking up in perplexity at an Ottoman flag. Behind him, a medieval knight stands behind a turbaned figure: warriors, wise men, Muslims and kings—no wonder Joseph feels overwhelmed!

Although preacher St. Bernardino of Siena (1380–1444) and French theologian Jean Gerson (1363–1429) would protest what they felt were disrespectful depictions, art historian Anne Williams has suggested that this laughter was a form of veneration.[52] Joseph was an "average Joe," a poor man in the presence of kings,

Adultery in Europe, ed. Sara F. Matthews-Grieco (Farnham: Ashgate, 2014), 154.

[51] Williams, "Satirizing the Sacred."

[52] Williams, "Satirizing the Sacred."

an uneducated foil to seers, a court jester amid the adoration of angels. People could see themselves in him and thus not only relate more closely to sacred mysteries but also find their place in the tremendous events of the age.

Furthermore, unlike their Italian contemporaries, these Northern artists tended to depict Joseph without a halo in their panels, distinguishing him from the Madonna and Child. The aureole served to separate the "sacred," a word derived from the Latin *sacrare*, meaning "to set apart." The singularity of God-made-man and the Virgin Mother of God set them apart from others, but Joseph remained one of the masses, a regular guy in extraordinary company.

Joseph, in this current of art, became a kind of vernacular devotion. In the fourteenth century, Dante composed *The Divine Comedy* in Italian, a language of the people, instead of the Latin of the erudite. Joseph, for his part, related the sacred histories through reactions and activities that would mirror those of the viewers.

This representation of Joseph had its roots in the revolutionary Franciscan spirituality, albeit translated into a rougher Germanic "dialect," as it were, instead of the more melodious and dignified Italian. St. Francis of Assisi, despite the advantages of wealth and status, not only had no fear of ridicule, but he embraced any opportunity to share in the humiliation that Christ experienced, abandoned by His friends, judged by the timid and the corrupt, stripped and shamed upon the pillory and the Cross.

St. Francis was also the composer of the first poem written in the vernacular Italian, "The Canticle of the Creatures," yet he eschewed the proud title of troubadour given to the courtly poets, preferring to be known as the "Jongleur de Dieu."[53] Jongleurs

[53] See chapter 5 in G. K. Chesterton, *St. Francis of Assisi* (London: Hoder and Staughton, 1923).

were also entertainers, but besides singing, they amused crowds with their slapstick tumbling and leaping.

As a love poet, St. Francis would always have a place among the troubadours for his profound and passionate love of Christ. At the same time, the Poor Man of Assisi invited the world to see his intimate vulnerability through his antics, whether removing his clothes in a public square to show his rejection of worldly goods or rolling naked in the rosebush at Porziuncola to quell bodily desire.

G. K. Chesterton wrote that Francis "found the secret of life in being the servant and the secondary figure," and the image of Joseph, too, appears to reflect the same revelation as the ever-present yet unremarked figure in Scripture tending the daily needs of his exalted family.[54] The Northern countries delighted in off-color humor, whether in farcical stories, ironic images, or bawdy songs, and they translated this saintly humility into visual cues that provoked both thought and laughter.

Hieronymus Bosch painted numerous altarpieces of the Magi during his long career spanning from 1470 to 1516, on several occasions placing St. Joseph in the left wing of the panel, scooping water from a stream. In these cases, the color of his tunic and his position match that of the elegant elder Magus offering his gifts. In the Antwerp version mentioned above, Joseph is placed behind the donor, drying a diaper, seen as a white cloth, by the fire (interestingly, the donor was in the textile business). The medieval viewer would have associated cloth with the *hosen* donated by Joseph for Jesus' swaddling, the first gift to be given to Christ. Joseph, who gave his clothes off his own body, is the charter donor, and though his gift may have been humble, it was

[54] Chesterton, *St. Francis of Assisi*, 78.

more essential than any gold, frankincense, and myrrh, or even a fancy painted panel.

Enormous wealth was accumulated in the late medieval and Renaissance eras through business and speculation, and successful merchants often wrestled with the concern of what would become of their souls. The Bible shows disdain for money on most occasions, with one remarkable exception being the Magi. These men, privileged both materially and intellectually, used their talents and riches to pay homage to Christ and, in doing so, found salvation. For that reason, this image became a preferred subject of altarpiece commissions among the commercial elite in Italy, Germany, and the Low Countries.

In these altarpieces, the pose of St. Joseph often mimics that of the donor: pouring water at the Nativity in the Prague altarpiece, he kneels directly across from the noble patron. In Jan van Dornicke's (ca. 1470–1527) numerous depictions of the *Adoration of the Magi*, Joseph lifts his hat in salutation, side by side with the royal visitor. In some Magi scenes, Joseph turns away from the exchange of gifts to attend to a rough wooden chest, an

Adoration of the Magi by Jan van Dornicke

example of carpentry, contrasting the fruit of his humble labor with the glamor and glitz of the regal coterie. Joseph gives his toil, his fidelity, and his flawed humanity to his family, a model for domestic providers then and now.

Joseph's presence by the fire, as in both Bosch's and Conrad von Soest's images, accentuates the visual association of Joseph with natural light that had started with St. Bridget's vision in the fourteenth century. It was not uncommon to see Joseph holding a candle by the crèche in early Renaissance art, contrasting the weak natural light with the supernatural radiance of the newborn Christ.

In these Northern paintings in which Joseph works by the fire, the flickering flames dimmed by the Christ Child's luminescence, the saint becomes an active participant, albeit less forcefully, in the advent of the Light of the World (see John 8:12). Joseph's presence, even when smiled upon, encouraged viewers to persevere in faith. Human efforts to holiness may seem fruitless at times, as if one "couldn't hold a candle" to the Savior and His saints, but Joseph proves otherwise. These entertaining images of Joseph were intended to celebrate humanity, as St. Francis had done, so that the almost comical efforts that people make to serve God could be seen as valuable, worthy, and appreciated.

Half a millennium later, St. Paul VI wrote, "St. Joseph is the model of those humble ones that Christianity raises up to great destinies; . . . he is the proof that in order to be a good and genuine follower of Christ, there is no need of great things — it is enough to have the common, simple and human virtues, but they need to be true and authentic."[55]

[55] Pope St. Paul VI, homily for the Feast of St. Joseph (March 19, 1969).

A delightful byproduct of Josephine humor was a series of affectionate hymns, capitalizing on Joseph's willingness to share in duties usually relegated to women. "Joseph dearest, Joseph mine, help me rock the Child divine," composed by the Monk of Salzburg in the fourteenth century, evokes tenderness toward the man who was unafraid to be a fool for love.[56]

[56] *The Canterbury Dictionary of Hymnology*, s.v. "Joseph Dearest, Joseph Mine" (Norwich: Canterbury Press, 2013), http://www. hymnology.co.uk/j/joseph-dearest,-joseph-mine.

THE PAPAL ALTER EGO

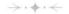

It is not a coincidence that St. Joseph's artistic rebirth coincided with the Renaissance. Artists, encouraged by exponentially increasing patronage, were eager to experiment with new techniques and visual interpretations to distinguish themselves in a congested art market. At the same time, the contemporary challenges faced by the Church required innovative solutions both in theology and iconography. It was a perfect artistic storm.

In 1419, the rediscovery of one-point linear perspective was a watershed moment for Renaissance art. At the same time, the Church was regaining her footing after a century of upheavals. The perennial tug-of-war between the papacy and temporal powers had culminated in the papal exodus to Avignon, scandalizing many of the faithful. The pope's authority, derived from his successorship of St. Peter, centered in Rome, where the apostle was both martyred and buried. Christ's words, recorded in Matthew 16:18, "You are Peter, and on this rock I will build my church" were taken literally in Rome, where Constantine had built one of the first Christian churches to correspond with Peter's grave on the Vatican hill.

For seventy years, almost three generations, the papacy remained camped on the other side of the Alps, provoking outcry

from everyone from humanists (Petrarch) to religious (St. Catherine of Siena). The long-awaited return of the popes to Rome in 1377 was immediately undermined by the death of Gregory XI the following year and the subsequent election of two successors. First, Urban VI was elected in Rome on April 8; then, on September 20, several of the same cardinals met eighty miles south of Rome, in Fondi, and elected Robert of Geneva as Pope Clement VII. The shocking reversal of the conclave by the cardinals caused chaos. Even more grave than the ineptitude or malfeasance of the clerical hierarchy, this ambiguity left the papacy vulnerable to interference by outside powers and bewildered the faithful with often contradictory messages from opposing popes.

Whatever shreds of justification the College of Cardinals might have had (some of the cardinals claimed that they had been forced to elect Urban VII under duress, while others said that Urban's ceaseless complaints about the Curia were intolerable) disappeared when the Council of Pisa was called to settle the question and concluded by adding a third pope, Antipope John XXIII in 1410.

Besides the farcical aspect of a trinity of sparring Petrine pretenders, rampant confusion among Christian believers was causing division and a rapidly waning belief in the authority invested in the successors of Peter. To guide the errant shepherds back to the fold, several theologians began to invoke a new model for the papacy: St. Joseph. This new ecclesiastical current would lead to a new role for Joseph as well as a deeper understanding of St. Peter.

Since apostolic times, the popes were considered the successors of St. Peter, the first bishop of Rome. Then, in the fifth century, Pope St. Gelasius I assumed the additional title of "Vicar of Christ." The latter term intensified the relationship between

the pontiff and the Church, increasing its similarity to marriage. As Christ was wedded to His Church, so the popes were expected to be good and faithful consorts to their spouse, the *Ecclesia.*

Once again, this new facet of Josephine devotion owed its origins to the Franciscan order. Peter John Olivi, a thirteenth-century disciple of St. Bonaventure, dedicated much thought both to the papacy, at the time embroiled in bitter battles with Roman nobles and French royals, and to Joseph, to whom he dedicated a treatise in his *Postilla Super Matthaeum.*[57]

In this work, probably the first systematic attempt by a Western writer to respond to the biblical and theological questions regarding St. Joseph, Olivi wrote that Joseph "represents God the Father for Christ because he is the spouse of the Church; he is also the type of the bishops, spouses of the Church.... And in the Christian religion which, like Mary, conceived the evangelical Word through the spirit of Christ, Joseph is also the image of the Roman pontiffs, installed as guardians of the Church."[58]

The dress rehearsal for St. Joseph's new role took place in 1303 in Giotto's frescoes for the Scrovegni Chapel in Padua. Revolutionary for the use of space, representation of human emotion, and iconographic exploration of Mary's Immaculate Conception, this proto-Renaissance milestone in the history of art is an amazing compendium of artistic experimentation. Giotto, formed in the Franciscan milieu and a third-order (lay) member of the Friars Minor, was very attuned to their devotional emphases and adapted his art accordingly. Giotto's brush produced a stately

[57] Michael O'Carroll, *Theotokos: A Theological Encyclopedia of the Blessed Virgin Mary* (Eugene, OR: Wipf and Stock, 1982), 274.

[58] Carolyn C. Wilson, *St. Joseph in Italian Renaissance Society and Art: New Directions and Interpretations* (Philadelphia: Saint Joseph's University Press, 2001), 152.

Flight to Egypt by Giotto

white-haired Joseph with thick curls cropped across his forehead in a form of the "Caesar cut" often used in depictions of Peter.

The other transformation took place in Joseph's clothing: instead of the diverse hues—green, blue, pink, yellow, brown—used at whim in earlier works, Giotto gives him a blue tunic under a yellow mantle, a color combination already established for St. Peter. Giotto went to some pains to make the connection between the two men even more evident: the panels showing scenes including Joseph are placed above scenes where Peter is an active participant so the viewers could note their physical similarities. The *Nativity*, the *Adoration of the Magi*, and the *Presentation at the Temple* are positioned above St. Peter, protesting his innocence at the *Last Supper*, questioning during the *Washing of the Feet*, and slicing off an ear at the *Arrest of Christ*. The uppermost level dedicated three more scenes to Joseph's divine selection as the spouse of the Virgin and to their nuptials, again underscoring the theme

Washing of the Feet by Giotto

of marriage and the Church. In the three images, Joseph moves from a barely perceptible profile in the far left of the picture plane to front and center as he claims his bride, an apt visual allegory for the saint's rise to prominence in this era.

Another Franciscan, St. Bernardino of Siena, admired Olivi's work and witness, referring to him as "an angelic man." He, too, argued for the dignity of St. Joseph and went so far as to rebuke the Northern painters for their satirical images of the saint.[59] In a sermon of 1420, St. Bernardino extolled Joseph as "the most cheerful old man that there ever was in the world" and railed against those "foolish painters who depict him as a sad old man with his hand on his cheek as if he were in pain or the throes of depression."[60]

Although, as we have seen, the satirizing images of the North were not entirely meant as disrespectful, Bernardino's defense is understandable in that Italians had little experience of mocking treatments of saints; and certainly his insistence on the honor due Joseph would have great impact on the art of the age. "It is beyond doubt that Christ did not deny to Joseph in heaven that intimacy, respect, and high honour which he showed to him as to a father during his own human life, but rather completed and perfected it."[61]

The Franciscan contributions toward promoting devotion to Joseph and proposing him as a model for the papacy were

[59] Decima L. Douie, "Olivi's 'Postilla Super Matthaeum,'" *Franciscan Studies* 35 (1975): 91, https://muse.jhu.edu/article/453151.

[60] Bernardino da Siena, *Le prediche volgari* (Florence, 1424), ed. Ciro Cannarozzi (PistoiaPacinotti, 1934), vol. 2, 278–279.

[61] Bernardine of Siena, "A Faithful Foster-Parent and Guardian," Sermon 2, "On Joseph," Vatican website, https://www.vatican.va/spirit/documents/spirit_20010319_bernardino_en.html.

complemented by Jean Gerson, theologian, preacher, and chancellor of the University of Paris. Fr. Gerson's passionate dedication to proclaiming the virtues of the silent saint was pivotal to launching Joseph to superstardom. A committed reformer, both in ecclesiastical as well as civil society, Gerson had run afoul of the Duke of Burgundy, whose power at the time matched that of the King of France.

When John the Fearless of Burgundy murdered the Duke of Orléans and subsequently successfully persuaded theologian Jean Petit to justify his deeds as tyrannicide, Gerson argued tirelessly against public violence, directing particular acrimony toward clerics who promoted false teaching, incurring royal wrath and ecclesiastical vendettas. Caught between warring sovereigns and partisan piety, Gerson attributed his escape from an assassination attempt to the intercession of St. Joseph.

Although Gerson's political influence ultimately waned, his threefold treatise on the Ten Commandments, Confession, and the art of dying well became an international bestseller, read by everyone from nobility to clerics to layfolk. The *Opusculum Tripartitum* was a practical guide to the essentials of Christian living, written in clear, accessible terms that everyone could understand. To Gerson, as a lone man striving to protect the Faith amid murderous rulers and as a theologian working to make the path to salvation intelligible to everyone, St. Joseph, who survived Herod and humbly witnessed the Incarnation, was an ideal guide for his endeavors.

In 1418, Gerson made a special contribution to the ever-increasing artistic hagiography of Joseph in the *Josephina*, a 2938-hexameter epic poem written in the style of the Roman author Virgil. It opens with the drama of the *Aeneid*: Joseph awakens from his dream and flees with his family to Egypt; then

there is a flashback to relive Joseph's first encounter with Mary, followed by the pageantry of his noble genealogy, the birth of Christ, and the succeeding events leading to the death of Joseph.

While mostly basing his account on Scripture, Gerson carefully culled the apocryphal texts to fill gaps in the story, his choices guided by faith and prayer. The result is more engrossing than the straightforward historical narrative: it is a stirring presentation of the wonder, drama, and psychology of the man who participated in the greatest event in history. Jean Gerson's Joseph was no geriatric but a strong, vigorous hero who chose chastity in his marriage to a woman he loved, cherished, and respected. The book, translated into numerous languages, forced Christendom to take another look at Joseph.

Gerson came to the Council of Constance, called in 1414 to resolve the scandal of the three popes dividing Christendom, armed with his Josephine devotion. In a homily delivered on September 8, 1416, the feast of the Nativity of Mary, the chancellor proposed instituting a feast for Joseph, so that, "through the merits of Mary and the intercession of the great and commanding influence of Joseph on his spouse, from whom Jesus the Christ is born, the Church be brought back to her unique and truthful spouse, the Supreme Pontiff, vicar of Christ."[62]

The council was convened to depose the three contending popes so as to clear the way for an election to select a universally acceptable successor to St. Peter. Gerson implored that "the

[62] Isabel Iribarren, "The Cult of the Marriage of Joseph and Mary: The Shaping of Doctrinal Novelty in Jean Gerson's *Josephina* (1414–17)," in *Individuals and Institutions in Medieval Scholasticism*, ed. Antonia Fitzpatrick and John Sabapathy (London: University of London Press, 2020), 253.

Church be delivered to a unique man, true and firm, the Highest High Priest pledged to her in place of Christ."[63] Joseph would serve as the perfect role model, being, in the words of historian Carol Richardson, the "archetype for a new solitary pope, a patient guardian and role model who will serve and protect the Church just as Joseph nurtured the Holy Family."[64]

This vision of the Holy Father seems to have resonated with the restored papacy, now permanently back in Rome after the Council. In a city founded by twins, there was a lingering affection for doppelgangers, and artists delighted in the new possibilities for iconography. Pope Sixtus IV, the Franciscan pope who added the feast for Joseph to the Roman Missal, was an energetic patron of the arts. One of his most personal projects, Santa Maria del Popolo, was placed by the northern gate of Rome, where it would be the first church pilgrims saw as they entered the Eternal City. Not only intended as a burial site for the della Rovere dynasty, it was also a space of private devotion where passersby would often see Sixtus and his relatives going to pray on Saturdays.

One of Sixtus's numerous nephews, Domenico della Rovere, commissioned a private chapel in the church, hiring one of the most sought-after painters in Italy, Bernardino Pinturicchio (1454–1513), to decorate it. Between 1488 and 1490, inside the hexagonal chapel, festooned with some of the earliest *grotesque* designs, personally seen by the painter in the underground vaults of Nero's newly discovered Golden House, Pinturicchio frescoed a splendid altarpiece showing the *Adoration of the Child with St. Jerome*.

[63] Carol M. Richardson, "St. Joseph, St. Peter, Jean Gerson and the Guelphs," *Renaissance Studies* 26, no. 2 (2012): 262, http://www.jstor.org/stable/24422361.

[64] Richardson, "St. Joseph, St. Peter, Jean Gerson and the Guelphs," 263.

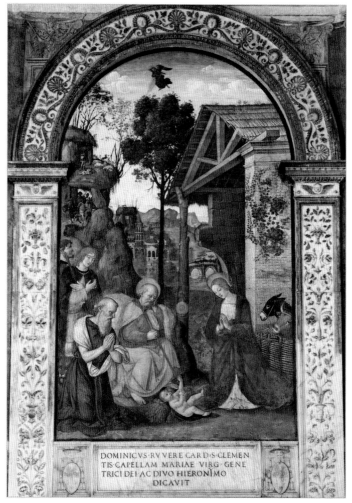

Adoration of the Child with St. Jerome by Bernardino Pinturicchio

Pinturicchio began his career as a miniaturist, and his eye for fine detail can be seen in the carefully painted bricks, overlaid with tendrils of ivy, and the spray of straw in the thatched roof, contrasting with the woven stall for the animals, a veritable feast

for the eyes. The background is studded with tiny embellishments: a bridge reflecting on the water, a classical dome next to a Gothic tower, shepherds on a cliff, and the Magi galloping in the distance.

This work served as a wonderful welcome for all pilgrims making their way to Rome, whether well-heeled or barefoot. Next to the Christ Child, whose nude body rests a matter of inches from the altar, St. Jerome, in purple, kneels in prayer across from the Virgin, the two bracketing the Infant with their purple and blue robes. St. Jerome, a patron of the donor, leads the eye to Joseph, also seen as an older man and sporting a similar tonsure, a sign of the clerical state. Joseph, lost in contemplation of Baby Jesus, wears the Petrine colors, blue and yellow, closely resembling the image of St. Peter painted in Pinturicchio's other chapel nearby.

These works of art encouraged pilgrims coming to papal Rome to associate Joseph with Peter and, by extension, with the reigning pontiff.

Pope Sixtus's diligent promotion of Peter as an "alter" Joseph continued in his most important legacy, the Sistine Chapel. In this space where the cardinals gather to elect the pope, Sixtus commissioned a fresco cycle narrating the life of Christ and the life of Moses along the side walls. Painted from 1480 to 1482 by what might be dubbed the "dream team of Florentine art" the star-studded list of artists included geniuses from Sandro Botticelli to Luca Signorelli.

Leading the team was Pietro Perugino, frequent collaborator of Pinturicchio and future teacher of Raphael. Perugino executed the lion's share of the work, including the most important fresco of the series, the *Delivery of the Keys*. This meticulously composed, majestic work shows the renewal of the Church through the election of Peter's successors. Peter kneels before Christ to receive the symbolic keys that bind or free the faithful from

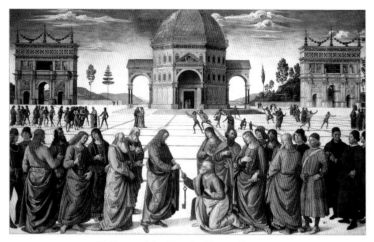

Delivery of the Keys by Pietro Perugino

sin, while the other apostles watch calmly. Triumphal arches in the background flank an octagonal temple. The latter structure, similar to Italian baptisteries, symbolizes rebirth and frames the transmission of authority from Jesus to Peter.

This composition is almost identical to the *Marriage of the Virgin*, executed for the high altar of the cathedral of Perugia by the same artist (see chapter 7 for the image). In this work, Joseph, standing against a backdrop of another octagonal structure, looks exactly like St. Peter as he places a ring on Mary's finger. Perugino had also painted Joseph in a Nativity over the altar wall of the Sistine Chapel, later destroyed to make room for Michelangelo's *Last Judgment*.

Other versions of the Nativity show that Perugino routinely painted Joseph as a mirror image of Peter. Many of the prelates (including Pope Sixtus and his nephew Giuliano della Rovere, later Pope Julius II) who attended services in the chapel had studied law at the prestigious University of Perugia and would

have noted the similarity of St. Joseph's solemn vow to care for the Virgin and St. Peter kneeling to receive the commission to husband Christ's Church.

In 1479, Pope Sixtus added Joseph's feast to the calendar, but its limited, localized devotion saw few altarpieces produced solely in his honor until 150 years later, when March 19 was finally declared a holy day of obligation. In Florence, however, at the time renowned for the most ingenious painters and patrons, an interesting attempt to confer artistic glory upon Joseph appeared in the Sassetti Chapel in the Vallombrosian Church of the Trinity.

Francesco Sassetti, a successful agent of the Medici banking family and personal friend of Lorenzo the Magnificent, commissioned a chapel dedicated to his name saint, Francis of Assisi, in 1478. To decorate the chapel, he called upon one of the most successful artists in Florence, Domenico Ghirlandaio (1448–1494), the future painting master of Michelangelo. The fresco cycle concentrated on the life of St. Francis, but the altarpiece, executed in 1485, showed a remarkably innovative *Adoration of the Shepherds*. Ghirlandaio expertly blended pagan and Christian elements: an inscription of Pompey the Great, a minute angel barely perceptible amid the clouds, and a triumphal arch enrich the scenery.

Ghirlandaio, like Pinturicchio in Santa Maria del Popolo, was inspired by the vision of St. Bridget for his composition but added more complexity to the scene. The Christ Child lies on the Virgin's mantle, His head resting by an empty stone sarcophagus, an overt allusion to His eventual death and Resurrection. Shepherds crowd in from the right, the one in the foreground probably a self-portrait of the painter. Ghirlandaio had studied the art of Northern painters—particularly Hugo van der Goes, whose enormous *Portinari Altarpiece* had just arrived in Rome—and developed a marked skill for rendering still-life detail in his work. The wool of

the sheep, the straw of the basket, and the little goldfinch perched on a block all add to the visual delight of the work.

The color scheme, with Mary enfolded in dark blue and the dim browns and grays of the shepherds' tunics, contrasts with the radiant Christ Child framed by the white marble. The only other exception to the somber shades is Joseph, appearing here in the golden yellow and blue associated with St. Peter. His humble saddle and baggage are left to the side as Joseph shines as the most colorful of the worshippers. The red of his sleeve picks up the red of Jesus' halo, linking the two figures together.

Despite this connection, Joseph is the only one to look away from the newborn, his attention fixated on the bright pageant of the Magi making their way down the hillside. Joseph, surrounded by the indigenous members of the scene, turns to greet the new element, the Gentiles, who have come to join the festivities. This blending of past and present, Old Testament and New, chosen people and the nations of the Roman Empire is achieved through the figure of Joseph, who, in this scene, receives greater prominence than any other figure except Christ. Joseph, resting his hand upon the stone sarcophagus, calls to mind the name of Peter, the "rock" upon which Christ built His Church.

Above Joseph's head, a minute city appears, with the Roman Mausoleum of Hadrian and Torre delle Milizie peeking over the walls, again directly linking St. Joseph with the city of Peter.[65] Ghirlandaio's Joseph/Peter leads the company of shepherds, recalling Christ's injunction to Peter to "feed my sheep

[65] The identification of the Roman monuments is from Heidi Hornik and Mikeal Parsons, "The Shepherds' Adoration," Center for Christian Ethics, Baylor University (2011): 39, https://www.baylor.edu/content/services/document.php/159113.pdf.

Adoration of the Shepherds by Domenico Ghirlandaio

and lambs" (see John 21:15–17), but at the same he prepares to welcome newcomers to the Faith, the Gentiles, in whose lands the Church will eventually establish its Holy See. Ghirlandaio painted this work shortly after his return from Rome, where he had worked alongside Perugino in the Sistine Chapel, and four years after Pope Sixtus established Joseph's feast. Placed at the center of the work, sharing the same axis as Christ, St. Joseph at last, it seemed, gained center stage in an altarpiece.

RENAISSANCE MR. RIGHT

St. Joseph's progressively unfolding versatility continued to serve the Church all through the transformative years of the Renaissance. After centuries of keeping Joseph and Mary apart like chaperones policing a high school dance, ecclesiastical authorities decided that the time had finally arrived for Joseph to take his place by Mary's side. After centuries of standing in the wings or crouching in corners, Joseph claimed the spotlight as a bridegroom to provide Christians with a "poster man" for the sacrament of marriage, with wonderful repercussions for the history of art.

The representation of Joseph the suitor owed its genesis to a gap between Church teaching and practice regarding the sacrament of marriage. Jesus may have saved the day at the wedding at Cana, but the Gospels did not reveal much about how the ceremony was carried out. Christ was clear that marriage was indissoluble and inviolate, yet the manner of conferring the sacrament took time to develop. Established Roman law and an optional priestly blessing served for marriage during the years of the Roman Empire, and, after its dissolution, the Church stepped in, but without a standardized rite or body of teaching.

From the early ages of Christianity, the vocation to marriage played second fiddle to celibacy, championed by St. Paul, who said that "he who marries his betrothed does well; and he who refrains from marriage will do better" (1 Cor. 7:38), and then the Church Fathers such as St. Jerome, who effusively praised the virgin martyrs and was among the first to propose St. Joseph as having "always preserved his virgin chastity."[66] However, as seen in earlier chapters, contemporary art preferred to avoid the problem of Joseph's chastity by either omitting the saint from the scene or depicting him as an elderly man, oblivious to the lustful desires of youth.

Medieval matrimony was mired in confusion. In the twelfth century, jurist Gratian had attempted to organize some form of ecclesiastical regulation for marriage, tackling the thorny question of whether consent or consummation is required for the validity of the sacrament. He concluded, using Mary and Joseph as an example, that consent originated marriage but was more ambiguous regarding the necessity of consummation.[67]

Pope Alexander III added to the chaos by maintaining the primacy of consent yet allowing for private agreement among individuals. As a result, clandestine marriages abounded and became a bane to bishops, for without witnesses, problems of polygamy proliferated. The Fourth Lateran council in 1217 finally reined in abuses by requiring the public reading of marriage

[66] St. Jerome, *Against Helvidius*, in Nicene and Post-Nicene Fathers, Second Series, vol. 6, ed. Philip Schaff, no. 21, Christian Classics Ethereal Library, https://www.ccel.org/ccel/schaff/npnf206.vi.v.html.

[67] Gratian, *Marriage Canons from the Decretum of Gratiani*, trans. John T Noonan Jr. (1967), http://legalhistorysources.com/Canon%20Law/MARRIAGELAW.htm.

banns. All the while, St. Joseph, divinely selected to be husband to Mary, was waiting off stage for his cue.

The debate over what constitutes a marriage was complicated by the fact that the word *matrimony* derived from the Latin words for "mother" and "state of being." That led many people to believe that procreation, and therefore consummation, defined marriage. In response, St. Raymond de Penafort penned a *Summa on Marriage*, in which he, too, acknowledged the importance of consummation but stated, definitively, that marriage is contracted by consent alone and is "truly a marriage, so that, even though he does not know her, neither is allowed to marry another."[68]

Who better to illustrate consent over consummation than St. Joseph? St. Raymond pointed out: "If it were understood of consent to carnal copulation, there would not have been marriage between Mary and Joseph."[69] A century later, Jean Gerson, while exhorting the Council of Constance to elect a successor to St. Peter who would resemble Joseph in his dedication to the Church, proposed that a feast day should be established for the Espousals of the Virgin, to celebrate the marriage of Mary and Joseph, even composing an office for the holiday. At first received warmly by some religious orders, the holiday migrated around the liturgical calendar—October 22, July 18, March 7 or 8, November 26, with most settling on January 23.[70] Today, however, the feast is all but gone.

[68] Raymond of Penafort, *Summa on Marriage* (Ontario: Pontifical Institute of Mediaeval Studies, 2005), 13.

[69] Raymond of Penafort, *Summa on Marriage*, 13.

[70] The feast was never incorporated into the universal calendar but was kept by many countries as well as religious orders. It has been removed from the calendar altogether since 1961 with very few exceptions. See Michael P. Foley, "The Feast of the

The proposal of a feast day meant that there was a new iconographic challenge to stimulate the creative fervor of artists: Joseph the ideal bridegroom. For the first time since he emerged from his house in the mosaics of St. Mary Major, Joseph would be able to claim his bride before the eyes of the world.

Florentine painter Giotto, never one to shrink from a challenge, was among the first to imagine the wedding of Joseph and Mary in the Scrovegni Chapel outside Padua in 1304. Giotto, as already seen, was a forerunner of Renaissance art with his figures modeled in light and shadow so as to create the illusion of weight and mass. His interest in the natural world extended to pictorial space, where he pioneered the attempt to depict a three-dimensional image on a two-dimensional surface. In Giotto's fresco, Joseph and Mary are seen inside a church-like space—a sacred locus for the sacrament. Numerous witnesses are present, watching as the priest guides the hands of Mary and Joseph together. This gesture not only underscores consent, but also recalls the solemn marriage rites of ancient Rome, involving the joining of hands of the bride and groom, as well as the public dimension of the institution.

Joseph, depicted here in his older guise (and bearing a strong resemblance to St. Peter), was far from a spur-of-the-moment choice for Mary's groom. To visually convey his marital destiny, artists referenced the apocryphal Pseudo-Matthew account of how Mary's spouse was selected. While Mary was living in the Temple, the high priest called all the men of the area to come to the precinct and to bring a wooden rod. Joseph, thinking himself too old for marriage, reluctantly joined the group of young men,

Espousals of Mary and Joseph," New Liturgical Movement, January 21, 2021, https://www.newliturgicalmovement.org/2021/01/the-feast-of-espousals-of-mary-and.html#.YOMqaOgzaUk M.

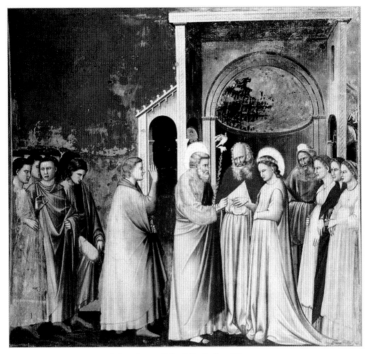

Marriage of the Virgin by Giotto

but when the rods were presented, a snow-white dove emerged from his, signaling that he had been chosen by the Holy Spirit.

In this case, Giotto depicts Joseph's staff blossoming into a lily, the symbol for purity usually reserved for Mary. This iconography underscored both Gerson's and Bernardino of Siena's teaching of Joseph's virginity, and this specific attribute indicating the saint's purity by choice persists in his imagery to this day.

The disappointed suitors, shocked at the selection of the unlikely candidate, react in rage. Giotto juxtaposes the serenity of the marriage rite with one youth snapping his stick over his knee while another two gossip maliciously. The enigmatic

young man standing with his hand raised at the doorway is more easily understood through another version of the story, painted by Giotto's student Bernardo Daddi, who set his wedding scene in a delightful enclosure, surrounded by floral tapestries and a garden. In Daddi's fresco, the women cast admiring glances at the Virgin while the men chatter and gesticulate in anger. One man directly behind Joseph raises his hand menacingly—one of the rejected suitors who wants to reclaim his honor through blows, not an uncommon occurrence in Italy.

The proposed feast of the nuptials of Mary and Joseph was propelled by the discovery of the alleged relic of Mary's wedding ring. It appeared in the city of Chiusi, outside Siena, and was transferred to the *Duomo*, or cathedral, in 1251. Interest grew in the relic, a simple smoke-colored quartz band, so it was moved to the Church of St. Francis for safekeeping in 1420. The ring was stolen by a disgruntled German friar in 1473 and brought to Perugia, where it remains to this day. In 1488, Bernardino da Feltre, who preached on the exemplary holiness of Joseph as husband and father, founded the company of St. Joseph to guard the Holy Ring from any eventual reprisals.[71] In thanksgiving for the relic, citizens of Perugia commissioned their greatest artistic son, Pietro Perugino, to produce an altarpiece of the *Espousals*, raising the subject from a predella scene, as was the case of the works by Bernardo Daddi, Fra Angelico, and Ghirlandaio, to the focal point of the church.[72]

[71] Enrico Barni, "Il *Santo Anello* e la Storia dei Rapporti nei Secoli tra le Communita di Perugia e Chiusi," in *Il Santo Anello: Leggenda, Storia, Arte, Devozione* (Perugia: Commune di Perugia Cultura, Perugia, 2005), 35.

[72] In Renaissance artworks, a *predella* is a small rectangular panel placed underneath the main altarpiece.

Perugino's *Marriage of the Virgin* marked the triumph of Renaissance order and perspective in art. In the foreground, five men and five women line up daintily on either side of the couple. Two people turn away from the viewer and toward the scene, inviting the faithful to join in as witnesses as Mary extends her finger to

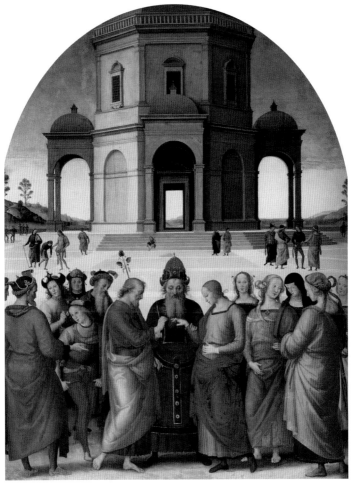

Marriage of the Virgin by Pietro Perugino

Joseph. Perugino pointedly gives the ring special prominence after its recent "acquisition" from Chiusi. The broad, regular paving stones create an atmosphere of calm, and even the angry young men seem subdued. Perugino omits any excess of passion in the scene, his solution to the problem of representing their chaste marriage without resorting to depicting a geriatric Joseph. Furthermore, as noted previously, Joseph bears a strong resemblance to St. Peter in Perugino's earlier *Delivery of the Keys*.

A fanciful eight-sided building, traditionally associated with baptisteries, occupies center stage in the scene, emphasizing the sacramental nature of marriage but also alluding to the impending birth of the Savior. All the receding perspective lines meet at a single point: the open doorway leading out into an endless horizon, an effective way of using the science of painting to express the permanence of marriage.

Working in the same time period (1500–1504), Raphael produced an altarpiece on the same theme and style for the town of Città di Castello in honor of the newly adopted feast of the Espousals. The twenty-year-old genius from Urbino was clearly inspired by his teacher, Perugino, but added a few special flourishes of his own. The elegantly portioned piazza remained the same, but instead of the figures standing almost flush along the base of the picture plane, they circle gently inward, appearing to make room for the viewer to join in the nuptial celebration. Raphael's deeper colors add greater sobriety to the scene, and the space seems more expansive behind the wedding party. Raphael narrowed the age gap between Mary and Joseph, depicting a younger man who will become a model of self-mastery in later works. Raphael's two greatest innovations, however, were in the tilted head of the priest, forcing a stronger focus on the ring, and the rounded temple in the background, where the circular form

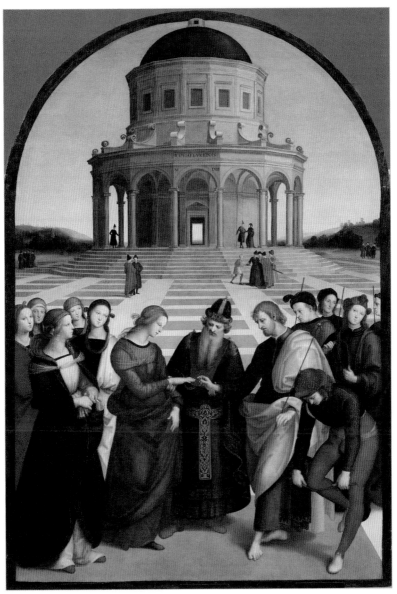

Marriage of the Virgin by Raphael

suggests not only the infinite but also the ring itself. Raphael's greatest strength, however, lay in his ability to empathize with the viewers; thus, he added a female figure to the left of Mary, unconsciously feeling her ring finger as she watches the marriage taking place.[73]

St. Joseph's metamorphosis into the Renaissance Mr. Right was complete by 1523, when Rosso Fiorentino painted the altarpiece of *Nuptials of the Virgin* for the Basilica of San Lorenzo in Florence. The numerous documents regarding the commission left by the patron, Carlo Ginori, show a man who, despite the loss of his heirs, maintained a strong commitment to his wife and a powerful devotion to St. Joseph.[74]

This resulted in the first full-scale vertical altarpiece of the subject to be produced in Florence, and Rosso, one of the city's most avant garde painters, rose to the occasion in this unique work.[75] He painted Mary and Joseph's wedding as a crowded scene taking place amid a captivating play of shadow and color, the light concentrating on the newlyweds in the center. Mary, demure, extends her elongated fingers, while Joseph, youthful and muscular with a cascade of strawberry blond curls, steps forwards to pledge his troth.

Joseph is no longer the reluctant suitor embarrassed by his selection. Now he is filled with confidence, a man with purpose. Rosso also added a nuanced emphasis on the role of husbands: the priest looks to Joseph with admiration as he indicates for

[73] Nicholas Penny and Roger Jones, *Raphael* (New Haven, CT: Yale University Press, 1983), 20.

[74] David Franklin, "Rosso Fiorentino's *Betrothal of the Virgin*: Patronage and Interpretation," *Journal of the Warburg and Courtauld Institutes* 55 (1992): 182.

[75] Franklin, "Rosso Fiorentino's *Betrothal of the Virgin*," 182.

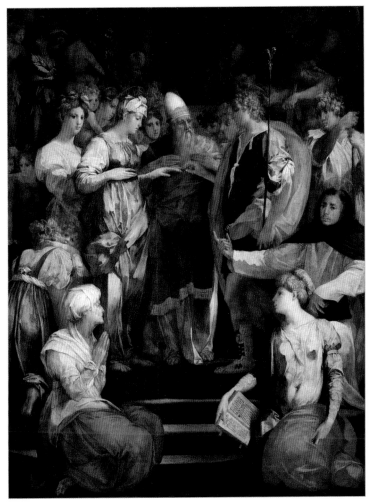

Nuptials of the Virgin by Rosso Fiorentino

him to place the ring on Mary's finger. For the first time, Joseph appears as a handsome and beardless young man, close in age to Mary, illustrating the claim attributed to St. Bernardino of

Siena that "Joseph was the living image of his Virgin Spouse; they resembled each other like two pearls."[76]

Three saints attend the nuptials: St. Apollonia (a Florentine favorite), St. Anne (Mary's mother and the patroness of childlessness), and St. Vincent Ferrer, a more surprising choice. Canonized in 1455, the Spanish saint, also devoted to St. Joseph, was famous for his preaching on the afterlife and eternity, a fact reflected by his gesture, pointing through the exchange of rings upward. The profoundly personal nature of this devotional work presaged the increasing individual devotions to St. Joseph, which, in turn, would produce a golden age of Josephine art.

Rosso painted his altarpiece five years after Martin Luther upended Christendom with his ninety-five theses on the Wittenberg cathedral, but as the Reformation grew in scope and intensity, the matter of marriage would come under fire alongside the other sacraments. Henry VIII's divorce and England's descent into schism scandalized the faithful and denigrated the sanctity of marriage, already degraded due to the lax practices and sexual mores of the age. Nobles treated marriage as a private-property deal, arranging contracts behind closed doors, which often led to bigamy, while the waning value set on the virtue of chastity led to an increase in prostitution and concubinage.

Rome was particularly notorious for its prostitutes: the trade was legal in the papal capital, shocking many pilgrims and supplying Protestants with fodder against the papacy, nicknamed "the Whore of Babylon" by Luther and his followers.[77] Counter-Reformation

[76] Père Binet, *The Divine Favors Granted to St. Joseph* (Charlotte, NC: TAN Books, 2009), 9.

[77] See Lucas Cranach the Elder's illustration of the "Whore of Babylon" for Martin Luther's New Testament in 1522. It is contained in the British Library, London.

popes worked to remove the scandal of the thousands of women who displayed themselves in doorways, in windows, and on street corners, like so much merchandise, offering sex for hire. Pope St. Pius V led the charge on the Roman cleanup, insisting that those women either marry or move, writing that "it is not good to tolerate that the prostitutes should reside in the most beautiful and public streets of holy Rome, where there is spread the blood of so many saintly martyrs."[78]

Between the prospect of easy divorce and the increasing acceptance of casual sexual relations, the Church needed to bolster the importance of the sacrament of Matrimony among the faithful and restore esteem for the virtue of chastity.

On November 11, 1563, the twenty-fourth session of the Council of Trent took matters in hand, denouncing that the "impious men of this age … have not only had false notions touching this venerable sacrament, but, introducing according to their wont, under the pretext of the Gospel, a carnal liberty, they have by word and writing asserted, not without great injury to the faithful of Christ, many things alien from the sentiment of the Catholic Church."[79] Asserting the indissolubility of marriage, condemning concubinage, and praising chastity, the Council needed a friendly face to persuade the faithful in light of the Protestant onslaught.

Nicolas Poussin, a French painter who came to dominate the Roman art world in the seventeenth century, produced a series of

[78] Elizabeth S. Cohen, "Seen and Known: Prostitutes in the Cityscape of Late-Sixteenth-Century Rome," *Renaissance Studies* 12, no. 3 (1998): 399.

[79] *The Council of Trent: The Canons and Decrees of the Sacred and Oecumenical Council of Trent*, ed. and trans. J. Waterworth (London: Dolman, 1848), session 24, pp. 193–194, Papal Encyclicals, https://www.papalencyclicals.net/councils/trent.htm.

canvasses on the seven sacraments for his influential patron Cassiano dal Pozzo. Pozzo, a Florentine scholar, worked for Francesco Cardinal Barberini, nephew of the reigning pope, Urban VIII. This series was so successful that Poussin was asked to repeat it later for Paul Fréart de Chantelou, Gian Lorenzo Bernini's host during his 1665 visit to the court of Louis XIV. To illustrate the sacrament of marriage, Poussin chose the example of Joseph and Mary, designing a work that would evoke both the sanctity and solemnity of marriage.

In his interpretation, Poussin dismissed the embittered suitors entirely to focus more closely on the nuptials themselves. The room is austere, and four Corinthian columns and unadorned stone walls add gravitas to the scene. The columns support a vaulted roof, similar to the canopy used for Catholic altars but also to the chuppah of the Jewish marriage rite. Young men and women look on. One woman on the right clasps a child to her skirts (an allusion to procreation as well as the Christ Child in Mary's womb) while a young man on the right points to the lily emerging from Joseph's rod, reiterating the saint's personal purity. Mary kneels in the quiet consent familiar from images of her fiat to the angel Gabriel, while the youthful Joseph sinks to his knees before her.

Poussin captures the moment when the priest asks Joseph to make his vow of consent. The priest, clad in gold and white, evoking the colors of the Catholic Church, unites the two young people under the wings of his robe, much like the medieval images of Mary protecting the faithful gathered under her mantle. Instead of focusing on the ring, Poussin draws attention to their clasped hands, a gesture from ancient Roman art to indicate the union of marriage. The young couple has moved beyond betrothal, and the two are joined in the great adventure that will welcome the Savior into the world.

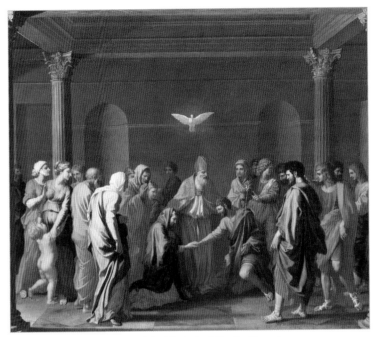

Marriage of the Virgin by Nicolas Poussin

Venerable Fulton Sheen saw this common commitment to Christ as the foundation of their chaste love, writing, "Why pursue the shadow when they had the substance? Mary and Joseph needed no consummation in the flesh for, in the beautiful language of Leo XIII: 'The consummation of their love was in Jesus.' Why bother with the flickering candles of the flesh, when the Light of the World is their love? Truly He is *Jesu, voluptas cordium*."[80]

[80] Fulton J. Sheen, *The World's First Love: Mary Mother of God* (New York: McGraw-Hill, 1952), 92.

The light of Poussin's painting comes from a dove, no longer perched above Joseph's flowering rod, but occupying the center of the work, as in Raphael's *Disputation* in the Vatican Museums. Raphael anchored that immense composition by placing the Holy Spirit above the Eucharist to unite Heaven and Earth in the scene. Poussin, who admired and emulated the earlier painter, expanded the significance of the dove as Holy Spirit, not only present in the selection of Joseph as spouse, but as witness to the indissoluble bond between one man and one woman.

ST. JOSEPH GOES FOR BAROQUE

➤ · ◆ · ⬅

The Council of Trent was a watershed for the history of St. Joseph in art. While the Church Fathers debated for twenty years on how best to reaffirm Catholic doctrine, the Council was also generating new religious orders, inspiring a fresh missionary spirit, and encouraging every human being to cooperate, in some way, in the work of salvation. Some might be called to dramatic service, such as the many martyrs killed in far-flung lands; others might dedicate their lives to the essential yet less glamorous work of raising faithful sons and daughters, in the manner of St. Joseph.

The Protestant Reformation collided with the Renaissance world, fracturing the Christian family and leaving many in a spiritual void. The Catholic Church was thus faced with the daunting task of regrouping its scattered children. The art world assisted in that effort by recruiting an elite team of saints: images of Mary Magdalene and St. Jerome to promote penitence, of St. Andrew for martyrdom, of St. Catherine for wisdom—and they added St. Joseph to this special squad as a model of fatherhood and fidelity.

Joseph had triumphed as the ideal bridegroom during the Renaissance, but in the later sixteenth century, he emerged as the perfect protective father. St. Teresa of Ávila's personal devotion to Joseph launched this new era, the Spanish mystic crediting the saint for her recovery from paralysis.

In her autobiography, Teresa writes that St. Joseph helped her in all her needs and that "because of my impressive experience of the goods this glorious saint obtains from God, I have had the desire to persuade all to be devoted to him. I have not known anyone truly devoted to him, and rendering him special services, who has not advanced more in virtue."[81] The manifold advocacy attributed to him by St. Teresa was a significant step in setting the stage for Joseph's eventual universal patronage of the Church.

Also propelling the Josephine ascendency were the twelve out of seventeen convents Teresa founded explicitly under his patronage. By the Baroque era, Joseph's devotional momentum was unstoppable, and in 1621, Pope Gregory XV made Joseph's feast a holy day of obligation, perhaps not coincidentally, the same year he canonized St. Teresa of Ávila.

For the first time, statuary was developed in honor of St. Joseph. Freestanding statues of saints had been the norm for church facades and chapel niches, but Joseph had been omitted from the hagiographic menagerie until the Counter-Reformation era, when his statues began to proliferate, starting in Spain. One of the loveliest examples still graces the high altar of San José in Ávila, the first convent founded by St. Teresa. It was produced around 1610 to 1620 by a member of the studio of

[81] *The Autobiography of St. Teresa of Avila*, trans. Kieran Kavanaugh, O.C.D., and Otilio Rodriguez, O.C.D. (New York: One Spirit, 1995), 80.

Statue in the Convent of San José, Ávila

the king's sculptor, Manuel Pereira, although the artist's name remains unknown.[82]

The life-size statue is carved out of wood, a homage to Joseph's profession, and richly painted to convey his regality. He

[82] Juan José Martín González, "El convento de San José de Ávila (patronos y obras de arte)," *Boletín del Seminario de Estudios de Arte y Arqueología* 45 (1979): 371.

effortlessly holds on one arm the Christ Child, who playfully turns to touch his face. This kind of iconography, long associated with Jesus and His mother, was at last to be shared with His foster father. The statue, because of its three-dimensionality, made the saint seem more present to the faithful, increasing his devotees, who saw him standing in their churches ready to help.

Although enshrined above the tabernacle, Joseph was still three and a half centuries from his inclusion in the Roman canon by Pope St. John XXIII in 1962, yet there he stands, holding the physical body of the infant Christ. One year after Joseph's addition to the Eucharistic Prayer, Pope St. Paul VI sent the cardinal prefect of the Sacred Congregation of Rites to crown the statue, a special sign of veneration usually reserved for images of the Virgin or Christ.[83]

At the same time St. Teresa was working to consecrate the world to St. Joseph, Johannes Molanus, the self-appointed overseer of post-Tridentine art, called for a facelift for the foster father of Christ. The apocryphal vignettes of the doddering geriatric were to be dismissed in favor of a "young, vigorous man, capable of supporting the Holy Family" as well as maintaining his chastity through self-mastery aided by God's grace.[84]

El Greco, the peripatetic painter who left his native Crete to work in Venice, Rome, and ultimately in Spain, was among the first to adhere to the new guidelines for Josephine imagery. Working in the cathedral of Toledo in 1597 for Martín Ramírez de Zayas, a professor of theology, El Greco produced an arresting altarpiece. The patron was an early follower of St. Teresa and

[83] Ibid.

[84] Johannes Molanus (van Vermeulen), *De Historia Sanctarum Imaginum et Picturarum* (Louvain: Typis Academicis, 1570), 270.

commissioned the chapel in honor of her favorite saint, whom she referred to as "my true father."[85]

El Greco's dynamic painting style was a perfect fit for the new Joseph: broad brushstrokes exuded muscular energy, while his signature elongated lines gave the saint a towering, yet protective, presence. Joseph's staff resembles a shepherd's crook as he leads the way for his Son, a beautiful boy clinging to his waist. Jesus wears a red tunic, the color typically used in Western art to symbolize His mortality, to evoke His human needs for food, shelter, and protection, which were provided by his foster father.

The jewel-like colors of Joseph's robes sparkled in the darkness of the chapel, inviting the faithful to emulate the Christ Child, who finds refuge in this beacon of the Church. The background landscape contains a small portrait of the city of Toledo, a visual device to indicate its special protection by the saint. At the top of the canvas, three angels swirl around Joseph's head, carrying two crowns: one of laurel, signifying the triumph of the saint after long years of obscurity, and the other of roses, usually used for the Virgin, who appears in another canvas directly above Joseph's altarpiece, floating in Heaven and engaged in a sacred conversation with Sts. Agnes and Martina.

The juxtaposition of the two paintings also hints at an increasing trend in Josephology: a belief that Joseph had been bodily assumed into Heaven. Jean Gerson, in his *Considerations sur St. Joseph* had been among the first to propose this singular honor for the spouse of Mary, claiming that after Christ's Passion, he had been reunited with his holy family in Heaven.[86]

[85] *The Autobiography of St. Teresa of Avila*, 290.

[86] Jean Gerson, *Oeuvres complètes*, ed. Palémon Gloriuex, 10 vols. (Paris: Desclée, 1961–1973), vol. 8, 66. "Dixit hoc forte ipsi in

Saint Joseph and the Christ Child by El Greco

For his part, St. Francis de Sales, bishop of Geneva and founder of the Visitation Order, pointed out that there was no tomb of Joseph, nor bodily relics; therefore, "how could we doubt that Our Lord raised glorious St. Joseph up into Heaven, body and soul? For he had the honor and grace of carrying Him so often in his blessed arms, arms in which Our Lord took so much pleasure.... St. Joseph is therefore in Heaven body and soul, without a doubt."[87] The campaign for the Assumption of Joseph was ultimately unsuccessful, but if there is one thing this saint teaches, it is that perseverance wins out in the end.

The concept of Joseph's assumption was promoted more overtly a generation later, when Francisco Zurbarán (1598–1664) painted *Christ Crowning Saint Joseph* in 1640 for the convent of the Discalced Carmelites in Seville. The large altarpiece shows Joseph kneeling before the resurrected Christ against a backdrop of golden clouds. Joseph appears older, with a few streaks of gray in his thick hair, but still trim and vigorous as he indicates Jesus. The yellow robe favored by Italian artists has dimmed to brown, intended to emphasize Joseph's humility as well as his carpentry. Christ, triumphant over death, holds the Cross in one hand while placing a wreath of roses on Joseph's head with the other. The floral crown was commonly used to represent the queenship of Mary, the feast on the octave of her Assumption into Heaven.

This work served visually to associate Joseph with Mary's near-universally accepted bodily Assumption, which would not

anima et corpore conresurgenti, quemadmodum multa corpora quae dormierant eo moriente surrexerunt. Apparuit denique fortassis dilectissimae uxori suae Mariae, ipso resurrectionis die, dicente filio ad eam : Salve sancta parens."

[87] St. Francis de Sales, *The Spiritual Conferences* (London: Aeterna Press, 1943), 274.

Christ Crowning Saint Joseph by Francisco de Zurbarán

be formally declared until 1950. Again, building on traditional Marian imagery, Zurbarán textured the background of his painting with smiling pudgy faces of cherubs, painted to look like clouds, and, very faintly in the upper right, God the Father watching with approval. The figure of God wears the inverse colors of the Second Person of the Trinity, and He holds the orb of the world in His hands, another hint at the growing appreciation of Joseph's patronage. The dove of the Holy Spirit hovers above Joseph, reinforcing the special graces of the saint.

St. Joseph was championed not only in the visual arts but also in literature. In 1597, Jerónimo Gracián, personal friend and spiritual director of St. Teresa of Ávila, penned a new Josephine elegy, *Excellencies of St. Joseph*, with six illustrations by Christophorus Blancus. In it, he declared that St. Joseph resembled Christ in "countenance, speech, complexion, habits, inclinations, and way of life."[88] The popularity of the work made a significant impact on art, especially in the work of painter Bartolomé Esteban Murillo (1617–1682). Murillo is best known as the Immaculate Conception painter par excellence, given the numerous versions of the subject that he produced, but his images of Joseph are almost as plentiful. Murillo explored different paternal qualities—vigilance, devotion, playfulness, loyalty, and forgiveness—in each of his numerous paintings of St. Joseph, leaving the world a beautiful body of Josephine art.

Gracián's poem reiterated St. Bernard's union of the homonymous Old Testament patriarch and the "righteous man" of

[88] *Just Man, Husband of Mary, Guardian of Christ: An Anthology of Readings from Jerónimo Gracián's* Summary of the Excellencies of St. Joseph *(1597)*, trans. and ed. Joseph Chorpenning, O.S.F.S. (Philadelphia: Saint Joseph's University Press, 1993), 257.

the Gospels by exhorting the faithful to "go to Joseph" as the pharoah had done in Egypt. Murillo's lovely portrait of *St. Joseph and the Child Jesus* extends this invitation in living color. Painted for the high altar of the Capuchin Church of Seville, the six-and-a-half-foot-tall canvas places Christ at the center, perched on a battered stone slab reminiscent of a pagan altar.

A truncated column overgrown with leaves juts up on the left, a remnant of an earlier world and its false gods before the advent of Christ. Jesus, again in pink garb as in El Greco's work, rests His luminous head against the shoulder of a strong, handsome Joseph, who resembles the adult Christ, complete with flowing dark hair and beard. This is the type of Josephine image that would inspire Spanish saint Josemaría Escrivá to write "Jesus must have resembled Joseph: in his way of working, in the features of his character, in his way of speaking."[89] The Baroque era revitalized the representation of St. Joseph in preparation for his many responsibilities yet to come.

Joseph's eyes stare watchfully into the distance, as if to ward off potential threats, while he cradles the boy protectively. Jesus, in turn, gazes at the viewer as if to say, "I trusted Joseph in times of danger. Shouldn't you?"

Murillo painted the flowering branch of Joseph in the hand of the Christ Child, who lays it against His foster father's shoulder, as if to underscore this point that Christ chose Joseph, of all the men in the world, to be His guardian. Murillo's portrait of Joseph, brave yet tender, comely yet manly, leader yet servant, is the captivating forerunner of what would later fade into the

[89] *Christ Is Passing By: Homilies by Josemaría Escrivá* (Sydney: Little Hills Press, 1995), https://www.escrivaworks.org/book/christ_is_passing_by-chapter-5.htm section 55.

St. Joseph and the Child Jesus by Bartolomé Esteban Murillo

often saccharine, mass-produced statues populating modern churches.

Roman artists eagerly joined in the new trend of father-and-son imagery, although retaining some of the old iconographic elements. Guido Reni's (1575–1642) lovely 1635 portrait of *St. Joseph Cradling the Infant Christ*, painted in Bologna for an

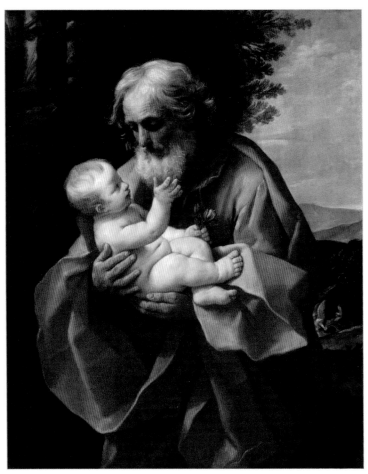

St. Joseph Cradling the Infant Christ by Guido Reni

unknown donor, was probably a private commission, intended for domestic contemplation.

Painted on a four-foot-tall canvas, the almost full-length Joseph appears to be the same size as the viewer, and the beholder almost feels like an intruder in this intimate moment. Reni worked for many years in Rome and avidly studied ancient sculpture to infuse his art with the elegance and gravitas mastered by the Greek artists of the classical age.

This painting was inspired by a statue of *Silenus with the Infant Dionysus*, a copy of a lost work by Lysippus in the papal collections. The fourth-century BC Greek sculptor had played with the humorous yet poignant vision of the faun, a mythological anthropomorphic forest reveler, gazing in wide-eyed wonder at the squirming baby in his arms. Reni built upon the motif, conferring the dignity due St. Joseph by depicting him as an older man, not decrepit with age, but with the experience and wisdom that maturity brings. Reni lightens the scene by portraying the Child enthralled by Joseph's fluffy beard, adding a new and playful note to the image. In the background, he added the tiny figures of the flight to Egypt, with an angel, in lieu of Joseph, leading the donkey carrying the Madonna and Child.

This, for the viewer up to date on St. Josephology, would have evoked Gracián's comparison of Joseph to the celestial beings who serve the Lord: "Because ... St Joseph exercised the principal offices and ministries of angels, he is rightfully called truth an angelic man or an angel on earth."[90]

The choice of an elderly Joseph might have been preferred in Rome to maintain the association, promoted by Jean Gerson, between St. Peter and St. Joseph as spiritual twins, a means of

[90] *Just Man*, 196.

asserting the pope's role as custodian of the Church. Joseph's periwinkle and marigold robes in the painting recall the traditional colors of St. Peter, and the gentleness with which this "holy father" cradles the son would reflect a paternal papacy, as opposed to an authoritarian one. For all the theology, however, the power of this work is in the manner with which Reni, the seventeenth-century heir to Raphael, captured the love and wonder of fatherhood.

Chapter 9

DOMESTIC BLISS

As the quest to honor Joseph at the altar produced grander and grander *retabli* (liturgical decorations), another type of image was multiplying in the homes of laypeople. These paintings contained scenes of the Holy Family in quiet domesticity, whether pausing on the flight to Egypt or sharing an intimate moment in their home in Nazareth.

Intended for private devotion, these works served to make St. Joseph a family fixture, encouraging fathers to model themselves after his saintly example. The high demand for these images meant that some of the greatest masters would turn their creative genius to devising charming pictures meant to bring a smile as well as a nudge toward devotion. The paintings were relatively small, appropriate adornment for a parlor, study, or nursery. Much like television, which brought, for better or for worse, scripted characters into people's homes, these works by Michelangelo, Raphael, Barocci, and Caravaggio turned Joseph into a household figure.

As befitting this silent saint, Joseph made his way into daily devotion quietly, through the private prayer of the pious. Among these numbered many laypeople, who owned special books of

prayers and readings called books of hours (the word *hour* being from the Latin *orare*, meaning "to pray"). Those made for the wealthy were often lavishly decorated with illuminations intended to focus prayer and foster personal holiness.

Among these, arguably the most lavish book of hours was created around 1440 in the Netherlands for Catherine of Cleves. Probably commissioned by her husband, Duke Arnold of Guelders, this sumptuous psalter was meant to sustain her through marriage and motherhood by means of pious readings and holy examples. One hopes the gilt images and selected psalms provided solace during her many battles with her husband over her son's inheritance.

Certainly, the extrabiblical images of the Holy Family at home gave her a glimpse of what might have been. Two of the most delightful illuminations in the text represent the Holy Family engaged in domestic activities in Nazareth, and one of the two offers an interesting clue to Joseph's next guise. Illustration 227 shows Mary nursing Jesus in a cozy room by a large fireplace. The family china sits on a shelf, and a soft rug is placed under Mary's feet, but most of the furnishings are beautifully crafted out of wood, an allusion to Joseph's trade (the previous illumination shows Joseph working wood).

As Mary feeds the infant Christ, Joseph stirs a bowl of porridge. He turns slightly as he holds the cup of white gruel, mirroring the position of the Virgin on the other side. In his own way, by providing nourishment, Joseph enters more fully into the domestic life of the Holy Family.

St. Bernard of Clairvaux's celebrated homily on Joseph had, on one hand, highlighted his kingly descent, but it also painted a picture of his loving domesticity. Bernard invited the listener to imagine Joseph's intimate relationship with Jesus, how he was

Detail from Catherine of Cleves' book of hours

able to "carry Him in His arms, rear Him, embrace Him, kiss Him, nourish and watch over Him."[91]

Bernardino of Siena continued this vision, exclaiming, "Oh, how many sweet kisses Joseph received from him! Oh, with how much sweetness he heard the little babbling child call him father!"[92] This invitation to imagine Joseph as a committed father and provider had long taken a back seat to the numerous other

[91] St. Bernard, *Laudes Mariae*, 2.
[92] Bernardino da Siena, *Opera omnia*, vol. 7, Sermo 2.

roles designated for him, but at last, in the fifteenth century, the image of Joseph, *Nutritor Domini*, "nourisher of the Lord," took root. [93] Joseph, father and provider, flowered into some of the most wonderful works in the history of art. St. Joseph became an affectionate presence in the family in a series of paintings that still captivate viewers today.

An entertaining byproduct of the early *Nutritor Domini* images where Joseph is seen cooking was a new patronage for the saint: in Venice, he became protector of milk vendors and pasta makers. [94] To this day in Italy, March 19 is celebrated with a cream-filled fried pastry called the *bignè di San Giuseppe* in honor of this sweet saint!

During the Renaissance, Italians thought a great deal about the importance of family and its role in building a strong society. In 1435, Leon Battista Alberti, a Florentine polymath and an illegitimate child of a noble house, wrote a wildly popular four-part treatise called *On the Family*. He framed the work in the form of a dialogue, with older family members trying to persuade a younger scion of the goods of marriage and family. Humorous, practical, and insightful, it sparked lively discussions in art and

[93] This title was already used in the ninth century in different martyrologies and, by 1500, was one of three principal titles used for St. Joseph, alongside *Sponsus Mariae* and *Confessor*. The question is discussed at length in Carolyn C. Wilson, "Sanctus Joseph Nutritor Domini: A Triptych Attributed to Jan Gossaert Considered as Evidence of Early Hapsburg Embrace of St. Joseph's Cult," in *Saint Joseph: Patron for Our Times* (Kalisz, Poland 2009), 502–503. The association between Mary nursing and Joseph preparing food was first brought to light by Sheila Schwartz in her doctoral dissertation "The Iconography of the Rest on the Flight into Egypt" (New York University, Institute of Fine Arts, 1975).

[94] Wilson, "Nutritor Domini," 505.

literature about family life. By the end of the fifteenth century, there was a marked increase in demand for images of the Holy Family, a transformation from the Madonna and Childs that had been a mainstay of private collections. These new works included other members of Jesus' family: St. Anne, St. John the Baptist, and, most importantly, St. Joseph.

From the fifteenth century onward, hundreds of Holy Family scenes were produced, including examples by geniuses such as Botticelli, Bellini, Dürer, and Lippi, attesting to the overwhelming popularity of this image. To list them all would require several volumes, so in the interest of space as well as efficacy, it will be sufficient to look at two versions produced at the same time by the greatest masters of the Renaissance, two men who also happened to be rivals: Michelangelo and Raphael.

Raphael, the younger of the two, had developed a formidable reputation as a painter of the Madonna and Child, but he welcomed the challenge of adding other family members to the scene. Raphael's *Holy Family with a Palm Tree* was probably painted for wealthy Florentine merchant Taddeo Taddei, who had hosted Raphael during his time in Florence.[95] The oil on canvas is round, a format used for domestic art, originating in the custom of offering plates of fruits and sweets to mothers of newborns. The plates were painted, so as to remain as souvenirs once the perishables were consumed, and eventually the gift became the *tondo*, as it was called. Taddei probably commissioned the work around 1507, after an earlier tondo purchased from Michelangelo was left unfinished when the artist abruptly left for Rome in 1505.

[95] Ettore Camesasca, *All the Paintings of Raphael, Part I* (New York: Hawthorn Books, 1963), 52.

A distinctive feature of the Renaissance Holy Family scene is its natural setting out-of-doors. The landscape is invariably peaceful and completely dominated by the sainted trio. The ease with which the characters interact, acting "naturally," served as a delightful device to render Mary, Jesus, and Joseph more accessible to the everyday imagination without running the risk of preoccupations with their social status based on household decor, or, more problematically, disrespect.

Under a bright azure sky, Mary, painted with the timeless elegance characteristic of the art of Raphael, sits on the edge of a stone slab. Closer inspection reveals that it is a sarcophagus, the first of several subtle hints that there is more to this scene than just a pleasant day in the park. The lovely Christ Child is perched at the edge of her knee, leaning forward as Mary loops her finger in His sash to hold Him more securely. Jesus is engrossed by the kneeling Joseph, who has gathered some wildflowers for Him to play with. Joseph, his hair just beginning to turn gray, gazes lovingly at the boy. Raphael mastered the ability to capture the intensity of human sentiment: no words are needed; the two are simply absorbed in the moment.

This idyll will not last forever, however. The dandelion, the cut flowers, the red berries on the ground reminiscent of drops of blood under Jesus' feet, and the shadowy coffin with the wooden stakes rising above it all presage Christ's eventual Passion. The mighty palm tree, however, symbolic of Heaven, anchors the work with the promise of Paradise after suffering.

These latent symbols do not diminish the wonder of this happy moment in the family. Watching the exchange between Jesus and Joseph, Mary gazes affectionately at her husband. Not only does Raphael depict the parental relationship but he also stresses the marital bond. Leon Battista Alberti made a beautiful

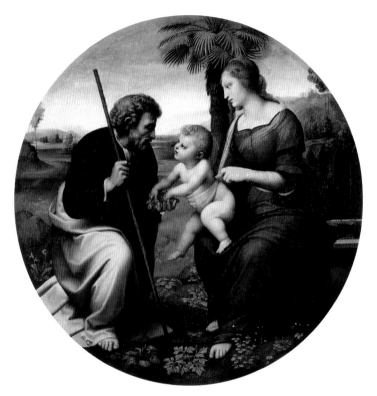

The Holy Family with a Palm Tree by Raphael

case for marriage as true friendship in book 2 of his treatise, writing, "We may consider the love of husband and wife the greatest of all.... This is a union, indeed, which one may well call true friendship. I will not lengthen my discourse by describing all the advantages stemming from this conjugal friendship."[96] Raphael's work perfectly represents this spirit of camaraderie between Mary

96 Alberti Leon Battista, *The Family in Renaissance Florence: I Libri della Famiglia*, trans. Renée Neu Watkins (Long Grove, IL: Waveland Press, 1994), 93.

and Joseph, an excellent example to keep present in the family home.

Meanwhile, Michelangelo was painting a Holy Family for another successful Florentine, banker Agnolo Doni, who had also commissioned Raphael to execute portraits of himself and his wife. These two artistic giants were circling each other in Florence, both eagerly sought after by collectors. They were also both unaware that, within two years, they would be vying for artistic supremacy in the Vatican, Raphael frescoing the papal apartments and Michelangelo on the scaffolding of the Sistine chapel. This clash of the titans would reverberate through the history of art, but in these two smaller commissions, the dramatic differences between the two artists are already visible.

Michelangelo's *Doni Tondo*, his only extant panel painting, can only be described as a tour de force. Like everything the Florentine sculptor, painter, and poet did, this work transformed the genre. The characters were all there—Jesus, Mary, Joseph, and John the Baptist—but the composition was anything but a scene of quiet domesticity. Michelangelo's brilliant hues beckon the viewer like jewels in a display window. Approaching the porthole-shaped frame, a mountain of figures projects into the center of the space. Joseph towers above them all, his voluminous robes enveloping the Madonna and the Child underneath. Both Michelangelo and Agnolo Doni were parishioners at the Franciscan Church of Santa Croce, where Joseph's feast had been kept since its institution in 1479 by Pope Sixtus IV; this probably influenced the surprising iconography.[97] While balding and significantly older than Mary, this Joseph has a powerful

[97] Regina Stefaniak, *Mysterium Magnum: Michelangelo's Tondo Doni* (Leiden: Brill, 2008), 50.

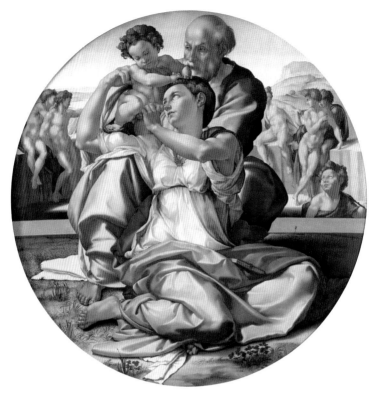

Doni Tondo by Michelangelo

presence, his furrowed brow resembling that of Michelangelo's colossal *David*, completed in Florence just a few years earlier.[98]

Joseph's bearing and placement are regal, his face like that of the Greek philosophers, whose busts were so eagerly collected by the Florentine nobility. Mary is nestled between his knees, a shocking development after centuries of their modest separation, but this placement was chosen to assert the protective virility

[98] Ibid.

of Joseph. Joseph hands the Christ Child to His mother, an energetic baby ready to step into the world. Mary's extraordinary pose (including the risqué bared shoulder) conveys the active cooperation of Mary in the project of salvation. Her body twists, knees pointed toward the viewer, torso turned, arms reaching for her Son. Like an unresolved chord, the tension in Mary's position leaves the viewer uneasy, waiting for her to uncoil, baby in hand, and to place the Savior in the little space in the foreground of the panel.

Michelangelo situates his scene in an outdoor setting, but where Raphael added palms and flowers, Michelangelo inserts a few brown blotches for rocks, a lump of blue for a hill, and a few green wisps as weeds. Instead of flora, the sculptor chose to fill the background with five nude youths, each physically perfect, similar to Greek statues. They languidly gaze at each other, completely self-absorbed in their beauty.

The palette here is subdued, beige and brown like the stone ledge framing them. Little John the Baptist, the last of the prophets, stands at the edge of a parapet, staring in wonder at Jesus. He is in sharper focus yet shares the same color scheme as the background figures, confined to this earlier world. Joseph introduces the new age, his radiant mantle a harbinger of the Light coming into the world. Joseph's role is literally pivotal: where the figures of the background are monochromatic and inward looking, Joseph introduces the color of the New Testament, bringing forth the Savior into the joyous era of the Gospel.

Michelangelo's majestic image of Joseph presaged what Leo XIII would call the "sublime" vocation of the saint, conferred on him not only by his role as foster father of Christ but also through marriage, since, as he wrote, "marriage is the most intimate of

all unions which from its essence imparts a community of gifts between those that by it are joined together."[99] Serving as the Virgin's companion and protector, Joseph became "a participator in her sublime dignity," a quality explored in both Michelangelo and Raphael's works, albeit in the former more forcefully and in the latter more subtly.

The dominant position of Joseph in Michelangelo's tondo also spoke to a growing perception of the preeminence of St. Joseph above the apostles and saints. From the time of Gerson, a teaching had been developing that Joseph, like John the Baptist, had been sanctified in the womb. From there, Jesus' cousin, once the mainstay of tondo paintings, was gradually flanked or even substituted by Christ's foster father, as theologians such as Francisco Suarez, S.J. (1548–1614), began to consider Joseph as belonging to the order of hypostatic union — the union of the human and divine natures in the Person of Jesus Christ. This doctrine proposed that Joseph, like Mary, contributed in an effective way to the Incarnation by accepting his role as spouse of Mary and foster father of Christ. Fortunately, both John the Baptist and Joseph evidently lived by the belief that "He must increase, but I must decrease" (John 3:30), so this good-natured "rivalry" bore only great spiritual and artistic fruits.

A striking work from 1516 shows an early attempt to incorporate the image of divine union with earthly union. Ludovico Mazzolino's (1480–1528) *Holy Family*, now in the Alte Pinakothek in Munich, represents Joseph, Mary, and Jesus seated in a landscape setting, with God the Father gazing at them from

[99] Pope Leo XIII, encyclical *Quamquam Pluries* (August 15, 1889), no. 3.

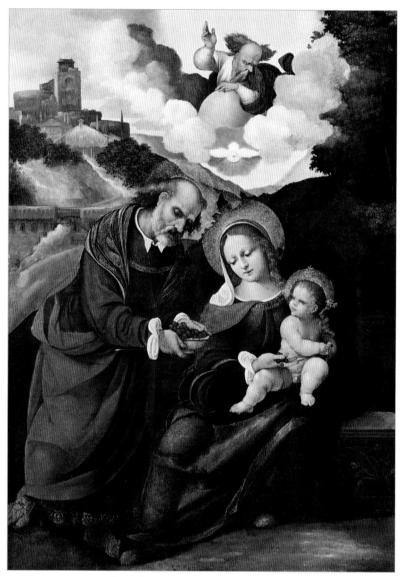

The Holy Family by Ludovico Mazzolino

above. In a surprising iconographical twist, Joseph resembles God the Father, not only with his gray hair, beard, and aquiline nose but even in the positioning of his head.

The Holy Spirit hovers above Mary and Joseph, His wings uniting the pair. Joseph holds a bowl of cherries; Mary has taken a few to give to the Christ Child. Joseph materially provides the fruit to Mary, who holds the Word Incarnate (underscored by the nude fleshiness of the infant). This iconography would be explored more explicitly in the following century by Murillo and others, but Mazzolino's first attempt to illustrate a complex theological teaching demonstrates how the budding discipline of Josephology provided a powerful stimulus to artists.

From the Holy Family at home, to the Holy family in a field, the next setting for the trio was a moment of rest on the Flight to Egypt. The scene of Mary, Jesus, and Joseph peacefully pausing as they escape from Herod's soldiers originated in the fourteenth century, but it took more than a century for the image to become mainstream.[100] In 1475, the "Life of St. Joseph" was added to *The Golden Legend*, firing both popular and artistic imaginations and resulting in the portrayal of new scenes from Joseph's life.[101] The earliest-known *Rest on the Flight to Egypt* is represented on a small panel in the Grabow Altarpiece, produced in Hamburg in 1379 by an artist named Master Bertram. Art historian Sheila Schwartz was the first to note that in this scene, Joseph's gnawing on bread and offering a flask to a nursing Mary was also an early attempt to establish the iconography of Joseph *Nutritor*

[100] Wilson, "Sanctus Joseph Nutritor Domini," 499.
[101] Carolyn C. Wilson, "St Joseph and the Process of Decoding Vincenzo Catena's *Warrior Adoring the Infant Christ and the Virgin*," *Artibus et Historiae* 67 (May 2021): 123.

Domini.[102] Images of this scene, however, did not proliferate until the sixteenth century.

One of the most magnificent versions of the subject was produced by Federico Fiori, aka Barocci (1535–1612), for a friend and patron in Perugia. Barocci, like Raphael, hailed from Urbino, and whereas the latter was a pioneer of High Renaissance painting, Barocci ushered in the new Baroque era in art. His vivacious use of color dazzled the eye and implied movement, as if the scene were happening before the viewer's eyes, yet his brush could suddenly shift to sharp definition, minutely rendering the smallest detail. Art in the post-Tridentine age was intended to make beholders feel, and color, like music, was a powerful vehicle for sentiment.

In Barocci's 1573 *Rest on the Flight to Egypt*, the three figures of the Holy Family dominate the space, revealing the artist's debt to Michelangelo's *Doni Tondo*. Mary's knees bend toward the viewer as she turns to collect some water, but instead of the Florentine's monumentality, the artist from Urbino evokes charm. Secluded in a quiet grove by a running stream, the cheerful serenity of the group is delightful; it seems impossible to imagine that these people are fleeing for their lives. As Mary fills her tin cup (exquisitely contrasted with the golden straw hat and the crusty bread), Joseph and Jesus are engaged in a playful exchange. Joseph is fetching cherries for the smiling toddler while the donkey placidly looks on.

This lovely image is derived from a less than flattering vignette from the apocryphal Pseudo-Matthew, where a truculent Joseph

[102] Sheila Schwartz, "St. Joseph in Meister Bertram's Petri-Altar," *Gesta* 24, no. 2 (March 1985): 154.

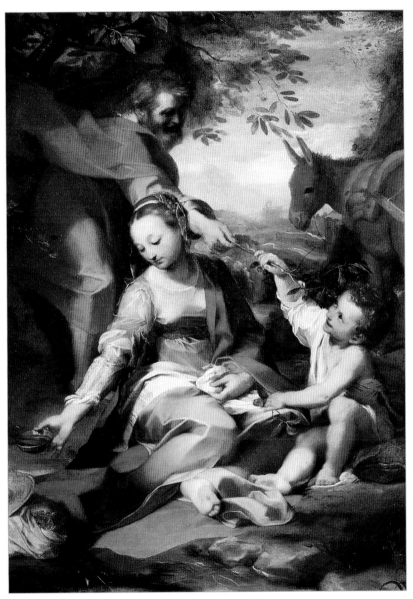

Rest on the Flight to Egypt by Barocci

is irritated with a pregnant Mary for asking for palm dates while he is worrying about water.

Around 1500, this story inspired a lovely English ballad called the "Cherry Tree Carol," in which Mary requests cherries of a petulant Joseph. Barocci, a devout lay member of the newly formed Capuchin Order, transformed the popular song into an inspiring showcase for Joseph as father and provider.[103] Joseph emerges from the shadowy depths of the canvas to reach across the pictorial plane and offer a cherry branch to his Son.

The genius of Barocci's color provokes the viewer to look more closely at the scene. Joseph's flame-colored robes catch the eye so that the beholder might note the wrinkled eyes and wide smile of the doting father, who gazes at his radiant Son, clad in brilliant white. The glistening red cherries dot the scene, contrasting with the cream-colored fingers of the child and symbolizing the drops of blood that will one day be spilled to redeem humanity. The brushstroke flickers over the canvas and appears to freeze this instant with fluttering clothes, quivering branch, trickling water, and the sound of laughter hanging in the air.

Once asked about his painting technique, Barocci quipped, "I am tuning music."[104] This work captures the immediacy of a tune, a moment of sound that vanishes as quickly as it comes.

Music is also central to Caravaggio's (1571–1610) sober *Rest on the Flight to Egypt*, painted around twenty-five years later, and

[103] Elizabeth Lev, *How Catholic Art Saved the Faith: The Triumph of Beauty and Truth in Counter-Reformation Art* (Manchester, NH: Sophia Institute Press, 2018), 145, 280.

[104] Giovan Pietro Bellori, *Lives of the Modern Painters, Sculptors and Architects*, trans. Alice Wohl Cambridge (New York: University Press, 2005), 172.

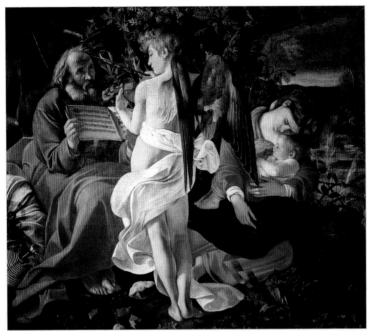

Rest on the Flight to Egypt by Caravaggio

the Milanese painter's first religious work.[105] In his version, the Holy Family seems compressed into the canvas, with a little landscape peeking out on either side of the figures. A still-life painter by training, Caravaggio dwelt on the details of the canvas bag, glass bottle, feathered wings, wood violin, acanthus plants, and parchment paper, setting the scene with familiar everyday objects.

A fourth figure joins the party: an angel, turned toward Joseph, playing music for their pleasure, but also reinforcing Gracián's epithet for the saint: "angelic man."[106] Caravaggio anticipates the

[105] Helen Langdon, *Caravaggio: A Life* (London: Pimlico, 1999), 123.
[106] *Just Man*, 196.

chiaroscuro, or "light and shadow," technique, which would catapult him to fame in a few years, by creating two distinct spaces on either side of the angel. On the right, Mary and Jesus are bathed in golden light, the picture of maternal bliss as they sleep, heads resting lightly together. Behind them, the landscape stretches outward, symbolic of the eternal. Joseph's side is a symphony of shadowy brown, from the donkey's hide to the dirt under his feet.

This persistent association of the saint with colors of soil plays on the Latin word for earth —*humus*— the root of the word *humility* and key to understanding the virtues of Joseph. Behind him, the ass impedes a view of the distance, suggesting the finite nature of Joseph's mission and his eventual death. In this peaceful moment, however, Joseph holds the music for the angel. The piece is a page of a motet by a Flemish composer written in 1519 setting to music "Quam pulchra est et quam decora" from the Song of Songs.[107] This poetic dialogue between Bridegroom and Bride alludes to the marriage between Christ and His Church, but by placing the text in the hands of Joseph, it also speaks to the husband and wife in the scene.

Caravaggio infused the scene with romantic melancholy, fading light tinging Mary's hair with red, yellowing leaves; even Joseph's evident exhaustion, with his elbows resting on his knees, underscores the fleetingness of the moment in a very different fashion than Barocci's work. In his depiction of St. Joseph, Caravaggio evokes mortality and the inevitability of death, but in the Madonna and Child he represents the promise of eternal life. Unbeknownst to him, Caravaggio was preparing the terrain for Joseph to become the model of a good death.

[107] Langdon, *Caravaggio*, 125.

MASTER OF THE *ARS MORIENDI*

⤗ · ◆ · ⤖

Benjamin Franklin famously noted that "nothing is certain but death and taxes," and Robert Bolt observed that "death … comes for us all." For his part, St. Paul asked, "O death, where is thy sting?" (1 Cor. 15:55), and that "every man must do his own believing and his own dying," has been attributed to Martin Luther. From apostles to sages and poets to pundits, all agree that life ends, but the question that loomed large in the sixteenth century was how to confront the inevitable. Christianity promised life after death, and the Catholic Church offered teachings and pious practices to prepare for it, but with the Protestant Reformation, people were faced with choices of what or whom to believe, and the stakes—eternity—were high. What if one chose unwisely?

The faithful needed a leader to guide them into the unknown, and St. Joseph, one of the first witnesses to the Savior to die after the Incarnation, would be called upon by theologians and artists alike to fill this new role.

Art had long been employed to help Christians prepare for the afterlife, particularly in the ubiquitous Last Judgment images, carved on the tympani of Gothic cathedrals or frescoed on

basilica walls. Paintings of the Dance of Death served to remind the carefree young that a plague could be awaiting around every corner, and St. Francis dedicated a stanza of "The Canticle of the Creatures" to "Sister Bodily Death," reminding listeners that from her, "no one living can escape," before cautioning, "Woe to those who die in mortal sin. Blessed are those whom death will find in Your most holy will for the second death shall do them no harm."

The medieval faithful were duly inculcated with the fear of sudden death but needed more instruction in how to prepare the soul for the end of its time on Earth. Dante Alighieri anticipated this need when he recounted the epic fictional journey from Hell through Purgatory to Heaven in his *Divine Comedy*, leaving helpful signposts of "dos" and "don'ts" amid the colorful characters encountered along the way.

A century later, Thomas à Kempis wrote the classic *De Imitatione Christi*, or *The Imitation of Christ*, a handbook of Christian living, and at the same time, another, anonymous, author penned the *Tractatus Artis Bene Moriendi*, a treatise on the art of dying well. The latter is generally believed to be the work of a mendicant, probably a Dominican, and written at the request of the Church Fathers present at the Council of Constance (1414–1418).[108] The treatise was undoubtedly based on the work of Jean Gerson, author of the *Josephina*, whose widely circulated *Opusculum Tripartitum* contained a chapter on dying well. Although Gerson fervently believed in Joseph's special sanctification in

[108] Jeffrey Campbell, "The Ars Moriendi: An Examination, Translation, and Collation of the Manuscripts of the Shorter Latin Version" (master's thesis, University of Ottawa, 1995), 4, https://ruor.uottawa.ca/bitstream/10393/10313/1/MM07840.PDF.

the womb, as well as his heavenly status, there was still a long way to go for him to become the paradigm of a good death.[109]

The Counter-Reformation, wrestling with increasing doubts about saints and sacraments, renewed emphasis on the *Ars Moriendi*, the art of dying well, especially in teaching about the Viaticum, the Eucharist given near death, and the last rites to prepare the soul. St. Robert Bellarmine vigorously promoted the *Ars Moriendi*, producing a handbook of sorts on how to die a holy death. This immensely popular tract insisted that to die well, one must live well, and to live well, one must die to oneself. A life lived in service to the divine will and completed in quiet acceptance found its perfect artistic personification in St. Joseph, soon-to-be model of the Good Death.

The earliest account of the saint's death was recounted at length in the apocryphal *History of Joseph the Carpenter*, purported to be a first-person account of the life of St. Joseph, told by Christ. The story claimed that St. Joseph lived to be 111 years old, and at the end of his life, he was deeply troubled, feeling himself weighed down by sin. Terrified, he cried, "What shall I do when I arrive at that place where I must stand before the most righteous Judge, and when He shall call me to account for the works which I have heaped up in my youth? Woe to every man dying in his sins!"[110]

[109] Paul Payan, "La sanctification *in utero* de Joseph : une proposition gersonienne," *L'Atelier du Centre de recherches historiques* 10 (2012) http://journals.openedition.org/acrh/4246.

[110] *The History of Joseph the Carpenter*, chap. 16, trans. Alexander Walker, in vol. 8 of Ante-Nicene Fathers, ed. Alexander Roberts, James Donaldson, and A. Cleveland Coxe (Buffalo, NY: Christian Literature Publishing, 1886), revised and edited for New Advent by Kevin Knight, https://www.newadvent.org/fathers/0805.htm.

Jesus as narrator, knowing the unrest in his heart, comforted His foster father and His mother, explaining that "assuredly upon all creatures produced in this world the same necessity of death lies; for death holds sway over the whole human race.... And yet ... the death of this pious man, is not death, but life enduring to eternity."[111] A promise of Heaven from the lips of Christ Himself, with the Blessed Virgin as witness: What could provide greater certainty of a glorious afterlife?

Shortly thereafter, death came for Joseph. Death is described in the tale as having "all Gehenna with him, closely attended by his army and his satellites; and their clothes, their faces, and their mouths poured forth flames."[112] Joseph's horror returned, but Jesus manifested His power, driving back demons and summoning the angels Gabriel and Michael to welcome Joseph into Heaven. The remaining eight chapters reflect on the meaning of death after the coming of Christ.

The subject of the death of St. Joseph got off to a slow start, and despite assertions by Bernardino of Siena and Jean Gerson regarding his bodily assumption, images did not appear until the sixteenth century.[113] The emphasis on martyrdom in the early Church likely overshadowed the question of death in less dramatic circumstances, although the frequency of war, devastating disease, and natural disasters kept the fear of sudden loss of life on the forefront of the collective mind. The impetus of the Council of Trent, however, launched an artistic interest in Joseph's death

[111] *The History of Joseph the Carpenter*, chap. 18.

[112] *The History of Joseph the Carpenter*, chap. 21.

[113] Joseph F. Chorpenning, "St. Joseph as Guardian Angel, Artisan, and Contemplative," in *Joseph of Nazareth through the Centuries*, ed. Joseph F. Chorpenning (Philadelphia: Saint Joseph's University Press, 2011), 122.

that resulted in a number of remarkable altarpieces by the end of the seventeenth century. These works, intended to instruct the faithful on how to face death from age and infirmity, gave a new opportunity for artists to flex their compositional muscles.

The Josephine devotee Jerónimo Gracián helped point post-Tridentine painters in the right direction. The Spanish Carmelite's work *Sumario de las Excelencias del Glorioso S. Ioseph, Esposo de la Virgen Maria*, or *Summary of the Excellencies of St. Joseph, Husband of the Virgin Mary*, became a source of inspirations for artists. The first edition, produced in 1596, contained six engravings by Christophorus Blancus depicting the life of Joseph. The final image portrayed the death of the saint in a few stark lines. Joseph lies moribund on a simple cot, the Virgin holding his hand while gesturing toward Jesus. Joseph turns to his Son, gazing into His face as the Savior takes his hand and offers him solace in his final moments. Jesus is in sharp profile, His attention only for Joseph, and behind His head light glows through the grates of a window, reinforcing Christ's promise of eternal life. The writing below affirms Joseph's new role. Translated from the Latin, it reads, "A happy death is the reward of the Just; how great then is Joseph's reward as he dies so happily with his Spouse and Christ."

French painter Jacques Stella (1596–1657) was among the first to tackle the subject in color. Named official painter of King Louis XIV upon his return to Paris after a lengthy Italian sojourn, Stella painted the *Death of St. Joseph* in 1655. The confined composition—flat wooden ceiling and thick stone wall—calls to mind a tomb, a powerful visual metaphor for death. To the left are mementos of the carpenter's industrious life to maintain his family: his workbench is visible through the door, implying that the wooden furniture is his handiwork.

Engraving by Christophorus Blancus in Jerónimo Gracián's
Sumario de las Excelencias del Glorioso S. Ioseph

The ashen Joseph is near death, the slate blue of the bedding accentuating his pallor. He sits up, articulating his fears as he looks hopefully toward Jesus. Mary, on the other side of the bed, clasps her hands, looking with sad compassion toward her agitated husband. One can imagine Joseph saying the words from the apocryphal account: "Indeed, the agony and fear of death have already environed me; but as soon as I heard Your voice, my soul was at rest, O Jesus of Nazareth!" Jesus, in turn, points to Himself, affirming that He is the Savior. The bright clothes of Jesus and Mary contrast with the ghostly grays of Joseph. The red of Christ's tunic (symbolic of His mortal nature) is closest to Joseph's pale body, evoking their shared humanity as well as Jesus' own eventual experience of death. On the other hand, the luminous blue of

Death of St. Joseph by Jacques Stella

His mantle, symbolizing divine favor, is mirrored by Mary's veil. In this painting, Joseph's death is "cushioned" by grace.

Stella also employed echoes of the earlier, Mannerist style of painting, already seen in Rosso Fiorentino's *Marriage of the Virgin*. The distinguishing characteristic of this type of painting was artifice — an element of the unnatural in pose, setting, or color. Stella's two angels, Gabriel and Michael, pose sweetly, their elongated limbs drawing the eye upward, to where the heavens have already opened to welcome Joseph. The fluorescent green of one angel's robes catches the eye and adds a festive touch. From the cold shades of Joseph to the warm luminescence of Heaven, Joseph's death is visualized through light and color as a transition into a glorious place.

A few years later, Carlo Maratta (1625–1713), the leading painter in Rome, produced an altarpiece on the same subject for Empress Eleonora Gonzaga in Vienna. Italian born, Eleonora married the Holy Roman Emperor Ferdinand III Hapsburg and brought her love of art, music, and faith to her new home in Austria. The House of Hapsburg was already nurturing a devotion to St. Joseph, which grew dramatically after 1675, when Ottoman troops threatened Vienna and Emperor Leopold I, Eleonora's stepson, invoked his assistance. The emperor went on to put all of the Holy Roman Empire under the saint's protection, and his son, born three years later, would eventually succeed him as Joseph I.[114] In 1676, Eleonora commissioned Maratta's work for her private chapel of St. Joseph in Hofburg Castle.

Maratta was no stranger to Josephine iconography. His Joseph cycle frescoed twenty years earlier for the Church of St. Isidore in Rome had launched him into the empyrean of Italy's most

[114] Wilson, "Sanctus Joseph Nutritor Domini," 499.

sought-after painters. Maratta was well prepared to produce a deathbed image suitable for the widowed queen.

Twelve feet high and rounded at its apex, the painting appears as an enormous portal. The point of view for the beholder is at the foot of the bed, as if standing at the doorway. Some discarded tools lie on the floor, a quick nod to Joseph's profession, but also a reminder of the transience of the things of this world. Joseph is extended along the bed, his kingly yellow mantle now used as a cover. Mary sits by his side in peaceful contemplation, a lesson in how family members should confront the death of a loved one. The fifteenth-century *Ars Moriendi* dedicated an entire chapter to family members, instructing them how to behave during these final moments. Mary prays for the suffering soul, compassionate yet calm. Friends and relatives were expected to accompany the dying without despair or histrionics in order to protect the soul of the moribund from distractions. Jesus, again in profile, gestures as if speaking, indicating upward. Joseph no longer looks at his family but peers Heavenward, just as the walls dissolve into a cascade of celestial beings who appear to tumble out of the sky to guide Joseph to his eternal reward. The ascension of Joseph is symbolized by the incense billowing out of the ornate thurible and wafting upward. One adorable angel sits on a cloud in the upper left corner, pointing toward Joseph while looking eagerly out of the picture frame. He appears to be readying the welcoming committee to celebrate the arrival of the saint. The solemnity of the death chamber gives way to jubilation in Heaven. Maratta's painting taught the faithful not only how to accept death but also how to minister to the dying—prayerfully, quietly, and peacefully, despite the sadness of separation.

The next generation of painters, following the example of Bolognese artist Giuseppe Maria Crespi (1665–1747), took the

Death of St. Joseph by Carlo Maratta

image in a different direction. Painting the *Death of St. Joseph* in 1712 for Pietro Cardinal Ottoboni, legate to Bologna and great nephew of Pope Alexander VIII, Crespi created a more

brooding atmosphere, omitting overt supernatural festivities. Ottoboni commissioned the work the same year he asked Crespi to illustrate the seven sacraments, his contribution to harnessing art in the service of doctrine.

In his *Death of Saint Joseph*, Crespi engulfs his figures in Caravaggesque shadows. Joseph is portrayed in the last agony of death, stretched out on a low bed with bare feet that protrude unsettlingly toward the viewer. Crespi leaves the space undefined, dark shadows filling the background. No longer a triumphant entry into Heaven, the work seems to depict a final battle with the last temptations that assail the dying, as described in the *Ars Moriendi*. The illustrated text warned of how the devil works hardest at the point of death to steal souls, testing their faith by provoking despair, impatience, pride, and avarice, and it seems as if those demons could be lurking in the murky setting. Angels in subdued tones emerge from the shadows, praying or conferring quietly while one gently cradles Joseph's head. They appear to fulfill the task described in the *Ars Moriendi* of providing "good inspirations" to defeat the encroaching vices.

The viewer is positioned to stand vigil at Joseph's feet. A tearful Mary, clasping a handkerchief, prays at what looks to be a makeshift altar. The glass jar on the table contains oil, an allusion to Extreme Unction. Crespi's skill as a still-life artist is visible in the exposed corner of a worn mattress and in the rendering of the carpenter's tools abandoned by the bed. The flowering staff, however, symbol of his chaste marriage, still blooms.

The old man, close to death, lies silent, comforted by Jesus, who, in the *History*, "held his hand for a whole hour."[115] Joseph

[115] *The History of Joseph the Carpenter*, chap. 19.

Death of Saint Joseph by Giuseppe Maria Crespi

receives the final blessing from Christ and, thus prepared, ends his earthly sojourn.

In the Roman world, the death of a father in a famous family was accompanied with parades, games, and speeches. Yet

the passing of Joseph, descendant of kings, goes unmarked in Scripture. The *res gestae* of his life would not look as lofty as that of an imperial general with titles and conquests: Joseph sired no children of his own, toiled much for little money, and made only one foreign trip. And thus, the privileged death of Joseph gave hope to the millions who lived and died working hard and raising families, without the perks of "bucket lists" or "fifteen minutes of fame." Even without earthly fanfare, they, too, could aspire to a joyous welcome in Heaven.

William Blake (1757–1827), illustrator extraordinaire of Milton's *Paradise Lost* and Dante's *Divine Comedy*, produced a powerfully personal version of the *Death of Saint Joseph*. As unique as it is lovely, it deserves a moment of attention.

Blake, a devout Christian, was fascinated by the mystical. Unlike the earlier artists who peppered their works with props and details from everyday life, Blake depicted an ethereal vision. In an 1803 watercolor, Joseph lies on a long bier, his head softly nestled in the luminous lap of the Virgin. Jesus hovers over him, almost as if drawing out his soul to convey it to Heaven. The trio are enclosed in a colorful arc of angels: a rainbow bearing the promise of peace. The work seems to presage Blake's own death, twenty-five years later; witnesses said that "Just before he died His Countenance became fair. His eyes Brighten'd and he burst out singing of the things he saw in Heaven."

In allowing people to witness his death, St. Joseph performed a significant service to the Church. While in earlier ages, death was so frequent and public that lay confraternities dedicated themselves to the collection and burial of bodies abandoned on roads or fields, as time wore on, death became more hidden and consequently much lonelier.

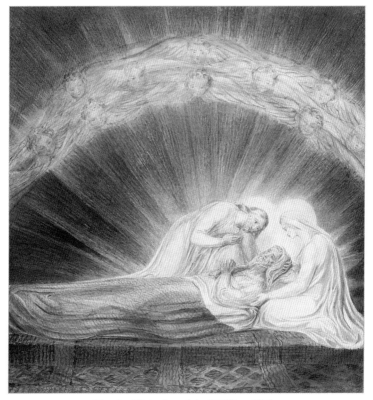

Death of Saint Joseph by William Blake

Thomas Howard, author and Catholic convert, reflected on the dying who were neatly secreted away in hospitals, hidden from the bustle and business of the living. He wrote, "Only a thickness of brick and plaster separates the lovely tree-lined street with its Georgian houses and iron balconies from the antiseptic hush where people moan out their last hours in emaciated agony. An intruder has visited them, and they must succumb to the outrage. They have other, more important things which they ought to be doing, but someone has thrust upon them the task of dying,

and they must comply."[116] The tyranny of death grows when its existence is denied, allowing it to upend the complacent and lead them to terror and despair.

St. Joseph, in his endless versatility, brought death into the home, onto the altar, and into museums, placing the reality of mortality before the eyes of believers and nonbelievers. At the same time, he showed the moribund an exemplary path of how to die with dignity, no matter what their social status or circumstances. St. Francis de Sales, a fervent promoter of Joseph as the patron of a happy death, asked, "How much sweetness, charity and mercy, did this good foster-father use towards our Savior, when he was born ... and who can then believe but that, at his departure out of it, this divine child rendered him the like a hundred-fold, filling him with heavenly delights?"[117]

St. Joseph democratized the art of dying well for all, perhaps the greatest universalizing factor for this saint whose fame was about to penetrate new lands and new hearts.

[116] Thomas Howard, *Christ the Tiger* (Eugene, OR: Wipf and Stock, 1990), pt. 3, 123.

[117] St. Francis de Sales, *Treatise on the Love of God* (Grand Rapids, MI: Christian Classics Ethereal Library, 2020), 275, http://hosted.desales.edu/files/salesian/PDF/love.pdf.

MISSIONARY MAN

In 1679, Joseph went "viral," to use a modern term. Beloved in Spain, thanks to the Carmelites, venerated in the Holy Roman Empire through the Hapsburgs, revered in Rome by the popes, had Joseph been like Alexander the Great, he might have wept at the end of the sixteenth century that "there were no more worlds to conquer." But, in Joseph's case, his dominion increased exponentially when seventeenth-century missionaries chose him as patron for their far-ranging feats of evangelization.

Truth be told, Joseph's missionary spirit could already be discerned as far back as the first mosaics in Santa Maria Maggiore, where he introduced Christ to the Egyptians at Sotinen-Hermopolis and presented the exotic Magi to the enthroned Savior. And as noted by art historian Carolyn Wilson, the enigmatic Joseph pensively gazing at a kneeling warrior in Ottoman garb in a 1520 painting by Vincenzo Catena might well signify his promotion of conversions.[118]

In 1522, Dominican preacher Isidoro Isolani completed his *Summa de Donis Sancti Joseph*, or *Summary of the Gifts of St. Joseph*,

[118] Wilson, "St. Joseph and the Process of Decoding," 126.

in which he urged the reigning pope, Hadrian VI, to expand the devotion to St. Joseph, promising it would "bring peace to war-torn Italy, and—in the cause of global peace—would spread the name of Christ to barbarian, Muslim, and Jew."[119] Joseph was thus poised to travel through the Mediterranean and beyond.

By 1679, King Charles II of Spain had invoked St. Joseph as protector of the monarchy, a declaration that served as a passport for Catholicism's favorite father to journey to the mission territories. In the wake of the Franciscans, Joseph became the patron of Mexico, Peru, and Canada, and, thanks to the Jesuits, his fame spread as far east as New Zealand, which is also under his patronage.

Alongside devotion came art. Joseph, who had proven to be so versatile in the Western artistic tradition, showed the same malleability overseas. Art was favored by missionaries as a means to overcome language barriers, so missionaries commissioned paintings and sculptures to bring with them to teach, delight, and persuade potential converts. Eventually the native peoples learned the artistic techniques, and indigenous art schools were born.

The Diocese of Lima in Peru was founded in 1546 in the midst of the Protestant Reformation. In 1580, it welcomed Spanish prelate St. Toribio Alfonso de Mogrovejo, who traversed all of his enormous diocese, spreading his piety every step of the way. He also sent the first student from the Americas to study in Italy: Diego de León Garavito attended the University of Bologna in 1601. The lively faith of Peru soon produced indigenous Catholic painters and native styles, the most famous known as the Cuzco School. Working from about 1650 to 1780, Cuzco painters created

[119] Wilson, "St. Joseph and the Process of Decoding," 123.

a trademark style based on local symbolism, bright colors, and copious use of precious gold leaf.

Among the most popular commissions were portraits of saints to be kept in the home. A transatlantic version of the Holy Family tondos, images of Jesus, Mary, and Joseph proliferated in domestic settings. St. Joseph also enjoyed extraordinary artistic status, with hundreds of works celebrating him as exemplary man, father, and husband. His popularity was such that sixty-three religious festivities still exist in his honor in Peru![120]

The Cuzco painters, who, unlike their European counterparts, remained anonymous, formulated an innovative look for Joseph in his new land. *Saint Joseph and the Christ Child*, now in the Brooklyn Museum, is a remarkable example of the new Josephine iconography, a happy fusion of Old World with the New. It is easy to see the influence of Spanish Baroque painters such as Murillo in the youthful face of Joseph and in his protective stance while he leads the Christ Child. The landscape, too, with its atmospheric perspective, resembles Flemish painting. Yet despite the European features of the sacred pair, the work proclaims its Peruvian roots. The painters do not apply perspective to the figures, their flat rendering resembling cutouts on a page. The robes of both Jesus and Joseph are dazzling in their intricacy. The Incas were extraordinary artisans, long before the arrival of the Spanish, specializing in textiles and gold smithy. The gowns of both figures depict "Cumbi" cloth, finely woven fabrics of cotton and alpaca reserved for rulers. They are decorated with a pattern of *estofado*, rococo designs tooled into gold leaf, thus adding an

[120] Jenny Mori, "St Joseph in Peruvian Culture," in *Journeying with Joseph: Josephite Essays for the Year of St Joseph*, ed. Mary Cresp, R.S.J. (Adelaide Australia: ATF Theology, 2021), 215.

extra element of luxury intended to underscore regality.[121] Keeping with the kingly imagery are the red Incan sandals on Jesus' feet. The bell-shaped robe was a multivalent symbol in the Cuzco School. It evoked "dressed statues," wooden figures clothed in wide skirts placed in churches or carried in procession during displays of public piety. It also recalled the peak of the Pachatata Mountain, the "Father Earth" pendant to the Pachamama "Mother Earth" formation, on the island of Amantani in Lake Titicaca, both revered by the indigenous people.

The radiance of their faces, accentuated by the golden rays of the halos, would equate these figures, in the minds of viewers, with the sun. Inca legend held that the first of their people was called Manco Capac. Son of the sun god, Inti, and founder of Cuzco, he traveled with a golden staff.[122] The love of the mythological founder was rechanneled to Jesus, the Light of the World, and to Joseph, who leads Christ to the New World as he once led Him into Egypt. Jesus also holds a woven basket filled with carpentry tools, an image designed to extol the sanctifying virtue of honest labor.

The birds and the flowers reflect the natives' love of their land. Birds, regarded as messengers between earth and the heavens, might allude to Joseph's communication with angels, the messengers of God. The lily, known as the *nukchu*, symbolizes the sacred "chosen" women of the Incas—an allusion to Joseph's care of Mary, the chosen Mother of God.[123] Images like these were often kept in bedrooms to inspire husbands and wives to

[121] Carol Damian, "The Survival of Inca Symbolism in Representations of the Virgin in Colonial Peru," *Athanor* 7 (1988), 22.

[122] Charlene Villaseñor Black, *Creating the Cult of St. Joseph: Art and Gender in the Spanish Empire* (Princeton: Princeton University Press, 2006), 30.

[123] Damian, "The Survival of Inca Symbolism," 22.

Saint Joseph and the Christ Child by the Cuzco School

constancy and fidelity in marriage. In Lima, Joseph's powers ap-
parently extended even to assuaging jealous spouses!

Jesus holds his hand while looking outward, inviting the newly
evangelized natives to "go to Joseph," the hard worker, faithful

husband, loving father, disciplined man, and avatar of the distant Vicar of Christ on Earth.

Twenty-six hundred miles to the north, Joseph was also winning hearts in Mexico. The first Franciscans to arrive in the country inculcated the love of this strong, silent saint as early as 1555, making Mexico the "chosen land of Saint Joseph."[124] There he displaced the god Tlaloc, the divinity of rain, who ensured the fertility of the land while protecting its people from natural disasters.[125] In that land, St. Joseph assumed the duty of rescuing people caught in storms, a throwback to his first miracle for the friars shipwrecked off Flanders.

Joseph's role as protector is evident in a 1753 painting by the celebrated native Mexican artist Miguel Cabrera (1695–1768). Born in Oaxaca, Cabrera spent fifty years of his successful career in Mexico City, where, thanks to the patronage of Archbishop Manuel José Rubio y Salinas and the Jesuit Order, Cabrera became the most famous artist in the Americas. His 1753 painting was executed for a church in Tepotzotlán, taking familiar Marian iconography and applying it to her spouse.

In this surprising work, Joseph, looking startlingly like Jesus, wears a shining silver robe with floral tracery that mirrors the lily in his hand, underscoring his purity. He spreads his arms to create an enclosure inside his broad cape. This gesture was traditionally used for images of the Madonna of Mercy, protecting all those who gather under the mantle of the Virgin, but in this painting, the same power passes to Joseph. Unlike in Marian

[124] Joseph F. Chorpenning, *Mexican Devotional Retablos from the Peters Collection* (Philadelphia: Saint Joseph's University Press, 1994), 41.

[125] Black, *Creating the Cult of St. Joseph*, 30.

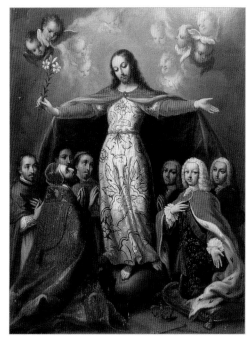

The Patronage of Saint Joseph by Miguel Cabrera

images, the kneeling figures under Joseph's wings, as it were, do not come from every walk of life: clerics gather on his right and state officials on his left. Pope Clement XIV, his tiara barely visible before him, and King Ferdinand VI of Spain (crown prominently placed) are in the foreground, with the local viceroy and Cabrera's archbishop patron in the background. The work unites Church and state under the protection of Joseph. As scion of kings and foster father of the Word Incarnate, Joseph was ideally situated to mediate between the temporal and the divine, but Cabrera placed a stronger emphasis on his ecclesiastical relationships. Pope Clement XIV, who was clean shaven, is shown bearded, creating a greater visual similarity between him and Joseph. The

papal mantle is the same material as that of the saint, a reminder of the pope's responsibility to keep these distant people under his protective arm. Joseph holds his lily above the heads of the clerics, calling them to higher service, his outstretched hand toward the statesmen, inviting them to generosity and outreach. The gaze exchanged between the saint and the pope suggests that Joseph, model caretaker of the Holy Family, is exhorting the Holy Father to extend the same care to the family of faithful.

Joseph's journeys were not limited to the West. The vigorous missionary spirit that brought the Jesuits to the East also carried Joseph to Asia. St. Ignatius of Loyola, like Isidoro Isolani, recognized Joseph's pivotal intercession in conversions and founded the Confraternity of St. Joseph in Rome in 1540. It soon spread to many other cities, its primary function to foster conversions among both Muslims and Jews.[126] As the Jesuits headed East, they brought Josephine devotion to China, Vietnam, Japan, and Cambodia, installing him as patron in each country. Eventually St. Joseph became patron of the Asian missionary effort, a hair's breadth from a dedication as patron of the universal Church. The Jesuits were remarkably effective in converting large swaths of the populations, but the backlash from the authorities was devastating. Along with numerous martyrs, enormous numbers of Christian artifacts were destroyed, leaving only the tiniest artistic trail of what had once been a thriving area of evangelization. In a strange twist of fate, it would be the Cuzco School that immortalized the dramatic witness of the martyrs of Nagasaki, shown under the protection of St. Joseph.

The Jesuit mission to Japan began with great success, converting more than 300,000 people by the end of the sixteenth

[126] Joseph P. Byrne, *The World of Renaissance Italy: A Daily Life Encyclopedia* (Greenwood ABC-CLIO, 2017), vol. 1, 370.

century.[127] Trouble soon brewed with the samurai lord Hideyoshi, and on February 5, 1597, 26 Christians—6 Franciscans, 3 Japanese Jesuits, and 17 Japanese laymen, including 3 young boys—were crucified and impaled in Nagasaki. Persecutions intensified, and in 1622, 205 Christians were martyred, followed, on July 23, 1626, by the burning of a "mountain of books" used for evangelization.[128]

There were several commemorations of these martyrdoms in art. In Italy, Tanzio da Varallo produced an altarpiece in 1627, the year of the martyrs' beatification. Another contemporary work survives from Japan, but the painting that best ties the martyrs' suffering to their heavenly reward was painted in Lima in the eighteenth century.

The martyrs are arrayed along the canvas with no attention to depth or perspective, although a Flemish-style atmospheric landscape with blue-tinged structures is visible between the bodies. Each martyr is given a nametag for easy identification. Cherubs gambol around the crosses, depositing crowns of glory or delivering palms of victory to the new heroes of the Faith. The Franciscans and the Jesuits wear their respective habits (although the indigenous martyrs look more Incan than Japanese), and they all gaze upward as they offer their lives. One little figure collects blood from the feet of the youngest martyr, the twelve-year-old Luis Ibaraki, a holy relic. Only three denizens of Heaven join the exalted group. One is St. Peter of Alcantara, a Spanish Franciscan beatified in 1622, who points toward one of his brothers to indicate that the martyred friars were Alcantarines, members who had chosen to follow the saint's rigorous reforms. St. Peter,

[127] Fr. Alessandro Valignano, S.J., reported this number in 1596 published in R. Wernham, *The New Cambridge Modern History* (Cambridge: Cambridge University Press, 1968), vol. 3, 552.

[128] J. F. Moran, *The Japanese and the Jesuits: Alessandro Valignano in Sixteenth Century Japan* (London: Routledge, 1993), 145.

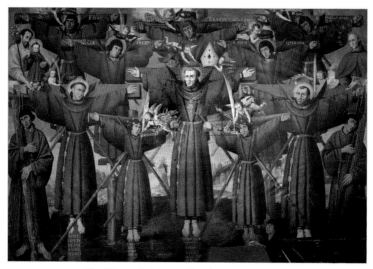

The Nagasaki Martyrs by the Cuzco School

like his close friend St. Teresa of Ávila, had placed his reformed congregation under the patronage of St. Joseph.

In the upper right of the work, the Christ Child (wearing a Franciscan habit!) looks upon the martyrs from the arms of St. Joseph. Joseph, dressed in white, is depicted as young and virile and holds his staff in full bloom. He directs attention to Philip of Jesus, a native of Mexico and the only martyr of the group from the Americas.

Baby Jesus holds the orb of the world as He presides over the scene, drawing together East and West in suffering and uniting the whole world in His redemptive sacrifice. The vast harvest of souls would need a universal caretaker, a father figure to guide them to safety amid the onslaught of dangers in the centuries to come.

HE'S GOT THE WHOLE
WORLD IN HIS HANDS

The eighteenth-century Church encountered plenty of obstacles in her evangelizing abroad, but the perils looming in her own backyard were equally challenging and carried consequences that persist even to this day. The efforts of many Enlightenment thinkers and politicians to bring about the secularization of Europe laid the foundations for the bloody purges inflicted by the French revolutionaries. Many laypeople as well as clerics renounced religion during the Reign of Terror, which forced priests to violate their vows of celibacy or be executed, redacted churches to pagan deities, and massacred thousands of citizens for their faith. A stalwart few held strong in the face of death, notably the Carmelite nuns of Compiègne. The faith-filled courage of these daughters of St. Teresa of Ávila's reform awed the crowds at their death by beheading in 1794.

The authority of the popes was openly defied by secular powers. Bullied by Holy Roman Emperor Joseph II, who, among other things, suppressed contemplative orders, and arrested by Napoleon, the pontiffs were losing their prestige on the international

political stage. With its sphere of influence shrinking by the day, the papacy was horrified to discover that unification efforts of Italy, its home turf, included plans for the capture of Rome, the See of St. Peter.

A tsunami of secular forces threatened to overwhelm the barque of Peter, sweeping away the very seat of the Church. Vocations dwindled, and popular revolts forced the popes to flee for their lives. The faithful were cast adrift to cling to the flotsam of "freedom" from ecclesiastical "rules." Global turbulence called for a steady hand at the helm. St. Joseph, with his centuries of experience, was ready for the task at hand.

Gregory XVI (1831–1846) encouraged the faithful in those turbulent times to "go to Joseph," by promoting "the Seven Sundays," a special devotional practice. This series of prayers had first been proposed in the sixteenth century, when two Capuchin friars who were saved from shipwreck off the shore of Flanders attributed the miracle to St. Joseph. Giovanni da Fano, who first recounted the story in 1536, relayed Joseph's wish that the friars recite seven Our Fathers and seven Hail Marys every day in remembrance of his sorrows. With the Catholic boat being tossed on the high seas of secularism, this pious practice was extended by dedicating the seven Sundays before March 19 to the joys and sorrows of St. Joseph. On January 22, 1836, Pope Gregory XVI granted indulgences to all those who performed the devotion, with the result that Joseph accompanied the faithful from the feast of the Presentation to his own day of commemoration.[129]

[129] Larry M. Toschi, O.S.J., "Part B—Other Official Recognition of Devotions," Oblates of St. Joseph, https://osjusa.org/st-joseph/liturgy/part-b-other-official-recognition-of-devotions/.

After weathering the Avignon exodus, three simultaneous popes, the sack of Rome, and the invasion of the French, the final blow to the Papal States came on September 20, 1870, when Rome was wrested from the pope by the soldiers of the Italian unification movement. At over a century of distance from the event, one might look upon the seizure in a positive light as Joseph Cardinal Ratzinger did. The future pope reflected that papal sovereignty had once filled the need for a "kind of spiritual independence that did not subject the pope directly to political authorities" but then noted that "the Papal States grew out of this situation, bringing with them many disastrous associations, until they were finally lost in 1870 — thank God, we would have to say today."[130] For the Catholics at the time, however, it seemed like the end of the world.

Bl. Pope Pius IX, exiled within the walls of the Vatican, without radio, television, or Internet, and with hostile journalists crowing over the end of papal sovereignty, deployed the most formidable search-and-rescue team he could muster. On the feast of the Immaculate Conception, the dogma he had declared sixteen years earlier, Pius IX consecrated the Church, scattered and frightened, to St. Joseph. Chased from his home, laden with the enormous responsibility of caring for the Savior and His glorious mother, Joseph would know how to protect the Catholic family even in these uncharted historical waters.

The decree acknowledged "these most troublesome times [when] the Church is beset by enemies on every side and is weighed down by calamities so heavy that ungodly men assert

[130] Joseph Cardinal Ratzinger, *God and the World: A Conversation with Peter Seewald* (San Francisco: Ignatius Press, 2002), 382.

that the gates of hell have at length prevailed against her."[131] Therefore, in response to the prayers of prelates and laypeople alike, Pius IX "solemnly declared him [Joseph] Patron of the Catholic Church."[132]

St. Joseph's increased spiritual purview was celebrated in a lovely altarpiece painted by Guiseppe Rollini (1842–1904) for the Church of the Sacred Heart in Rome. The building began on land purchased by Pius IX with the intention of dedicating a church to Joseph, but the project was halted when the pope found himself a "prisoner of the Vatican." With help from St. John Bosco, who was deeply devoted to the saint, the church was completed under Pius' successor, Leo XIII. The Salesians consecrated a special altar to Joseph, where, in 1893, Rollini would unveil one the first images of Joseph as patron of the universal Church. Rollini, orphaned as a child, had been taken in by Don Bosco and encouraged to study art. With the personal support of the saint, he became the one the foremost painters of the day.

Working for his friend and benefactor on an image of his name saint seems to have inspired Rollini to new artistic heights. A soft, peaceful light fills the pictorial space, a welcome solace in the stormy revolutionary times. St. Joseph dominates the composition, standing majestically in the center of the canvas. He is swathed in gold and white robes, evoking the colors of the papal flag. Mature, but certainly not elderly, he raises his hand in blessing toward the model of St. Peter's Basilica presented to him by a kneeling angel. Joseph cradles the Christ Child easily

[131] Pope Pius IX, decree *Quemadmodum Deus* (December 8, 1870), Oblates of St. Joseph, https://osjusa.org/st-joseph/magisterium/quemadmodum-deus/.

[132] *Quemadmodum Deus.*

Joseph, Universal Patron by Giuseppe Rollini

on one arm, while Mary prays slightly behind him. She appears solemn yet calm; with her hands on her heart, Mary recalls the sorrow of Christ's Crucifixion, that sadness now directed toward the suffering Church. A modern *Stabat Mater*, she evokes the

beautiful thirteenth-century hymn to the Virgin watching the death of her Son from under the Cross. Framing her in the background are three angels to represent faith, hope, and charity, the theological virtues. Holding a little blue orb surmounted with a golden cross, Jesus, Savior of the World, turns to engage viewers directly, pointing to His foster father and instructing all to "go to Joseph." To underscore this injunction, the same words are written on the banner held by the radiant angels above. Gentle yet authoritative, Joseph is ready to respond to the cries of a Church struggling in the industrial, nationalistic, revolutionary age.

Eventually, Joseph even crossed the channel to England. The vigorous promotion of Joseph in mainland Europe during the seventeenth century had bypassed the British Isles, due to the intense persecution of Catholics in the wake of King Henry VIII and Queen Elizabeth I. From the Glorious Revolution in 1688 to the Catholic Relief Act of 1791, Catholics were prohibited from owning property, and priests were banned from executing their faculties openly. But the nineteenth century saw the formation of Catholic dioceses and the flowering of new churches. In 1844, the Jesuits built on Farm Street in London the Church of the Immaculate Conception, an elegant neo-Gothic building designed by Catholic architect Joseph John Scoles and filled with splendid works of devotional art. Immediately after Pius IX's declaration of St. Joseph's patronage, architect Henry Clutton added a new chapel dedicated to the saint and commissioned a statue of Carrara marble to grace its altar.

The work fuses two of the most famous and favored artistic styles among the English: Greek classicism and medieval Gothic. The balanced proportions and air of restraint—not overly emotive, yet not devoid of sentiment—strike the aesthetically pleasing harmony perfected in ancient Greek art. The soft draperies,

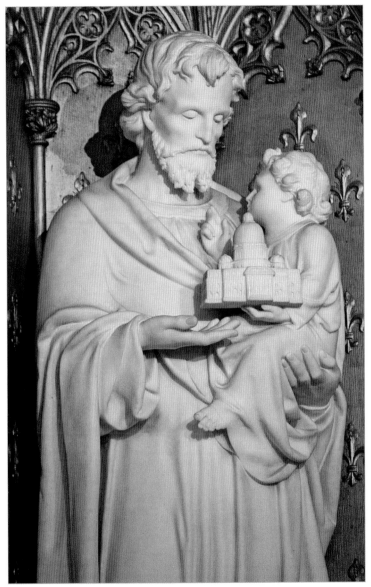

Statue of St. Joseph and the Christ Child,
Church of the Immaculate Conception, London

however, never intended to showcase anatomy but to lead the eye gently around the work, come from the tradition of Gothic cathedral sculpture. The sweetness of the scene, exemplified in the filial affection captured by the unknown artist as Jesus blesses His father while entrusting him with His Church, is also a medieval trait. The pure-white marble against a golden background flecked with lilies in relief serves as an innovative way of suggesting Joseph's best-known attribute. This composition also flies the papal colors, a fitting gesture on the part of the Jesuits, who make an oath of allegiance directly to the pope.

The most illustrious of commissions to represent St. Joseph as patron of the universal Church was, unsurprisingly, made for St. Peter's Basilica. In 1891, Francesco Grandi presented Pope Leo XIII with the monumental painting of *St. Joseph and the Christ Child*. Roman by birth, Grandi had worked for Pope Pius IX on the project of redecorating St. Paul Outside the Walls, destroyed by fire in 1823. After the unification of Italy, he remained close to the papacy, directing the mosaic studio inside the Vatican walls.

Grandi's painting is sumptuous, riveting, and powerful. No longer cushioned by clouds or set against golden light, Joseph is framed in a stone arch, reminiscent of the triumphal arches erected by Roman emperors to celebrate their military victories. The surface decoration is executed in *cosmatesque*, a style invented in Rome in the twelfth century by the Cosmati family. The technique used semiprecious stones brought to Rome from all over the world during the imperial era—stones that had crumbled as the pagan empire fell. These fragments were sourced by the Cosmati and arranged into intricate patterns to cover floors, altars, tombs, and walls. Not only lovely to look at, the technique also had a deeper symbolic meaning: the Romans had taken the stones from their subject nations to proclaim their

St. Joseph and the Christ Child by Francesco Grandi

vast dominion; after their implosion, the Christians picked up those pieces to unite the world under Christ.

The Roman symbolism is also evident in the two columns flanking Joseph and the Christ Child. Their twisting design recalls the curving Solomonic columns that surround the tomb of St. Peter. These columns flank a *cattedra*, or throne, the seat of authority of the bishop of Rome. The message seems to suggest that the pope may be imprisoned within the Vatican walls, but no one can confine Joseph. Joseph occupies the center of the composition, three disks surrounding his halo. The topmost circle is of porphyry, the rare Egyptian purple stone used only for royalty. Above his head, the inscription, taken from Genesis, reads, "You shall be in charge of my palace," the words spoken by the pharoah to the Old Testament Joseph. Once again, the foster father and the patriarch are conflated, but this time to assert the newly expanded authority of St. Joseph. Where the pharaoh once told Joseph, "All my people shall order themselves as you command; only as regards the throne will I be greater than you" (Gen. 41:40), Jesus now confers the same authority upon the man who cared for Him from birth. This manly Joseph, with his intent gaze focused on those gathered at the altar, steps forward, ready to accompany his charges and to throw his protective mantle around his imperiled children.

Today this work, one of the most powerful and beautiful images of Joseph, can be found in the sanctuary of the Blessed Virgin in Ossuccio on Lake Como, where it was sent as a gift by Pope St. John XXIII.

Another contemporary, Paul Claudel, French poet and Catholic convert, was deeply devoted to St. Joseph, who, he felt, could help the faithful navigate the onslaught of Nazism, nihilism, and communism that the twentieth century would bring. Though not

a visual artist like his sister, sculptor Camille, Paul employed the beauty of words to pay homage to his beloved saint. These lines seem to evoke in verse what Grandi's brush did in paint:

> Joseph enters with a deep sight into conversation
> with God.
> He preferred Wisdom and she had been brought
> to him for marriage.
> He is as silent as the earth when the dew rises,
> He feels the fullness of night, and he is at ease
> with joy and with truth.[133]

With his new title and expanded authority, Joseph was more than equipped to intercede in the approaching age of thorny modern conflicts.

[133] Paul Claudel, "St. Joseph," trans. Wallace Fowlie, *Poetry* 87, no. 3 (December 1955): 140.

Chapter 13

THE LABORS OF ST. JOSEPH

Much of modern history has been written against the background of changes in the world of work. Poor labor conditions and unemployment plagued the industrial age of the nineteenth century, fueling many of its revolutions. Debates raged in bars and ballrooms and across the barricades in the Paris Commune over such matters as whether and how labor relations should be regulated and whether the state should control all employment.

Between Adam Smith and Karl Marx lay a sea of differing theories, but how was a Catholic to navigate between the shoals of unfettered capitalism and the authoritarian oppression of communism? Amid this confusion and conflict, St. Joseph emerged in what might be described as his finest hour.

For his part, deeply concerned with the rise of communism, Pope Leo XIII wrote the encyclical *Rerum Novarum*—also known as "On the Conditions of Labor"—to address the dangers of nascent socialism. In the encyclical, the pope asserted the dignity of those who live by labor, those often disdained by the wealthy or aristocratic classes, by using the model of Joseph's work. Leo noted that Christ Himself "chose to seem and to be considered the son of a carpenter—nay, did not disdain to spend a great

part of His life as a carpenter Himself. 'Is not this the carpenter, the son of Mary?' (Mk. 6:3)."[134]

Pope Leo devoted an entire encyclical to St. Joseph, *Quamquam Pluries*, opening a path that future popes would follow, dedicating apostolic letters and exhortations to him. Besides echoing familiar thoughts on the saint's singular virtues, Leo XIII invoked the saint as a steady guide amid the religious and social crises of his day, imploring the poor to take St. Joseph, not socialists, as their guide in seeking justice. For workmen, the pontiff wrote, "recourse to Joseph is a special right, and his example is for their particular imitation."[135] This spirit of the dignity of labor also found an outlet in the arts, with several new, beautiful images to uplift the nobility of those who work.

Leo XIII was not the first to celebrate Joseph's industrious spirit. Back in 1540, under the pontificate and with the approval of Pope Paul III, Roman woodworkers formed a lay confraternity for charitable activities and dedicated it to St. Joseph. The first of its kind, the Venerabile Arciconfraternita di san Giuseppe dei Falegnami, was installed in a church built above the Mamertine Prison, the site where St. Peter had been held before his execution. The confraternity of St. Joseph enjoyed such esteem that other branches were formed throughout the Italian peninsula, and the brothers were accorded a singular honor. Every year, one prisoner condemned to death was remitted into their custody to learn a trade and seek rehabilitation through honest work.

As a prosperous association of successful men with a prestigious site for their headquarters, the confreres turned their space

[134] Pope Leo XIII, encyclical *Rerum Novarum* (May 15, 1891), no. 23.
[135] Pope Leo XIII *Quamquam Pluries*, no. 4.

of worship into a place where they displayed their professional skills. Elaborate wood carvings decorated the church, with a special focus on the oratory, where the members prayed and made corporate decisions together. There, the carpenters of Rome created their masterpiece, a coffered gilt ceiling with stories of Joseph carved throughout. The exquisite central panel portrayed the marriage of Joseph and Mary, an artistic way of enjoining the laymen of the fraternity to be good husbands, providers, and craftsmen.

Carving in the Oratory of San Giuseppe dei Falegnami

The exhortation for men to be productive workers, loving husbands, and engaged fathers found its greatest visual representation in Murillo's *Holy Family with a Bird*, painted around 1650 and housed today in Madrid's Prado. At 4.7 feet by 6 feet, the canvas was surprisingly large for a work that was not intended as an altarpiece, perhaps destined for a wealthy home. Murillo composed the scene in a similar fashion to the Holy Family paintings of the Renaissance. The three figures are grouped tightly together with the parents focused on the Christ Child. But instead of placing the family in a field, Murillo enclosed them in Joseph's small, slightly cramped workshop. The mélange of living and workspace not only suggests their poverty but also emphasizes the domestic intimacy of the husband, wife, and child. Both parents are at work. Mary winds yarn, using a spindle probably made by her husband. A woven basket of laundry waits on the floor. Joseph's modest workbench, with his awl and saw, is visible in the background. Joseph seems to be making a yoke, probably a reference to Justin Martyr, who wrote that Jesus, Son of Joseph the carpenter, learned his father's trade and "was in the habit of working as a carpenter when among men, making ploughs and yokes; by which He taught the symbols of righteousness and an active life."[136] Joseph's lifetime of quiet toil was his yoke, his manner of assisting his Son's work of salvation.

Murillo, however, chose to depict a moment of pause from work, with spindle and tools momentarily forgotten as the couple

[136] Justin Martyr, *Dialogue with Trypho*, chap. 88, trans. Marcus Dods and George Reith, in vol. 1 of Ante-Nicene Fathers, ed. Alexander Roberts, James Donaldson, and A. Cleveland Coxe (Buffalo, NY: Christian Literature Publishing, 1885, revised and edited for New Advent by Kevin Knight, https://www.newadvent.org/fathers/01286.htm.

delights in their cheerful Son, who is playing with a bird. Jesus, nestled against Joseph's knee, teases the adorable family dog by holding a goldfinch high above it. The dog, traditionally a symbol of loyalty, waits patiently with one paw raised, eyeing the goldfinch, often used to represent Christ's Passion. The diagonal composition leads the eye to Joseph, now a protagonist of the scene, with the Virgin receding into the background. Joseph would seem to be pointing out the animal's patient fidelity, a parallel to his own steadfast devotion.

The influence of Flemish art permeates the painting in the details of daily life and the simplicity of the figures, portrayed without halos or attendant angels. This family could almost be any family, and the simple joy they evince appears attainable by all. Only Murillo's light reveals the specialness of the group: the

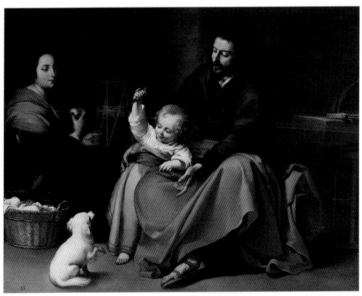

The Holy Family with a Bird by Bartolomé Esteban Murillo

golden-haired Christ Child seems to be the source of illumination for the family, the Son around whom they orbit.

The Baroque era produced numerous paintings portraying Joseph at work in his shop, particularly in Spain and Italy, where, malicious tongues suggested, the "siesta culture" needed more instigation to labor than their Northern neighbors. More likely, the Counter-Reformation's exhortation to the practice of charity, active devotions alongside contemplative prayer, fueled the patronage of images of Joseph working. "Idle hands are the devil's workshop," says the book of Proverbs (see 16:27), and thus Joseph's industriousness became an example of how to ward off the temptation of evil.

A stunning piece exemplifying the sanctifying power of work was painted by French artist Georges de La Tour (1593–1652) in 1642. During his studies in Italy, he came in contact with the art of Caravaggio and developed what would become his own signature candlelight effect. His painting of St. *Joseph the Carpenter*, now in the Louvre, invites the viewer to peer into the shadows of a late night in Joseph's workshop, as he is perhaps finishing an important order. Joseph is stooped, the old man straining his body to work the drill into the block on the floor. The tenebrism surrounding him is unnerving, as if the temptations to slack off, to cut corners, might be lurking there. But Joseph keeps his focus on the Christ Child, who accompanies him at his work, holding a candle. The flame of the candle rises behind the fingers of the child, sending up a powerful beam that illuminates Jesus' face. The natural light is enhanced by the Light of the World.

In Joseph's task at hand, the arrangement of the drill and the block form a cross. Joseph's toils, described by St. Josemaría Escrivá as "nothing but work: work every day, with the same constant effort. And at the end of the day, a poor little house

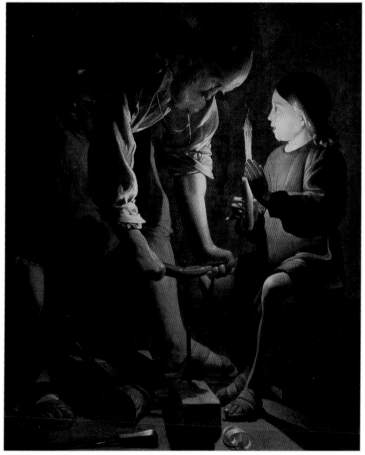

St. Joseph the Carpenter by Georges de La Tour

in which to rest and regain energy for the next day." This un-
broken life of labor was Joseph's personal cross.[137] The founder
of Opus Dei, Latin for "the work of God," exhorted the faithful

[137] St. Josemaría Escrivá, homily on the feast of St. Joseph, March 19,
1963, https://opusdei.org/en/document/in-joseph-s-workshop/.

to take Joseph as the model of how to approach work, writing that "the effort to improve your own daily occupation will give you the chance to experience the cross which is essential for a Christian."[138]

Georges de La Tour's masterful use of the warm colors of wood tinged with the smallest amount of red enhances the intimacy between the father and Son. Jesus looks animated, speaking intently to Joseph, perhaps sharing the mysteries of His mission with him.

Joseph's involvement with the salvific mission of Christ was explored in a magnificent altarpiece produced in the Netherlands. Robert Campin's *Mérode Triptych* is an early reflection on the meaning of Joseph's labors. Painted around 1425, the central panel shows the Annunciation, the left panel portrays the donor at prayer, and the right panel depicts St. Joseph in his atelier. The judicious use of oil paint facilitated the meticulous rendering of his workshop, from the different types of wood and metal tools to the townhouses outside the window. Joseph, in a lapis-blue cap and sporting shiny leather shoes, is busily drilling holes in a board. One homemade mousetrap sits on the desk while another waits outside the window. Between the two lies another cross-shaped drill, a key to reading the work as Joseph's participation in the divine plan of salvation.

In 1945, art historian Meyer Schapiro proposed that Joseph was complicit in God's snare to trick the devil. Schapiro suggested that Jesus' existence in human flesh was meant to be bait for Satan; Schapiro cited St. Augustine of Hippo's words: "The Devil exulted when Christ died, but by this very death of Christ the devil is vanquished, as if he had swallowed the bait in

[138] Ibid.

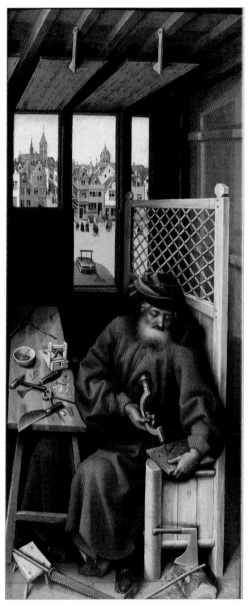

Mérode Triptych panel by Robert Campin

the mousetrap."[139] The Columbia professor argued that Joseph's marriage and the humble nature of his work served to fool the evil one into thinking Jesus was merely a man. He also noted that by the dawn of the Renaissance, a current in both theology and art envisioned Joseph as "the guardian of the mystery of the incarnation and one of the main figures in the divine plot to deceive the devil."[140] In this view, work becomes not only a means of providing for his family but an active participation in the conquest of sin. This notion would eventually blossom into one of Joseph's many titles, conferred upon him by Bl. Bartolo Longo, a nineteenth-century Italian convert from Satanism: "St. Joseph, Terror of Demons."[141]

Bartolo Longo may have influenced the renewed devotion to St. Joseph under Pope Pius XI, who fought the "scourge of Communism" head-on. In his encyclical *Divini Redemptoris*, promulgated on the feast of St. Joseph in 1937, Pius XI accused the devil himself, "the ancient tempter [who] never ceased to deceive mankind with false promises,"[142] of inspiring the evils of atheist communism. Pius XI realized the serious threat that communism posed to the common good and called upon St. Joseph to protect the Church from the many errors of a materialistic view of the human person. He concluded by placing "the vast campaign of the Church against world communism under the standard of St. Joseph, her mighty protector."[143] No longer would Joseph

[139] Schapiro, "Muscipula Diaboli," 182.

[140] Schapiro, "Muscipula Diaboli," 185.

[141] Donald Calloway *Consecration to St. Joseph: The Wonders of Our Spiritual Father* (Stockbridge, MA: Marian Press, 2020), 208.

[142] Pope Pius XI, encyclical *Divini Redemptoris* (March 19, 1937), no. 2.

[143] Ibid., no. 81.

fight from the shadows of his workshop; now he was placed in the front lines.

At the same time, artists started to take more interest in images of Joseph in his workshop, either plying his trade or teaching a young Jesus how to drill, lathe, or polish. One notable effort was the elegant mural in the Church of St. Joseph in Nazareth. Painted in the early twentieth century by an unknown artist, this work depicts the Holy Family pausing in their labors to watch the young Jesus who has just fashioned a wooden cross. The workshop is out in the open air, separated from the street by a wall of worn planks, where Joseph's wares hang. Stone steps lead up to their living quarters, but for the moment, Mary has paused from her spinning, Joseph has stopped sawing, and they both gaze upon Christ's handiwork, the preparation of His own Cross. Jesus wears

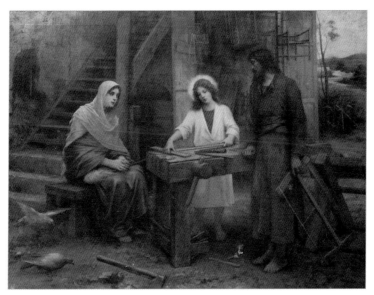

Holy Family painting by an anonymous artist,
Church of St. Joseph, Nazareth

a radiant, white robe, but His undershirt is the same earthy brown as Joseph's tunic: the painter has united the foster father and his Son through color, through the common direction of their gaze, and through their work. As Joseph makes sacrifices for his family, so Jesus will sacrifice Himself for the world. The setting is humble and the people poor, but their dignity is great.

The Holy House of Loreto contains another wonderful fresco of *Joseph the Worker*, painted around 1890 by Modesto Faustini (1839–1891). Joseph's spacious studio beckons the viewer to observe a day in the life of the Holy Family. Mary reads quietly in an elaborate chair, probably carved by her husband. Jesus, a golden-haired child, stands before His mother, hands clasped in prayer. An embroidered curtain frames them, and a soft woven rug cushions their feet. Mary wears a brocaded dress, and Christ is robed in royal purple. This more decorous side of the mural

Joseph the Worker by Modesto Faustini

represents the contemplative life of the Madonna and Child. In this work however, Joseph is not excluded, even as he works at his bench, festooned with wood shavings and surrounded by the jumbled instruments of his craft. Joseph, swathed in a red that draws the eye but also underscores mortality, directs his gaze and tilts his body to direct the viewer's gaze toward the prayerful group on the right. The window in the center is framed by an arch, its two points poised above the heads of Joseph and Jesus. By uniting the two figures, Faustini suggests that St. Joseph, through his work, his long hours of *labora*, or work, also participated in prayer, *ora*.

St. Joseph was officially recognized as the patron saint of workers by Pope Pius XII in 1955, just as the cold war was intensifying between communist and democratic countries. His feast day became May 1, baptizing the international May Day holiday dedicated to workers, to combat the communists' utilitarian view of labor with the Christian belief in the inherent dignity of every human being.

Pope Francis, during a May 1 audience in the first year of his pontificate, emphasized work as "fundamental to the dignity of a person. Work, to use a metaphor, 'anoints' us with dignity, fills us with dignity, makes us similar to God, who has worked and still works, who always acts (cf. Jn 5:17)." Joseph points the way for everyone to cooperate in God's plan through labor.[144]

The decision to create a second feast for Joseph on May 1 did more than address the labor question from a Christian perspective. The holiday is the gateway to the month dedicated to Mary, his beloved spouse, and highlights Joseph's role as model

[144] Pope Francis, Wednesday Audience, May 1, 2013.

husband in a world that no longer believed in the indissolubility of marriage.

Defender of workers, patron of the Church, protector of marriage, model for the papacy, by the end of the twentieth century St. Joseph seemed to have everything covered. His greatest challenge, however, was yet to come, as the very meaning of manhood was about to be called into question in the new millennium.[145]

[145] This chapter was first printed as an article in Aleteia, May 7, 2021, https://aleteia.org/2021/05/07/the-labors-of-st-joseph/.

Chapter 14

GO TO JOSEPH!

Over the last several decades, St. Joseph has continued to accumulate honors and accolades. Pope St. John XXIII added the saint to the Roman Canon of the Mass, and Pope Francis extended his presence to the other Eucharistic prayers. St. Joseph's altars, a custom brought to America by Italian immigrants, flourish in parishes, and some hopeful homeowners bury his likeness in the yard, looking for successful real estate sales. His name remains in the top twenty-five picks for baby boys in the United States (it is the second most popular name in Italy), and no March 19 in Rome is complete without the maraschino-topped cream puff named in his honor. Factories churn out millions of plastic statues of the saint, posing with his lily and mawkish smile or kneeling in vapid adoration for churches and crèche scenes. Despite his ubiquity, however, he has returned to the sidelines of artistic innovation. The statues go unnoticed; his placement at the Nativity, *pro forma*; his might and authority, almost forgotten. St. Joseph has become so visible as to have become invisible.

One cannot blame the papal Magisterium. Pope after pope has written on Joseph: St. John XXIII placed the Second Vatican Council under his protection; St. Paul VI and Benedict XVI

eulogized his virtues in homilies and addresses; St. John Paul II wrote the beautiful *Redemptoris Custos* in his honor; and Pope Francis dedicated the year 2021 to Joseph to "increase our love for this great saint, to encourage us to implore his intercession and to imitate his virtues and his zeal."[146]

Nor can one accuse the rest of the clergy of slacking. From St. Josemaría Escrivá to Fr. Donald Calloway, whose book *Consecration to St. Joseph: The Wonders of Our Spiritual Father* was published just in time for the Year of Joseph, invitations to "go to Joseph" abound.

Art, on the other hand, seems to have stagnated in its depictions of St. Joseph.

Modern art has lived by a mantra of freedom. Artists demand freedom from formal rules such as perspective and proportion; they insist on being liberated from decorum and proclaim themselves the arbiters of truth. Beholden only to the marketplace and the media who can assure them fame and future, they choose to amplify artistically whatever the prevailing zeitgeist demands. How can Josephine iconography survive in a world where most outlets of visual media are committed to the agenda of transgenderism, gay rights, and the slaughter of the unborn through abortion? Joseph dropped everything to spirit his Son away from Herod's massacre of newborns; the new Herods certainly do not want to see him immortalized in art.

Joseph presents a model of manliness despite and even because of his chastity, the last thing a sex-drenched society appreciates. When people define themselves through their sexual activity, measure success through conspicuous consumption, and believe they can stave off or dictate death, there is little motivation for

[146] Pope Francis *Patris Corde* 7.

artists to take on the challenge of depicting Joseph's chaste marriage, humble life of labor, or good death.

This might be the moment for the laity to galvanize artists to aspire to what Pope Francis described as Joseph's "creative courage." The obstacles of the day may seem overwhelming, but through Joseph, Pope Francis notes, "God always finds a way to save us, provided we show the same creative courage as the carpenter of Nazareth, who was able to turn a problem into a possibility by trusting always in divine providence."[147] The man who figured out how to find shelter in Bethlehem, to flee to Egypt, and to make a living in a strange land might be the one to awaken the sedated power of art. To do this, laypeople need to encourage artists by commissioning works for the home, as in the Renaissance, or in public spaces. What kind of Josephine image could speak to a young man more powerfully than the LGBTQ noise filling his ears? How could a painting of the *Death of Joseph* give hope to those in hospices, especially to those dying alone? How could families benefit from portrayals of the Holy Family to underscore the importance of fathers, mothers, and marriage? And in society at large, where the denigration of fatherhood through divorce, contraception, and abortion has led many to turn their backs on the Eternal Father, how could Josephine art remind people of their shared identity as children of God?

There are a few pioneers out there. Fr. Calloway, for instance, commissions Josephine art, and parishes occasionally will spring for innovative Christian art. We should remember, however, that it was the Taddei and the Doni families, rather than members of the clergy, who harnessed the might of Michelangelo and

[147] *Patris Corde* 5.

Raphael. For every church commission in these pages, there is an equally beautiful private commission.

Some glimmers of hope appear on the contemporary artistic landscape. Janet McKenzie, a New York native, has produced numerous works that contemplate problems of race in the context of religious art. Her majestic 2007 *Holy Family*, featuring the Madonna, Child, and Joseph as African Americans updates the European iconography yet still upholds tradition: Mary and Joseph sit side by side as the Virgin cradles the Christ Child. The textures, some intricate, some simple, present a visually compelling pattern similar to yet distinct from the usual textiles used in Western art. The subtle shades of violet, rose, and lavender, and the beautifully modeled faces and graceful composition infuse the scene with quiet dignity. McKenzie creates gentle contrasts between the man and woman; though Joseph's features are more boldly drawn, his downward gaze and gentle touch convey his tenderness. In *Patris Corde*, Pope Francis explained that "tenderness is the best way to touch the frailty within us."[148] This quality, embodied in McKenzie's Joseph proposes a new model for men in an age where "toxic masculinity" has become a buzzword threatening to devalue manhood itself. The dual lilies to the right of Mary evoke their respective chastity, and yet with one white and the other rose toned, they suggest the differing yet complementary experience of men and women.

McKenzie was inspired in her work by the fact that Joseph is so rarely portrayed as a handsome man, yet, she argues, "his love for the child Jesus surely would have radiated outwardly, and beautifully." Her art is meant to uplift Joseph, who, she claims,

[148] *Patris Corde* 2.

The Holy Family by Janet McKenzie

"like many fathers and stepfathers today, is undercelebrated and an unsung hero."[149]

[149] Interview with the artist, July 21, 2021.

Sr. Wendy Beckett, the Carmelite nun and art historian, noted how "McKenzie makes it beautifully clear that here is a family unit, three individuals bound together. We notice that both Mary and Joseph look not at us or at each other, but at Jesus. Highlighted by the glancing sunlight, Joseph's body language makes it unmistakably clear that he is devoted, body and soul, to the support of his beautiful wife, resolute to share with her the extraordinary responsibility of raising the child Jesus to manhood. This was most definitely not a one-parent family."[150]

McKenzie's interpretation of Joseph showcases his ability to speak to a community in which so many are fatherless, a brilliant new look for this universal saint.

On the other side of the Atlantic, the young Irish sculptor Dony Mac Manus also experienced a transformative encounter with St. Joseph. Commissioned in 2001 by Opus Dei to cast a bronze sculpture of *St. Joseph and the Child Jesus*, Mac Manus began to reflect on what a Joseph would look like in the twenty-first century.

Mac Manus wanted to show the world a Joseph who was "attractive and manly, but at the same time refined." His five-foot-tall statue portrays a strong man, his shoulders broadened by physical labor, wearing clothes suited to contemporary blue-collar work. Joseph's fine features, however, hint at his royal ancestry, and his bare feet maintain an old iconographic tradition from classical art. Joseph's hammer hangs heavily from his belt, as does the tool pouch slung around his waist. He was born to carry a heavy burden and strong enough to bear it.

[150] Wendy Beckett, "Sister Wendy Beckett meditates on Janet McKenzie's 'The Holy Family,'" *America*, January 18, 2002, https://www.americamagazine.org/arts-culture/2010/01/18/sister-wendy-beckett-meditates-janet-mckenzies-holy-family.

The Christ Child, however, is certainly no burden. Joseph effortlessly cradles the boy as he seems to tickle the bare skin. Jesus abandons Himself to the joy of His father's embrace, His round face beaming at the gentle caress. Mac Manus says he was inspired by a phrase of St. Josemaría Escrivá: "Throw yourself into the strong arms of the father."

The pouch follows the curve of the infant's body, recalling how Joseph carried the boy to the temple, home to Nazareth, and across the desert to Egypt. However, taken with the heavy arm of the baby drooping downward (a motif from Michelangelo's *Pietà*,) the statue also presages Jesus' sacrifice and death. MacManus captures a precious moment of joy, before sorrow and suffering set in.

Mac Manus's *St. Joseph* speaks to the thought of St. John Paul II, who defended the authentic fatherhood of the saint in light of his virginal marriage. In *Redemptoris Custos*, the pope wrote, "Joseph is the father: his fatherhood is not one that derives from begetting offspring; but neither is it an 'apparent' or merely 'substitute' fatherhood. Rather, it is one that fully shares in authentic human fatherhood."[151]

Purity doesn't detract from masculinity, and sexual activity doesn't define manhood. One of the centerpieces of the pontificate of John Paul II was his teaching on human sexuality in a series of lectures called the Theology of the Body. Dr. Christopher West, founder of the Theology of the Body Institute, devoted to the promulgation of this body of teaching, asserts that "Joseph was not an old man with no libido."[152]

[151] St. John Paul II, *Redemptoris Custos*, no. 21.
[152] Christopher West, "St. Joseph Was Not a Prude," Theology of the Body Institute, https://tobinstitute.org/st-joseph-was-not-a-prude/.

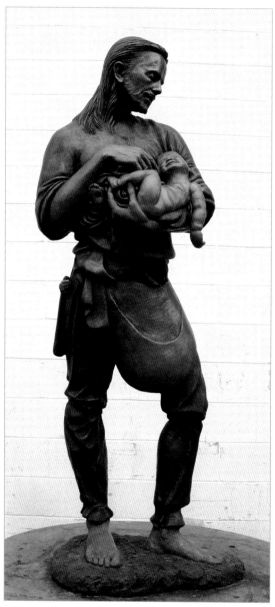

St. Joseph and the Child Jesus by Dony Mac Manus

West points out that "virginity and eros are only 'contradictory' ideas in light of our lack of virtue, in light of the disintegration that came with original sin. St. Joseph is a model for all of us in what it means to overcome that disintegration and live eros as the power to love as God loves."[153]

The Josephs of Mac Manus and McKenzie portray handsome men, role models of self-restraint in the modern age of bodily objectification. They are made to love and be loved.

The 2000 film *Joseph of Nazareth* directed by Raffaele Mertes and Elisabetta Marchetti and starring Tobias Moretti recounts the story of a young, rugged Joseph whose relationship with Mary grows in love as they face the challenges of their vocations together. They remind married couples of what John Paul II described as the "fullness of 'eros,' which implies the upward impulse of the human spirit toward what is true, good, and beautiful, so that what is 'erotic' also becomes true, good, and beautiful."[154]

The tribulations of the modern age may seem overwhelming, but the more acrimonious the battle, the more St. Joseph shines. Now would be the time for artists to muster their "creative courage" to serve as faithful squires to this silent knight.

[153] West, "St. Joseph Was Not a Prude."

[154] John Paul II, *The Redemption of the Body and Sacramentality of Marriage (Theology of the Body): From the Weekly Audiences of His Holiness September 5, 1979–November 28, 1984* (Vatican City: Libreria Editrice Vaticana, 2005), 123, https://d2y1pz2y630308. cloudfront.net/2232/documents/2016/9/theology_of_the_body. pdf.

IMAGE CREDITS

→ · ◆ · ←

1. The Elusive Saint

2. The Enigmatic Elder

3. The Silent Knight

Image Credits

14. Go to Joseph

BIBLIOGRAPHY

Alberti, Francesca. "'Divine Cuckolds': Joseph and Vulcan in Renaissance Art and Literature." In *Cuckoldry, Impotence and Adultery in Europe*, edited by Sara F. Matthews-Grieco. Farnham: Ashgate, 2014.

Altet, Xavier Barral I. *Romaico: Citta cattedrali e Monateri* Cologne: Taschen 1999.

Angiola, Eloise M. "Nicola Pisano, Federigo Visconti, and the Classical Style in Pisa." *Art Bulletin* 59, no. 1 (March 1977).

Annals of St. Joseph. Vol. 10, no. 1. De Père, WI: Archconfraternity of St. Joseph, 1898.

Averil, Cameron A. "Nativity Poem of the Sixth Century A.D." *Classical Philology* 74, no. 3 (July 1979): 222–232.

Avery, Myrtilla. "The Alexandrian Style at Santa Maria Antiqua, Rome." *Art Bulletin* 7, no. 4 (1925): 131–149. doi:10.2307/3046494.

Bagnoli, A., R. Bartalini, L. Bellosi, and M. LaClotte. *Duccio. Siena Fra Tradizione Bizantina E Mondo Gotico*. Milan: Silvana Edit. per Monte dei Paschi di Siena, 2003.

Barbagallo, Sandro. *St. Joseph in Art*. Città del Vaticano: Edizioni Musei Vaticani, 2014.

Barni, Enrico. "*Il Santo Anello* e la Storia dei Rapporti nei Secoli tra le Communita di Perugia e Chiusi." In *Il Santo Anello: Leggenda,*

storia, arte, devozione. Perugia: Commune di Perugia Cultura, Perugia, 2005.

Baronius, Caesar. *Annales Ecclesiastici*. Vol. 10. Rome, 1602.

Battista, Alberti Leon. *The Family in Renaissance Florence: I Libri della Famiglia*. Translated by Renée Neu Watkins. Long Grove, IL: Waveland Press, 1994.

Beckett, Wendy "Sister Wendy Beckett meditates on Janet McKenzie's 'The Holy Family.'" *America*, January 18, 2002. https://www.americamagazine.org/arts-culture/2010/01/18/sister-wendy-beckett-meditates-janet-mckenzies-holy-family.

Bellori, Giovan Pietro. *Lives of the Modern Painters, Sculptors and Architects*. Translated by Alice Wohl Cambridge. New York: University Press, 2005.

Bernard, St. *Laudes Mariae 2*. Prayers4Reparation. https://prayers4reparation.wordpress.com/2013/08/04/writings-of-the-church-fathers-st-bernard-of-clairvaux-on-st-joseph-the-spouse-of-mary/.

Bernardine of Siena. "A Faithful Foster-Parent and Guardian." Sermon 2, "On Joseph." Vatican website. https://www.vatican.va/spirit/documents/spirit_20010319_bernardino_en.html.

Bernardino da Siena. *Le prediche volgari* (Florence, 1424). Edited by Ciro Cannarozzi. Pistoia: Pacinotti, 1934.

Bellori, Giovan Pietro. *Lives of the Modern Painters, Sculptors and Architects*. Translated by Alice and Hellmut Wohl. New York: Cambridge University Press, 2005.

Binet, Père. *The Divine Favors Granted to St. Joseph*. Charlotte, NC: TAN Books, 2009.

Black, Charlene Villaseñor. *Creating the Cult of St. Joseph: Art and Gender in the Spanish Empire*. Princeton, NJ: Princeton University Press, 2006.

Bonaventure, St. Sermo III, Vig. Epiph. Dmni. Quoted in Noel Muscat, O.F.M., "Saint Joseph in Franciscan Theology." Franciscan Studies, October 3, 2018. https://franciscanstudies.files.wordpress.com/2018/10/ns31-st-joseph-fran-theology.pdf.

Bridget of Sweden, St. *The Revelations of St. Brigitta of Sweden*. Vol. 3. Translated by Denis Searby. Oxford: Oxford University Press, 2006–2015.

Byrne, Joseph P. *The World of Renaissance Italy: A Daily Life Encyclopedia*. Greenwood ABC-CLIO, 2017.

C., A. "Le développement historique du Culte de Saint Joseph." *Revue Bénédictine* 14, nos. 1–4 (1897): 104–114.

Cadogan, Jean. *Domenico Ghirlandaio: Artist and Artisan*. New Haven, CT: Yale University Press, 2000.

Calloway, Donald. *Consecration to St. Joseph: The Wonders of Our Spiritual Father*. Stockbridge, MA: Marian Press, 2020.

Camesasca, Ettore. *All the Paintings of Raphael, Part I*. New York: Hawthorn Books, 1963.

Campbell, Jeffrey. "The Ars Moriendi: An Examination, Translation, and Collation of the Manuscripts of the Shorter Latin Version." Master's thesis, University of Ottawa, 1995. https://ruor.uottawa.ca/bitstream/10393/10313/1/MM07840.PDF.

The Canterbury Dictionary of Hymnology. Norwich: Canterbury Press, 2013. http://www.hymnology.co.uk/.

Caracciolo, Raffaele. *Il Santo Anello. Leggenda, storia, arte, devozione*. Perugia: Comune di Perugia, 2005.

Chorpenning, Joseph F. "Francis de Sales's Emblematic Interpretation of the Death of St. Joseph (*Treatise on the Love of God*, Book 7, chapter 13)," in *Emblematic Images and Religious Texts: Studies in Honor of G. Richard Dimler, S.J.*, 123–143. Philadelphia: Saint Joseph's University Press, 2010.

———. *Holy Family in Art and Devotion*. Philadelphia: Saint Joseph University Press, 1998.

———. *Mexican Devotional Retablos from the Peters Collection*. Philadelphia: Saint Joseph's University Press, 1994.

———. *Patron Saint of the New World: Spanish American Colonial Images of St. Joseph*. Philadelphia: Saint Joseph's University Press, 1992.

————, ed. *Joseph of Nazareth through the Centuries*. Philadelphia: St. Joseph's University Press, 2011.

Claudel, Paul. "St. Joseph." Translated by Wallace Fowlie. *Poetry* 87, no. 3 (December 1955).

Cohen, Elizabeth S. "Seen and Known: Prostitutes in the Cityscape of Late-Sixteenth-Century Rome." *Renaissance Studies* 12, no. 3 (1998).

The Council of Trent: The Canons and Decrees of the Sacred and Oecumenical Council of Trent. Edited and translated by J. Waterworth. London: Dolman, 1848. Papal Encyclicals. https://www.papalencyclicals.net/councils/trent.htm.

Couzin, Robert. "Death in a New Key: The Christian Turn of Roman Sarcophagi." Doctoral thesis, University of Toronto 2013. https://tspace.library.utoronto.ca/bitstream/1807/70067/3/Couzin_Robert_201311_PhD_thesis.pdf.

Cresp, Mary, R.S.J., ed. *Journeying with Joseph: Josephite Essays for the Year of St Joseph*. Adelaide Australia: ATF Theology, 2021.

Damian, Carol. "The Survival of Inca Symbolism in Representations of the Virgin in Colonial Peru." *Athanor* 7 (1988).

De Cherance, Leopold. *St. Margaret of Cortona: The Magdalen of the Seraphic Order*. Dublin: Sealy, Bryers, and Walker, 1903. Internet Archive. https://archive.org/stream/stmargaretofcort00cher/stmargaretofcort00cher_djvu.txt.

Dell'Amico, Giuseppe. *Federico Visconti Di Ricoveranza, Arcivescovo Di Pisa*. Doctoral thesis, University of Pisa, 2011. https://core.ac.uk/download/pdf/14701665.pdf.

Derbes, Anne. *Picturing the Passion in Late Medieval Italy: Narrative Painting, Franciscan Ideologies, and the Levant*. New York: Cambridge University Press, 1996.

Douie, Decima L. "Olivi's 'Postilla Super Matthaeum' (MS. New College B. 49)." *Franciscan Studies* 35 (1975): 66–2. http://www.jstor.org/stable/41974786.

Duniway, David Cushing. "A Study of the Nuremberg Chronicle." Papers of the Bibliographical Society of America 35, no. 1 (1941):

17–34. https://www.journals.uchicago.edu/doi/10.1086/pbsa.35.1
.24296510.

Dusserre, Joseph. *Les origines de lu dévotion à Saint Joseph: Cahiers de Joséphologie* 1, no. 1 (January–June 1953), Les origines de la dévotion à saint Joseph (liberius.net).

Dzon, Mary. "Joseph and the Amazing Christ-Child of Late-Medieval Legend." In *Childhood in the Middle Ages and the Renaissance: The Results of a Paradigm Shift in the History of Mentality*, edited by Albrecht Classen, 135–157. Berlin: De Gruyter, 2005.

Edgerton, Samuel Y., Jr. *The Renaissance Rediscovery of Linear Perspective*. New York: Basic Books, 1975.

Elliott, James Keith. *The Apocryphal New Testament: A Collection of Apocryphal Christian Literature in an English Translation*. Oxford, UK: Clarendon Press, 2005.

———. *A Synopsis of the Apocryphal Nativity and Infancy Narratives*. Leiden: Brill, 2016.

Escrivá, St. Josemaría. *Christ Is Passing By: Homilies by Josemaría Escrivá*. Sydney: Little Hills Press, 1995. https://www.escrivaworks.org/book/christ_is_passing_by-chapter-5.htm section 55.

———. Homily on the feast of St. Joseph, March 19, 1963. https://opusdei.org/en/document/in-joseph-s-workshop/.

Facchinetti, Vittorino. "San Bernardino Di Siena." *Aevum* 4, no. 3/4 (1930): 319–381. http://www.jstor.org/stable/25818461.

Filas, Francis Lad. *Joseph: The Man Closest to Jesus*. Boston: St. Paul Editions, 1962.

Foley, Michael P. "The Feast of the Espousals of Mary and Joseph." New Liturgical Movement, January 21, 2021. https://www.newliturgicalmovement.org/2021/01/the-feast-of-espousals-of-mary-and.html#.YOMqaOgzaUkM.

Folgerø, Olav. "The Sistine Mosaics of S. Maria Maggiore in Rome: Christology and Mariology in the Interlude between the Councils of Ephesus and Chalcedon." *Acta Ad Archaeologiam et Artium Historiam Pertinentia* 21 (September 2017): 33–64.

Francis, Pope. Apostolic letter *Patris Corde* (December 8, 2020).

———. Wednesday Audience (May 1, 2013).

Francis de Sales, St. *The Spiritual Conferences*. London : Aeterna Press, 1943.

———. *Treatise on the Love of God*. Grand Rapids, MI: Christian Classics Ethereal Library, 2020. http://hosted.desales.edu/files/salesian/PDF/love.pdf.

Franklin, David. "Rosso Fiorentino's *Betrothal of the Virgin*: Patronage and Interpretation." *Journal of the Warburg and Courtauld Institutes* 55 (1992): 180–199.

Freeland, Jane Patricia, and Agnes Josephine Conway. "Christmas." In *Sermons*, vol. 93 of *The Fathers of the Church: A New Translation*, translated by John N. Hritzu, 76–131. Washington, D.C.: Catholic University of America Press, 1996. doi:10.2307/j.ctt32b3ts.9.

Gardini, P., and P. Novara, eds. *Le collezioni del Museo Arcivescovile di Ravenna* [The collections of the archiepiscopal Museum of Ravenna]. Ravenna: Opera di Religione di Ravenna, Ravenna 2011, 2016. https://www.scribd.com/document/134926391/Catterdra-Di-Massimiano.

Gerson, Jean. *Josephina, L'épopée de saint Joseph*. 2 vols. Introduction, notes, and commentary by Isabel Iribarren. Paris: Les Belles Lettres, 2019.

———. *Oeuvres complètes*. Edited by Palémon Gloriuex. 10 vols. Paris: Desclée, 1961–1973.

Gertrude of Hefta. *The Life and Revelations of Saint Gertrude: Virgin and Abbess of the Order of St. Benedict* (London: Burns, Oates and Washbourne [1870?].

González, Juan José Martín. "El convento de San José de Ávila (patronos y obras de arte)."

Boletín del Seminario de Estudios de Arte y Arqueología 45 (1979): 349–376.

Glorieux, Palémon. "Saint Joseph dans l'oeuvre de Gerson." *Cahiers de Joséphologie* 19 (1971): 414–428.

Gospel of Pseudo-Matthew. In vol. 8 of Ante-Nicene Fathers, edited by Alexander Roberts, Sir James Donaldson, and Arthur Cleveland Coxe. New York: Christian Literature Publishing, 1886. Gnostic Society Library. http://gnosis.org/library/psudomat.htm.

Gracián, Jerónimo. *Just Man, Husband of Mary, Guardian of Christ: An Anthology of Readings from Jerónimo Gracián's* Summary of the Excellencies of St. Joseph *(1597)*. Translated and edited by Joseph Chorpenning, O.S.F.S. Philadelphia: Saint Joseph's University Press, 1993.

———. *Sumario de las Excelencias del Glorioso S. Ioseph, Esposo de la Virgen Maria* 1597.

Gratian. *Marriage Canons from the Decretum of Gratiani*. Translated by John T Noonan Jr. 1967. http://legalhistorysources.com/Canon%20Law/MARRIAGELAW.htm.

Hearn, Millard Fillmore. *Romanesque Sculpture: The Revival of Monumental Stone Sculpture in the 11th and 12th Centuries*. Ithaca, NY: Cornell University Press, 1985.

The History of Joseph the Carpenter. Translated by Alexander Walker. In vol. 8 of Ante-Nicene Fathers, edited by Alexander Roberts, James Donaldson, and A. Cleveland Coxe. Buffalo, NY: Christian Literature Publishing, 1886. Revised and edited for New Advent by Kevin Knight. https://www.newadvent.org/fathers/0805.htm.

Hope, Janet Elizabeth. *Transformations of the Image of St. Joseph in Early Modern Art*. Birmingham, UK: Birmingham City University, 2011.

Hornik, Heidi, and Mikeal Parsons. "The Shepherds' Adoration." Center for Christian Ethics, Baylor University (2011). https://www.baylor.edu/content/services/document.php/159113.pdf.

Howard, Thomas. *Christ the Tiger*. Eugene, OR: Wipf and Stock, 1990.

Huizinga, Johan. *The Waning of the Middle Ages*. Harmondsworth: Peregrine, 1919.

Ilsink, Matthijs, Jos Koldeweij, and Ron Spronk. "From Bosch's Stable: Hieronymus Bosch and the Adoration of the Magi." Netherlands: WBOOKS, 2018.

Iribarren, Isabel. "The Cult of the Marriage of Joseph and Mary: The Shaping of Doctrinal Novelty in Jean Gerson's *Josephina* (1414–17)." In *Individuals and Institutions in Medieval Scholasticism*, edited by Antonia Fitzpatrick and John Sabapathy, 253–268. London: University of London Press, 2020.

Jeep, John. *Routledge Revivals: Medieval Germany*. New York: Garland Publishing, 2001.

Jerome, St. *Against Helvidius*. In Nicene and Post-Nicene Fathers. Second Series. Vol. 6. Edited by Philip Schaff. Christian Classics Ethereal Library. https://www.ccel.org/ccel/schaff/npnf206.vi.v.html.

John Paul II, Pope St. Apostolic exhortation *Redemptoris Custos* (August 15, 1989).

John Paul II. *The Redemption of the Body and Sacramentality of Marriage (Theology of the Body): From the Weekly Audiences of His Holiness September 5, 1979–November 28, 1984*. Vatican City: Libreria Editrice Vaticana, 2005. https://d2y1pz2y630308.cloudfront.net/2232/documents/2016/9/theology_of_the_body.pdf.

Langdon, Helen. *Caravaggio: A Life*. London: Pimlico, 1999.

"Josephology Part 10: Francisco Suárez and the Order of the Hypostatic Union." *The Rad Trad* (blog), June 11, 2015. http://theradtrad.blogspot.com/2015/06/josephology-part-10-francisco-suarez.html.

Justin Martyr. *Dialogue with Trypho*. Translated by Marcus Dods and George Reith. In vol. 1 of Ante-Nicene Fathers, edited by Alexander Roberts, James Donaldson, and A. Cleveland Coxe. Buffalo, NY: Christian Literature Publishing, 1885. Revised and edited for New Advent by Kevin Knight. https://www.newadvent.org/fathers/01286.htm.

Kalavrezou, Ioli. "Images of the Mother: When the Virgin Mary Became 'Meter Theou.'" Dumbarton Oaks Papers 44 (1990): 165. doi:10.2307/1291625.

Kelly, J. N. D. *Lives of the Popes*. New York: Oxford University Press, 1986.

Krautheimer Richard. *Rome: Profile of a City 312–1308*. Princeton: Princeton University Press, 2000.

L'Arte nel Medioevo Conosci L'Italia. Milan: Touring Club Italiano, 1964.

Leo I, Pope St. Sermon 33. In *Sermons of St. Leo the Great*. Translated by Charles Lett Feltoe. In vol. 12 of Nicene and Post-Nicene Fathers, Second Series, edited by Philip Schaff and Henry Wace. Buffalo, NY: Christian Literature Publishing, 1895. Revised and edited for New Advent by Kevin Knight. https://www.newadvent.org/fathers/360333.htm.

Leo the Great, St. *Sermons*. Translated by Jane Patricia Freeland and Agnes Josephine Conway. Washington, DC: Catholic University of America Press, 1996.

Leo XIII, Pope. Encyclical *Quamquam Pluries* (August 15, 1889).

———. Encyclical *Rerum Novarum* (May 15, 1891).

Lev, Elizabeth. "In Giotto's 'Nativity' a Novel Pope Has Chosen a Novel Image." Aleteia, December 18, 2016. https://aleteia.org/2016/12/18/in-giottos-nativity-a-novel-pope-has-chosen-a-novel-image/.

Lidova, Maria. "Sulla più antica immagine mariana nella diocesi di Firenze: Maria Regina nella basilica di San Marco." In *L'Assunzione di Maria*, by Giorgio La Pira, edited by Maria Lidova, Giulio Conticelli, and Stefano De Fiores, M. Lidova, 163–184. Florence: Polistampa, 2013.

Matthews-Grieco, Sara F., ed. *Cuckoldry, Impotence and Adultery in Europe*. Farnham: Ashgate, 2014.

Miller, Father Frederick L. *St. Joseph: Our Father in Faith*. New Haven, CT: Knights of Columbus Supreme Council 2021). https://www.kofc.org/un/en/resources/cis/cis328.pdf.

Lev, Elizabeth. *How Catholic Art Saved the Faith: The Triumph of Beauty and Truth in Counter-Reformation Art*. Manchester, NH: Sophia Institute Press, 2018.

Molanus, Johannes (van Vermeulen). *De Historia Sanctarum Imaginum et Picturarum*. Louvain: Typis Academicis, 1570.

Moran, J. F. *The Japanese and the Jesuits: Alessandro Valignano in Sixteenth Century Japan*. London: London, 1993.

Mori, Jenny. "St Joseph in Peruvian Culture." In *Journeying with Joseph: Josephite Essays for the Year of St Joseph*. Edited by Mary Cresp, R.S.J. Adelaide Australia: ATF Theology, 2021.

O'Carroll, Michael. *Theotokos: A Theological Encyclopedia of the Blessed Virgin Mary*. Eugene, OR: Wipf and Stock, 1982.

Oen, Maria H. "Iconography and Visions: St. Birgitta's Revelation of the Nativity of Christ." In *The Locus of Meaning in Medieval Art: Iconography, Iconology, and Interpreting the Visual Imagery of the Middle Ages*, edited by Lena Liepe, 212–237. Kalamazoo / Berlin: Medieval Institute Publications / Walter De Gruyter, 2018.

Paleotti, Gabriele. *Discourse on Sacred and Profane Images*. Edited by Paolo Prodi. Translated by William McCuaig. Los Angeles: Getty Research Institute, 2012.

Paliouras, Athanase. *Monastère de St. Catherine au Sinai*. Sinai: Monastère du sacré du Sinai, 1985.

Paul VI, Pope St. Homily for the Feast of St. Joseph (March 19, 1969).

Payan, Paul. *Joseph: Une image de la paternité dans l'Occident medieval*. Lonrai, France: Aubier, 2006.

———. "La sanctification *in utero* de Joseph : une proposition gersonienne." *L'Atelier du Centre de recherches historiques* 10 (2012). http://journals.openedition.org/acrh/4246.

———. "Ridicule? L'image ambiguë de saint Joseph à la fin du Moyen Âge." *Médiévales* 39 (2000): 96–111. https://doi.org/10.3406/medi.2000.1497.

Penny, Nicholas, and Roger Jones. *Raphael*. New Haven, CT: Yale University Press, 1983.

Petersen, William L. "The Dependence of Romanos the Melodist upon the Syriac Ephrem: Its Importance for the Origin of the Kontakion." *Vigiliae Christianae* 39, no. 2 (1985): 171–187. doi:10.2307/1584408.

Pius IX, Pope. Decree *Quemadmodum Deus* (December 8, 1870). Oblates of St. Joseph. https://osjusa.org/st-joseph/magisterium/quemadmodum-deus/.

Pius XI, Pope. Encyclical *Divini Redemptoris* (March 19, 1937).

Pogliani, Paola. "Il Perduto Oratorio di Giovanni VII nella Basilica di San Pietro in Vaticano. I Mosaici." In *Santa Maria Antique tra Roma and Bizanzio*. Curated by Giuseppe Morganti, Giulia Bordi, and Maria Andaloro Electa. Milan: Electa, 2016.

Prcela, J. Ivan. *Joseph: Husband of the Immaculate Mary*. Victoria, B.C., Canada: Friesen Press, 2016.

Protoevangelium of James. Translated by Alexander Walker. In vol. 8 of Ante-Nicene Fathers, edited by Alexander Roberts, James Donaldson, and A. Cleveland Coxe. Buffalo, NY: Christian Literature Publishing, 1886. Revised and edited for New Advent by Kevin Knight. https://www.newadvent.org/fathers/0847.htm.

Ratzinger, Joseph Cardinal. *God and the World: A Conversation with Peter Seewald*. San Francisco: Ignatius Press, 2002.

Réau, Louis. "Joseph." In *Iconographie des saints*. Vol. 3, pt. 2 of *Iconographie de l'art chrétien*. Paris: Presses Universitaires de France, 1958.

Richardson, Carol M. "St. Joseph, St. Peter, Jean Gerson and the Guelphs." *Renaissance Studies* 26, no. 2 (2012): 243–268. http://www.jstor.org/stable/24422361.

Rizzardi, Clementina. "Massimiano a Ravenna: la cattedra eburnea del Museo Arcivescovile alla luce di nuove ricerche." In *Ideologia e cultura artistica tra Adriatico e Mediterraneo orientale (IV-X secolo)*. Bologna Ante Quem, 2009.

Roccati, G. "La *Josephina* de Jean Gerson et la tradition médiévale du poème biblique narratif." *Le Moyen Âge* 122 (2016): 627-641. https://doi.org/10.3917/rma.223.0627.

Sapin, Christian. *Bourgogne Romane*. Dijon: Edition Faton, 2007.

Sarah, Robert Cardinal. *The Power of Silence: Against the Dictatorship of Noise*. San Francisco: Ignatius Press, 2017.

Schapiro, Meyer. "Muscipula Diaboli, the Symbolism of the Mérode Altarpiece." *Art Bulletin* 27, no. 3 (September 1945): 182–187. http://www.jstor.org/stable/3047011.

Schwartz, Sheila. "The Iconography of the Rest on the Flight into Egypt." Doctoral dissertation, New York University, Institute of Fine Arts, 1975.

———. "St. Joseph in Meister Bertram's Petri-Altar." *Gesta* 24, no. 2 (March 1985): 147–156.

Sgarlata, Mariarita. "Il sarcofago di Adelfia." In *La Rotonda di Adelfia. Testimonianze archeologiche dalla catacomba di S. Giovanni.* Palermo: Regione siciliana, Assessorato dei beni culturali e dell'identità siciliana, 2014.

Sheen, Fulton J. *The World's First Love: Mary Mother of God.* New York: McGraw-Hill, 1952.

Stefaniak, Regina. *Mysterium Magnum: Michelaneglo's Tondo Doni.* Leiden: Brill, 2008.

Strong, Eugénie. "Professor Josef Strzygowski on the Throne of St. Maximian at Ravenna, and on the Sidamara Sarcophagi." *Burlington Magazine for Connoisseurs* 11, no. 50 (1907): 108–111. http://www.jstor.org/stable/857103.

Teresa of Avila, St. *The Autobiography of St. Teresa of Avila.* Translated by Kieran Kavanaugh, O.C.D., and Otilio Rodriguez, O.C.D. New York: One Spirit, 1995.

Thode, Henry. *Francesco d'Assisi e le origini dell'arte del Rinascimento in Italia.* Rome: Donzelli Editore, 2003.

Toschi, O.S.J., Larry M. "Part B—Other Official Recognition of Devotions." Oblates of St. Joseph. https://osjusa.org/st-joseph/liturgy/part-b-other-official-recognition-of-devotions/.

Voltan, Anna Maria, Jorgé Maria Mejía, and Stefano Liberati. *Venite Adoremus: Le Immagini della Natività da Turer a Tiepolo.* Milan: F. Motta, 2004.

Wernham, R., ed. *The New Cambridge Modern History.* Cambridge: Cambridge University Press, 1968. doi:10.1017/CHOL9780521045438.

West, Christopher. "St. Joseph Was Not a Prude." Theology of the Body Institute. https://tobinstitute.org/st-joseph-was-not-a-prude/.

"Who Is Saint Joseph?" St. Joseph's Church, San Antonio, Texas. https://stjsa.org/who-is-saint-joseph.

Williams, Anne L. *Satire, Veneration, and St. Joseph in Art, c. 1300–1550.* Amsterdam: Amsterdam University Press, 2019.

———. "Satirizing the Sacred: Humor in Saint Joseph's Veneration and Early Modern Art." *Journal of Historians of Netherlandish Art* 10, no. 1 (Winter 2018). https://jhna.org/articles/satirizing-sacred-humor-saint-josephs-veneration-early-modern-art/.

Wilson, Carolyn C. "A Leonardo *Concetto* in the Context of the So-Called *Adoration of the Shepherds.*" *Source* 24, no. 3 (2005): 28–35. http://www.jstor.org/stable/23207937.

———. "Sanctus Joseph Nutritor Domini: A Triptych Attributed to Jan Gossaert Considered as Evidence of Early Hapsburg Embrace of St. Joseph's Cult." In *Saint Joseph: Patron for Our Times.* Kalisz, Poland 2009.

———. "St Joseph and the Process of Decoding Vincenzo Catena's *Warrior Adoring the Infant Christ and the Virgin,*" *Artibus et Historiae* 67 (May 2021): 117–136.

———. *St. Joseph in Italian Renaissance Society and Art: New Directions and Interpretations.* Philadelphia: Saint Joseph's University Press, 2001.

Zirpolo, Lilian. *Historical Dictionary of Baroque Art and Architecture.* London: Rowman & Littlefield, 2010.

ABOUT THE AUTHOR

$\rightarrow \cdot \blacklozenge \cdot \leftarrow$

Elizabeth Lev studied art history at the University of Chicago and the University of Bologna with a special emphasis on Italian Renaissance and Baroque art. She leads tours of Rome and the Vatican and has taught art history at Duquesne University's Italian Campus since 2002. She is the author of several books, including *How Catholic Art Saved the Faith* (Sophia Institute Press, 2018). Lev lives in Rome with her husband, Thomas D. Williams, and has three children.

Sophia Institute

Sophia Institute is a nonprofit institution that seeks to nurture the spiritual, moral, and cultural life of souls and to spread the gospel of Christ in conformity with the authentic teachings of the Roman Catholic Church.

Sophia Institute Press fulfills this mission by offering translations, reprints, and new publications that afford readers a rich source of the enduring wisdom of mankind.

Sophia Institute also operates the popular online resource CatholicExchange.com. *Catholic Exchange* provides world news from a Catholic perspective as well as daily devotionals and articles that will help readers to grow in holiness and live a life consistent with the teachings of the Church.

In 2013, Sophia Institute launched Sophia Institute for Teachers to renew and rebuild Catholic culture through service to Catholic education. With the goal of nurturing the spiritual, moral, and cultural life of souls, and an abiding respect for the role and work of teachers, we strive to provide materials and programs that are at once enlightening to the mind and ennobling to the heart; faithful and complete, as well as useful and practical.

Sophia Institute gratefully recognizes the Solidarity Association for preserving and encouraging the growth of our apostolate over the course of many years. Without their generous and timely support, this book would not be in your hands.

www.SophiaInstitute.com
www.CatholicExchange.com
www.SophiaInstituteforTeachers.org

Sophia Institute Press® is a registered trademark of Sophia Institute.
Sophia Institute is a tax-exempt institution as defined by the
Internal Revenue Code, Section 501(c)(3). Tax ID 22-2548708.